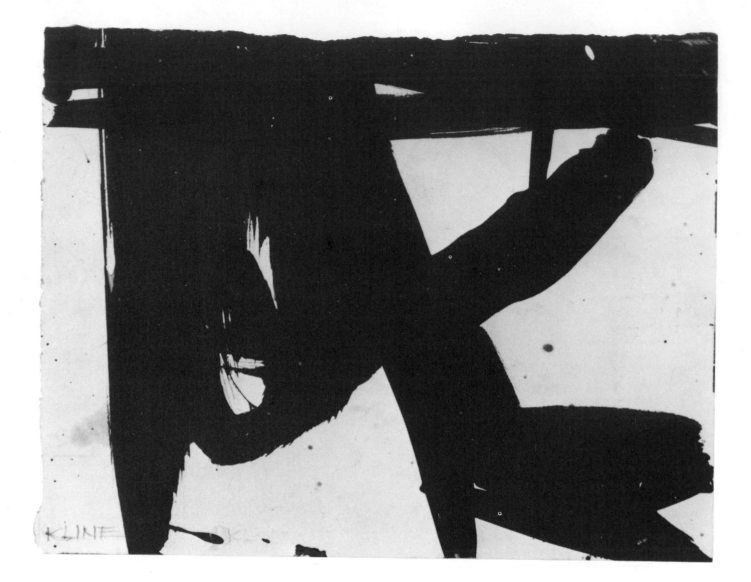

TWENTIETH-CENTURY DRAWINGS

Selections from the
Whitney Museum of American Art

Selected and with Commentary by
Paul Cummings
Adjunct Curator, Drawings

DOVER PUBLICATIONS, INC.
NEW YORK

Frontispiece: FRANZ KLINE, *Untitled*, 1960
Ink on paper, 8½ x 10½ (21.6 x 26.7). Gift of Mr. and Mrs. Benjamin Weiss, 78.53.

Published in Canada by General Publishing Company, Ltd., 30 Lesmill Road, Don Mills, Toronto, Ontario.
Published in the United Kingdom by Constable and Company, Ltd., 10 Orange Street, London WC2H 7EG.

Twentieth-Century Drawings: Selections from the Whitney Museum of American Art is a new work, first published by Dover Publications, Inc., in 1981. All photographs by Geoffrey Clements, except plate 48 by Oliver Baker.

International Standard Book Number: 0-486-24143-2
Library of Congress Catalog Card Number: 81-68242

Manufactured in the United States of America
Dover Publications, Inc.
180 Varick Street
New York, N.Y. 10014

FOREWORD

This is the first major publication devoted solely to the drawings in the Permanent Collection of the Whitney Museum of American Art. It signifies that we recognize drawings as important works of art in their own right, not—as many still think—anticipations of greater accomplishment in other media. The works illustrated are among the finest owned by the Museum, and represent the broad range of expression possible in the drawing medium.

Although in recent years attention has been increasingly directed toward drawing as a primary mode of expression rather than as a subordinate art form, truly comprehensive public collections of twentieth-century American drawings are nevertheless few. We are pleased that the Whitney Museum can therefore make a definite contribution to the appreciation of American art by building an outstanding collection in this field. Several years ago, Paul Cummings, Adjunct Curator, Drawings, and Flora Biddle, President of the Whitney Museum of American Art, established a Drawing Committee to guide the course of our acquisitions and support activities which would bring attention to drawings.

When the decision was made to pursue this objective, the response by both collectors and the public was extremely encouraging. It is our hope that this book will add to both the knowledge and connoisseurship of American drawing.

TOM ARMSTRONG
Director

PREFACE

In selecting the drawings for inclusion in this volume, I have attempted to present the broadest range of taste and to show the artists at the high point of their accomplishments. Many of the works chosen are among the finest produced by these individuals. This book, however, should not be considered a history of drawing in the twentieth century, but rather a refined view of a public collection formed with the affection and vagaries which distinguish most such ventures. Because of the Whitney Museum's important sculpture collection, we have a special interest in gathering drawings by sculptors. Many such works are included in this selection. Our expectation is that this effort will encourage individuals as well as public institutions to support the study and collecting of drawings.

Accompanying each illustration are brief critical commentaries that, I hope, will stimulate interest in how to look at drawings, and will provoke one to consider the impulses which caused them to be made. My aim has been to encourage some understanding of the graphic means employed by the artists in expressing their aspirations and to evaluate their accomplishments by closely observing their work. In any such volume as this, it would be difficult not to reflect current taste, critical enthusiasms or mutable fashion. One must first look to see, and it has been my purpose in the text to serve as a catalyst to enlarge the emotional and intellectual experience these works produce, thereby augmenting our understanding of the art, the artist and something of our own times.

I should like to thank Hayward Cirker of Dover Publications, Inc., who commissioned this book, and Tom Armstrong for his approval and continued encouraging support. Gratitude is also extended to Doris Palca, Head of Publications and Sales, and her associates—Sheila Schwartz, James Leggio, Anita Duquette and Anne Munroe—for their editorial aid; to Laura Laughlin for the initial research, and to Kristie Jayne for substantial further research and for typing. And as always, a special note of thanks to Joan Sumner Ohrstrom for her tasteful, imaginative and enlightened editorial advice.

P.C.

New York City, 1981

INDEX OF ARTISTS

References are to plate numbers.

Dimensions for plates are given first in inches, then in centimeters; height precedes width.

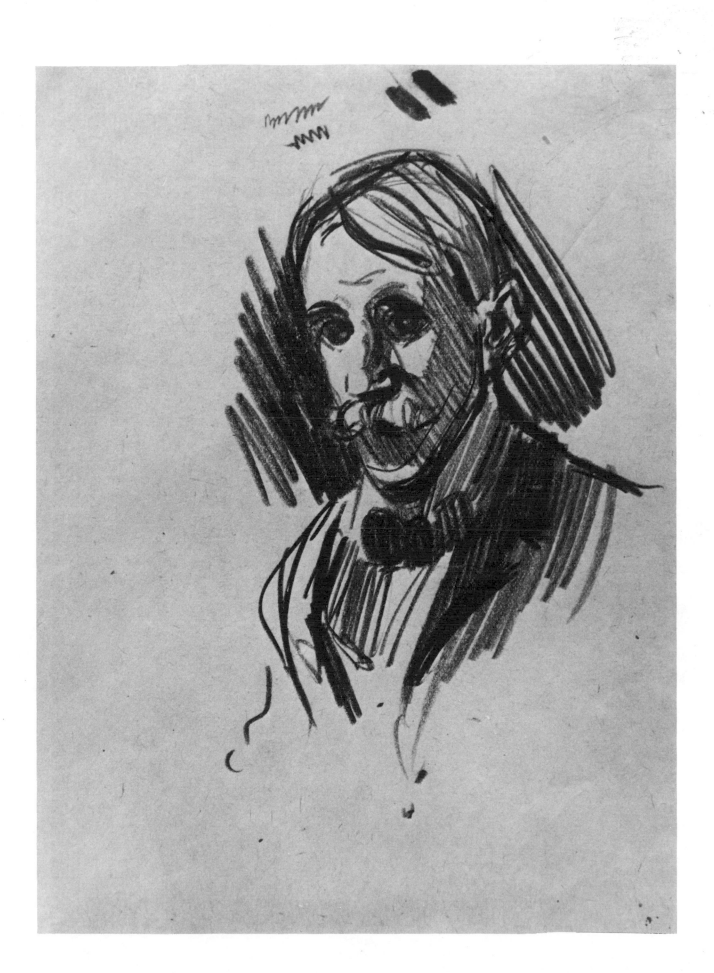

1. GEORGE LUKS, *Maurice Prendergast*, c. 1904

Pencil on paper, 10 x 6¾ (25.4 x 17.2). Gift of Mr. and Mrs. Edward W. Root, 42.38.

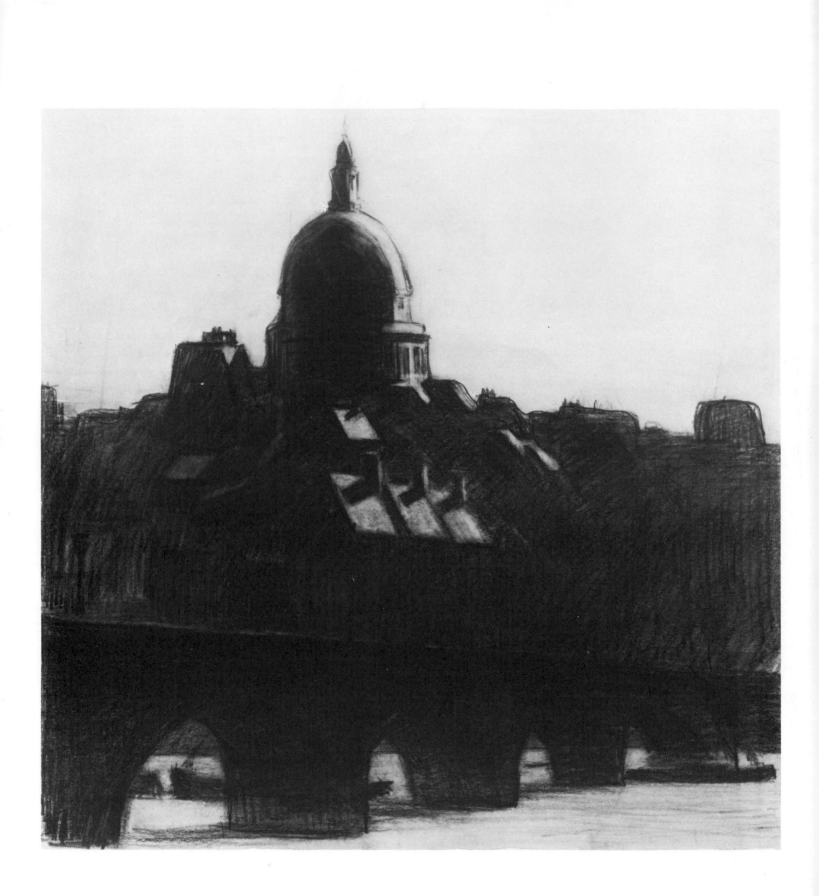

2. EDWARD HOPPER, *Dome*, 1906–7 or 1909

Conté, wash, charcoal and pencil on paper, 21⅜ x 19⅞ (54.5 x 50.5). Bequest of
Josephine N. Hopper, 70.1434.

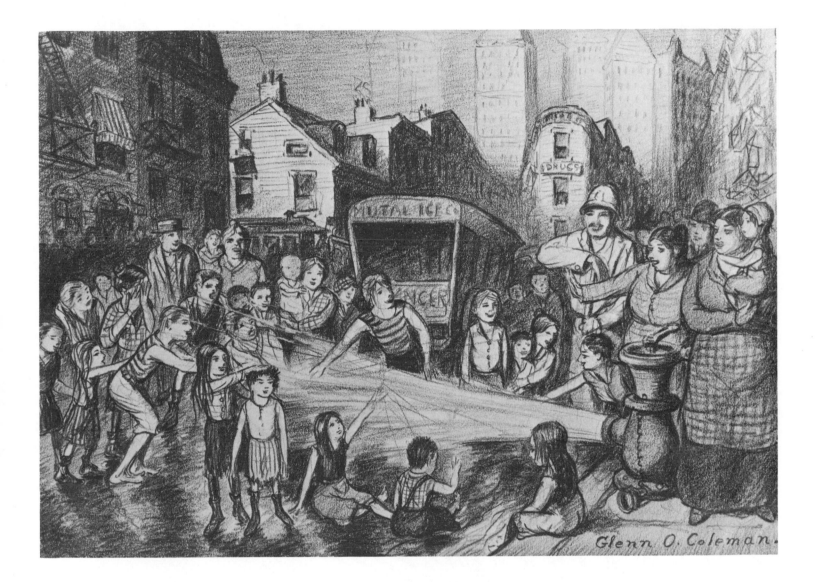

3. GLENN O. COLEMAN, *Street Bathers*, c. 1906
Crayon on paper, 11 x 15¾ (28 x 40). Purchase, 32.44.

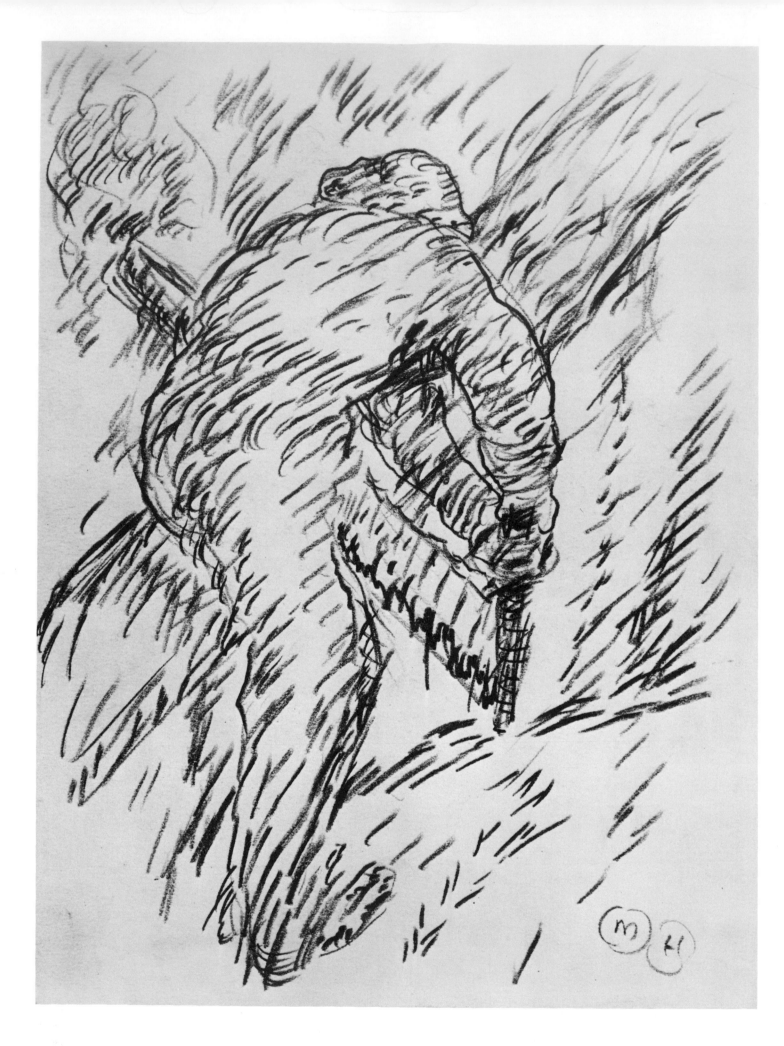

4. MARSDEN HARTLEY, *Sawing Wood*, c. 1908
Pencil on paper, 12 x 8⅞ (30.5 x 22.5). Gift of Mr. and Mrs. Walter Fillin, 77.39.

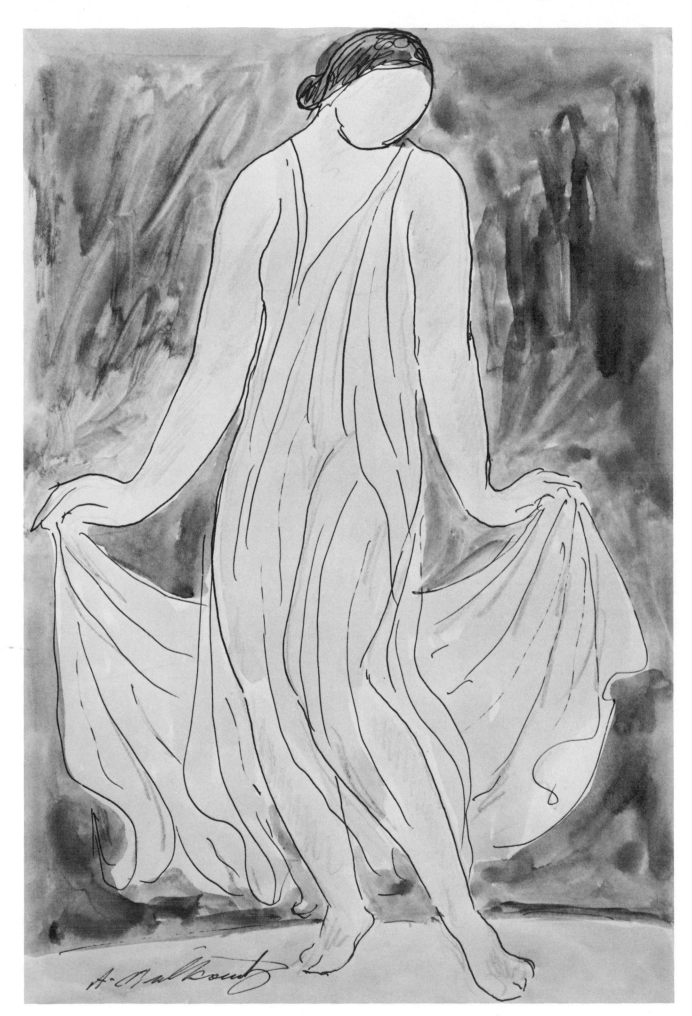

5. ABRAHAM WALKOWITZ, *Isadora Duncan*, n.d.

Watercolor and ink on paper, 12¹⁵/₁₆ x 8½ (32.9 x 21.6). Gift of Mr. and Mrs. Benjamin Weiss, 78.15.

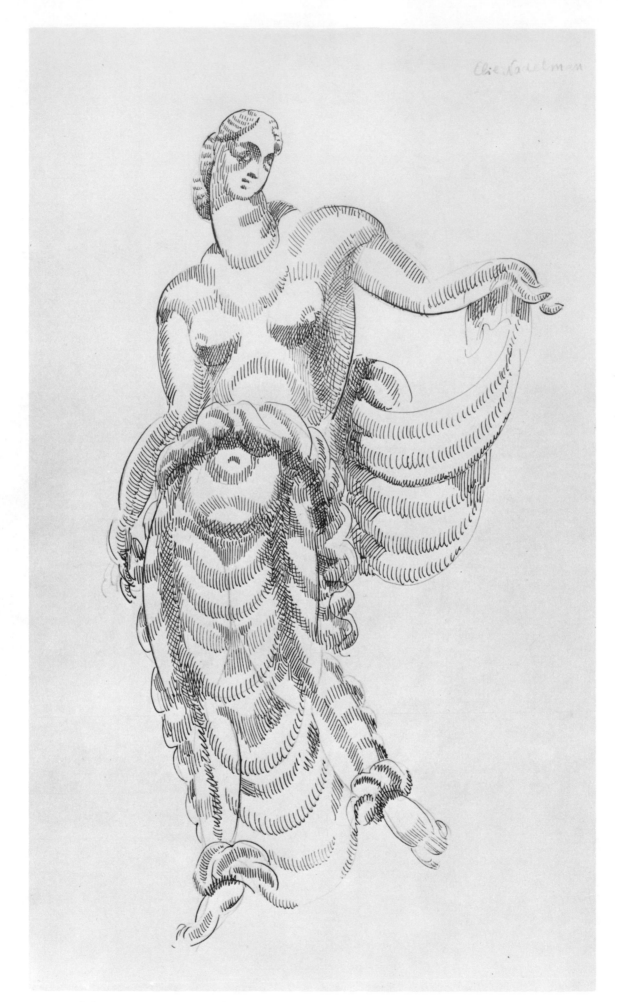

6. ELIE NADELMAN, *Standing Figure, Draped*, 1910

Ink on paper, 15¾ x 9¾ (40 x 24.8). Richard and Dorothy Rodgers Fund (and purchase), 76.1.

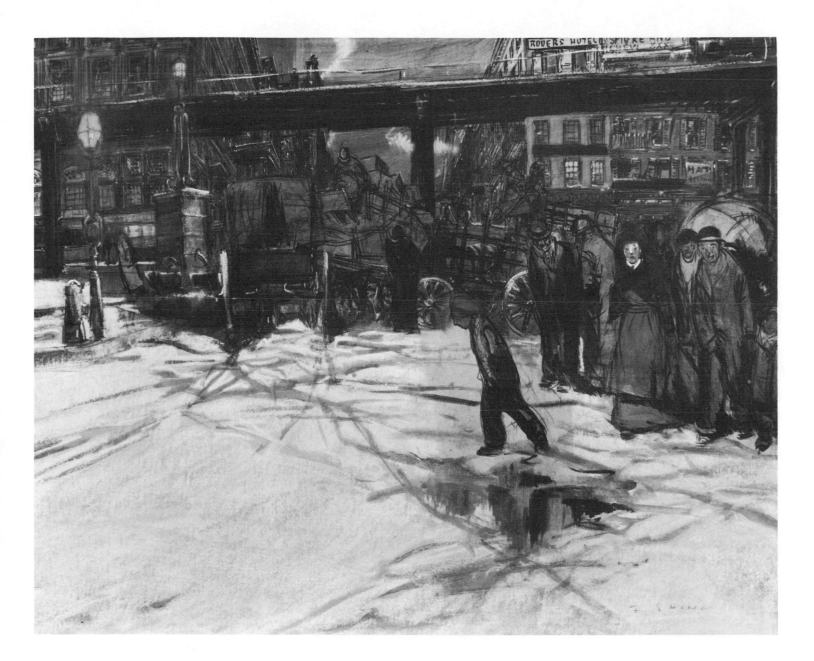

7. EVERETT SHINN, *Under the Elevated*, n.d.

Charcoal and pastel on paper, 21¼ x 27 (54 x 68.6). Gift of Mr. and Mrs. Arthur G. Altschul, 71.230.

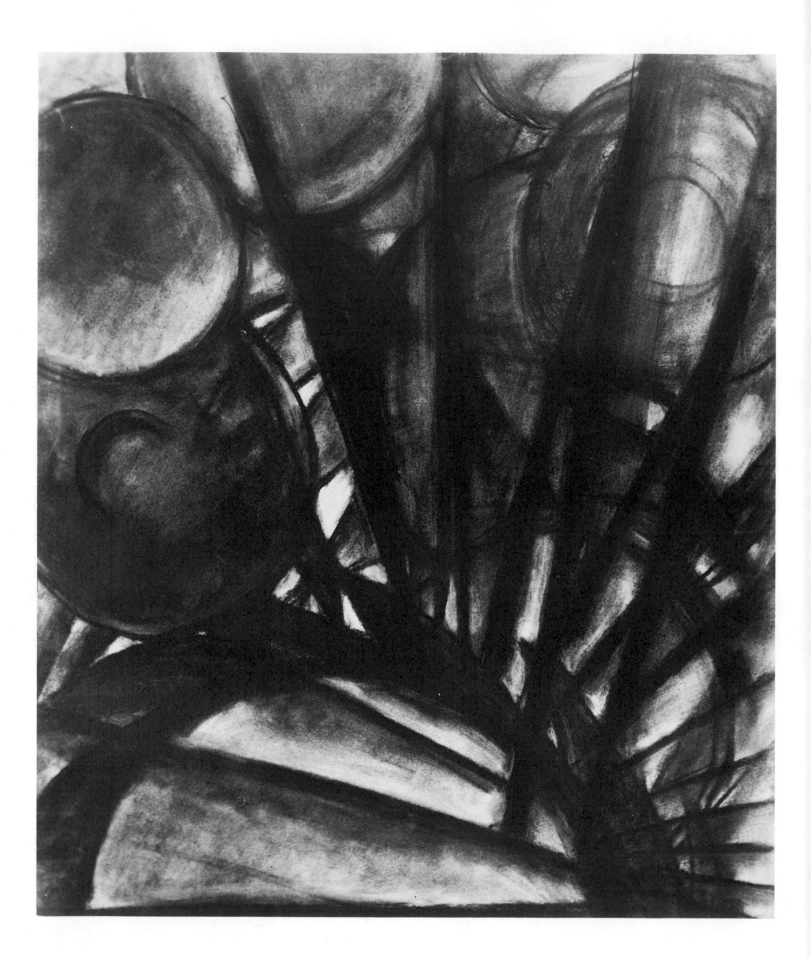

8. ARTHUR G. DOVE, *Abstraction, Number 2*, c. 1911
Charcoal on paper, 20⅝ x 17½ (52.6 x 44.5). Purchase, 61.50.

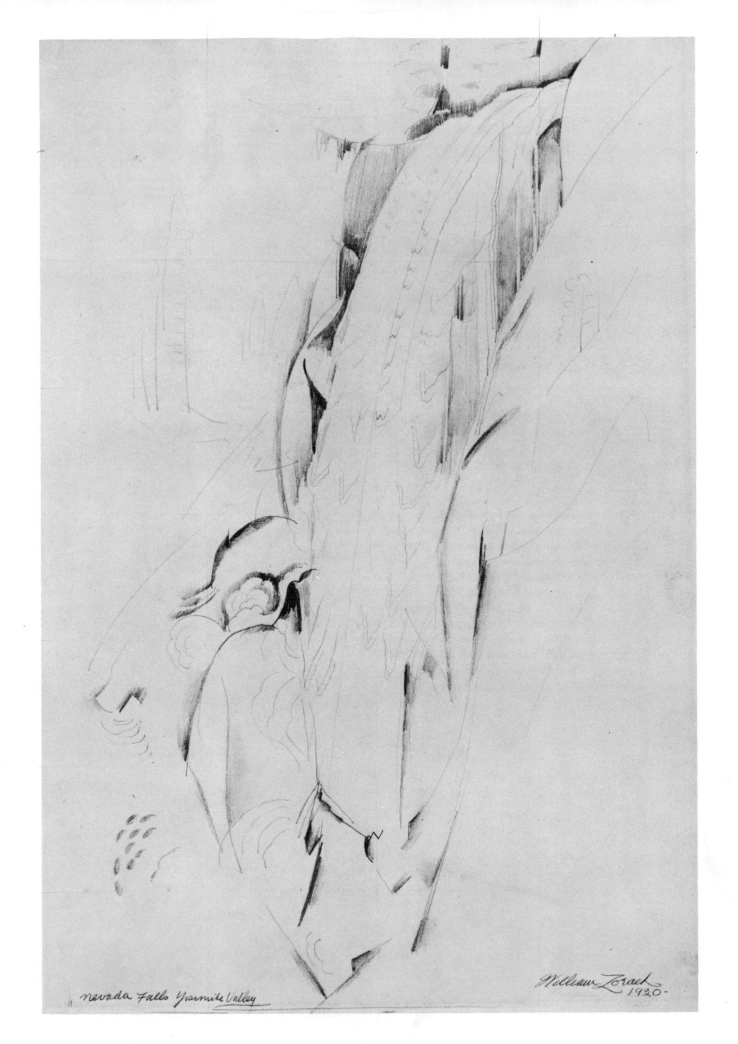

nevada Falls Yosemite Valley

William Zorach
1920-

9. WILLIAM ZORACH, *Nevada Falls, Yosemite Valley,* 1920
Pencil on paper, 18¾ x 11⅞ (47.6 x 30.2). Anonymous gift, 59.40.

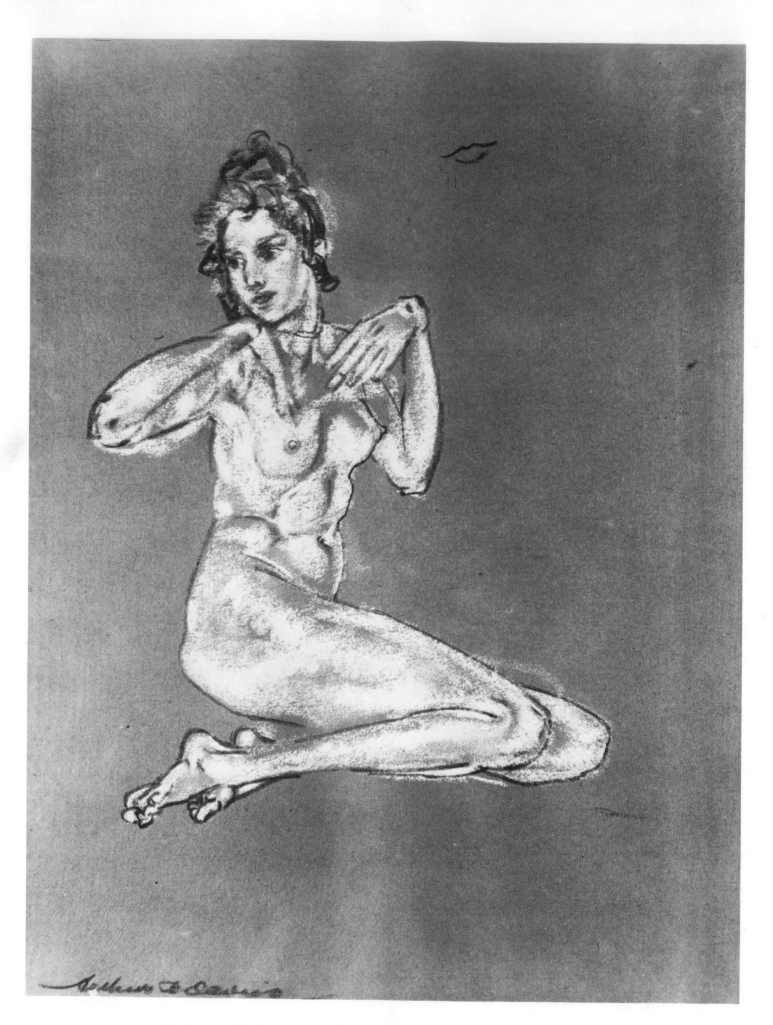

10. ARTHUR B. DAVIES, *Crouching Nude, Number 1*, n.d.
Chalk and charcoal on paper, 12¼ x 9⅝ (31.1 x 24.4). Purchase, 31.516.

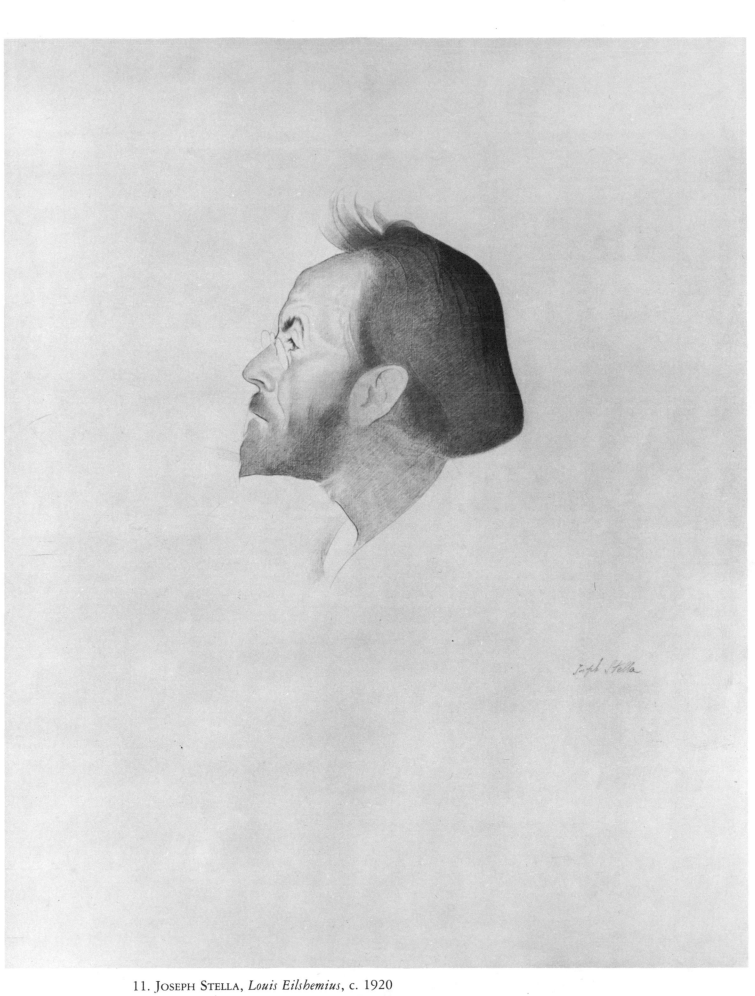

11. JOSEPH STELLA, *Louis Eilshemius*, c. 1920

Pencil on paper, 28⅜ x 21⅝ (72.1 x 54.9). Gift of Gertrude Vanderbilt Whitney, 31.581.

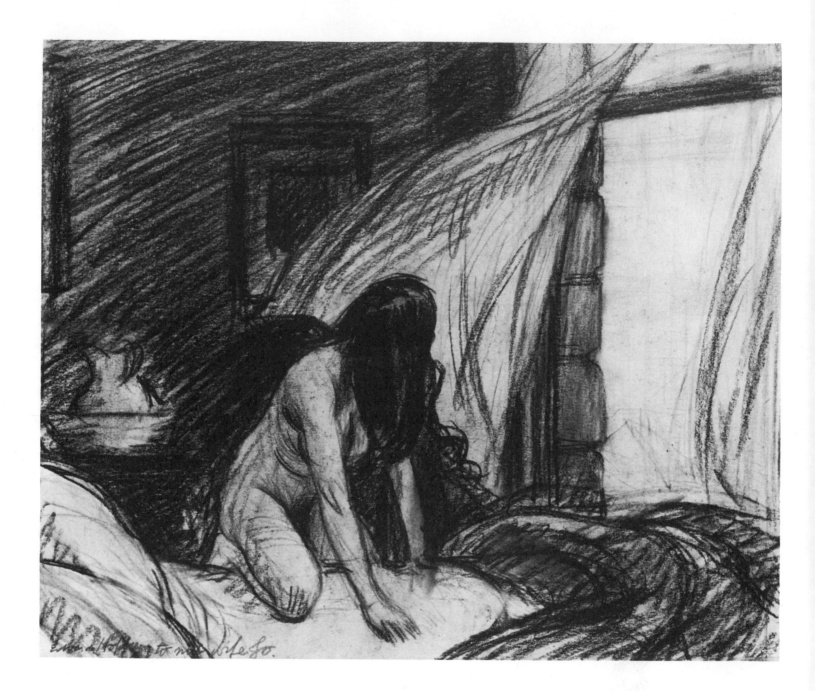

12. EDWARD HOPPER, Study for *Evening Wind*, 1921

Conté and charcoal on paper, 10 x 13¹⁵⁄₁₆ (25.4 x 35.4). Bequest of Josephine N. Hopper, 70.343.

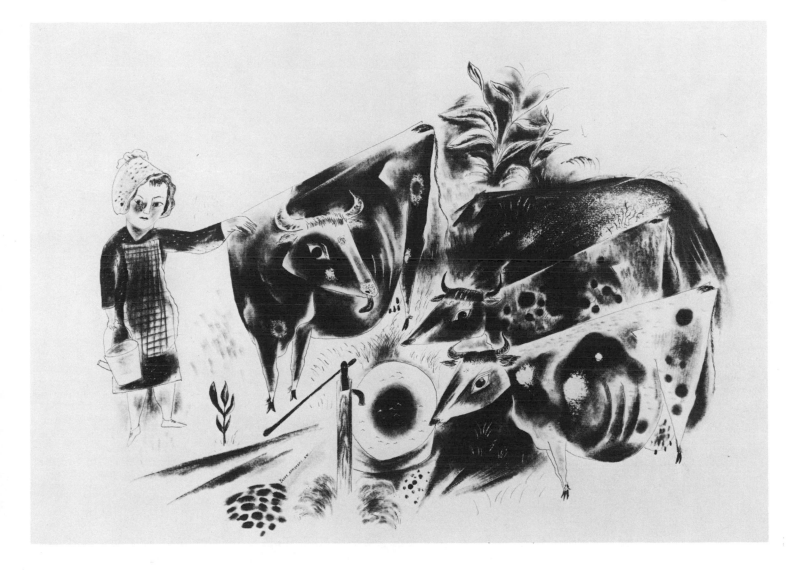

13. YASUO KUNIYOSHI, *Farmer's Daughter with Three Cows*, 1922
Ink on paper, 12¾ x 18¾ (32.4 x 47.7). Gift of Mrs. Edith Gregor Halpert, 57.1.

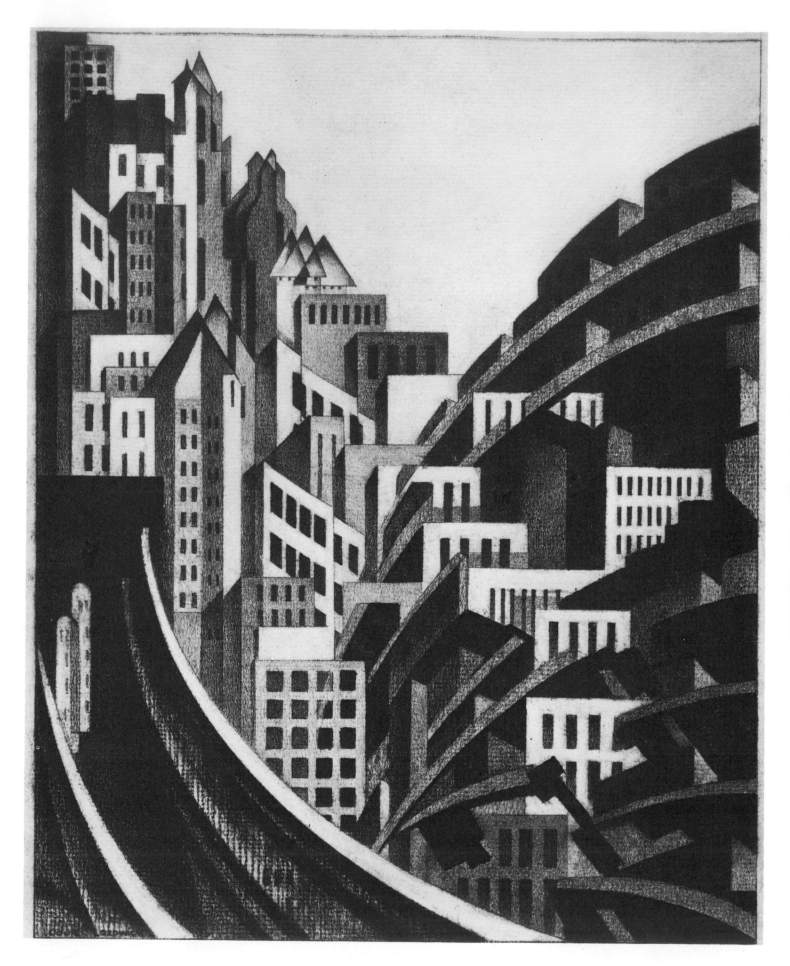

14. Louis Lozowick, *New York*, c. 1923

Carbon pencil on paper, 12½ x 10 (31.7 x 25.4). Richard and Dorothy Rodgers Fund, 77.15.

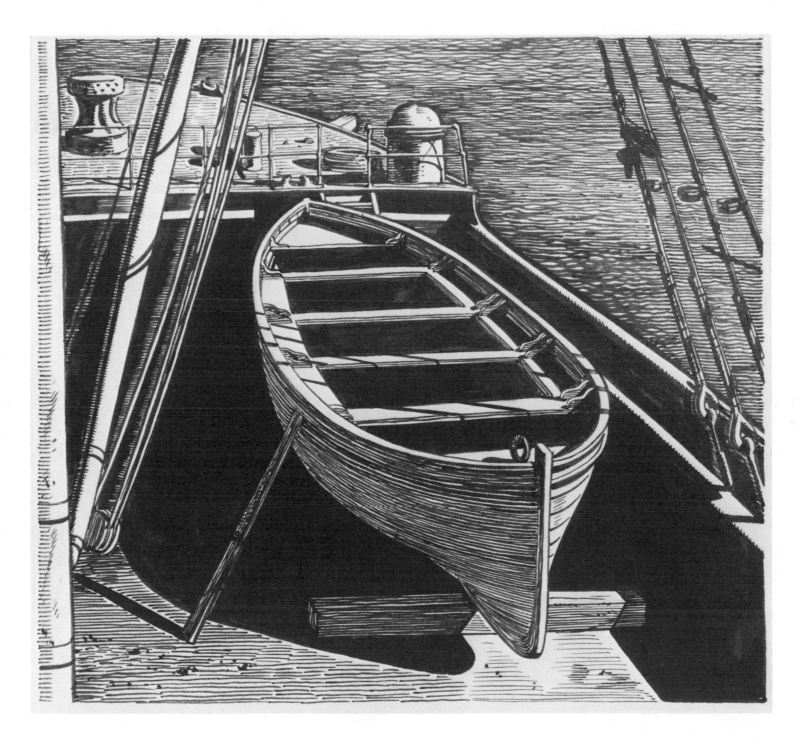

15. ROCKWELL KENT, *The Kathleen*, 1923

Ink on paper, 6½ x 7 (16.5 x 17.8). Gift of Gertrude Vanderbilt Whitney, 31.548.

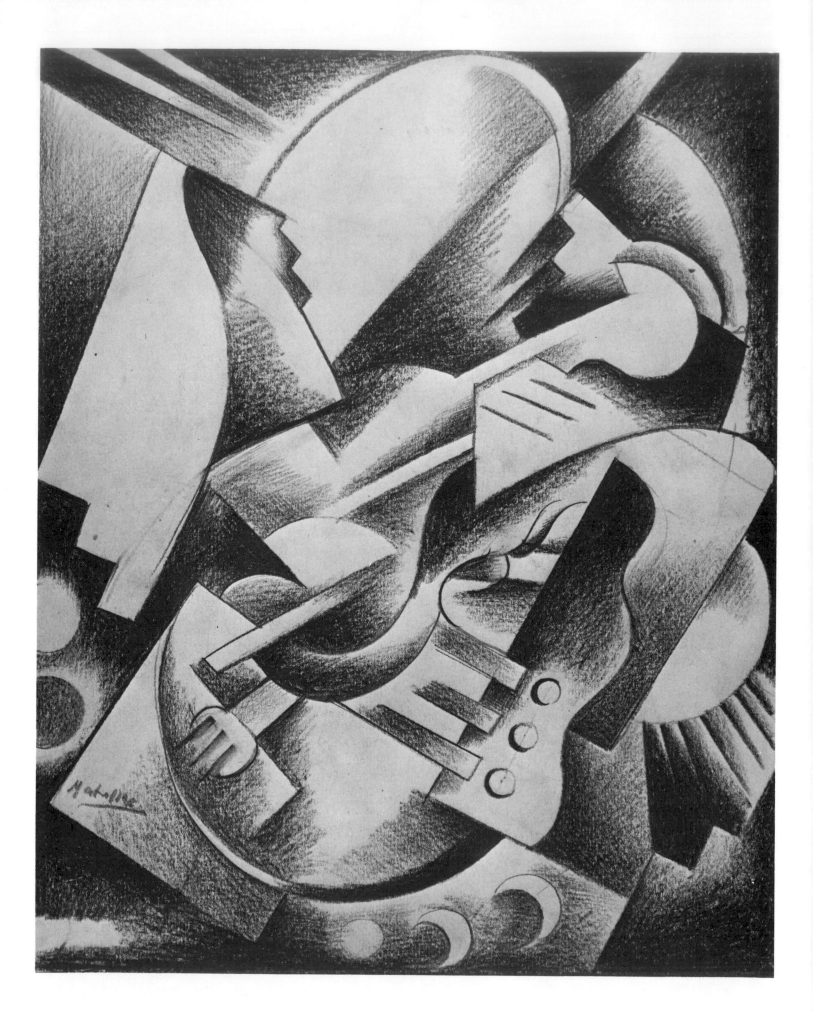

16. JAN MATULKA, *Cubist Still Life with Guitar*, c. 1923
Conté and pencil on paper, 14⅝ x 11⅝ (36.9 x 29.8). Lawrence H. Bloedel Bequest,
77.1.32.

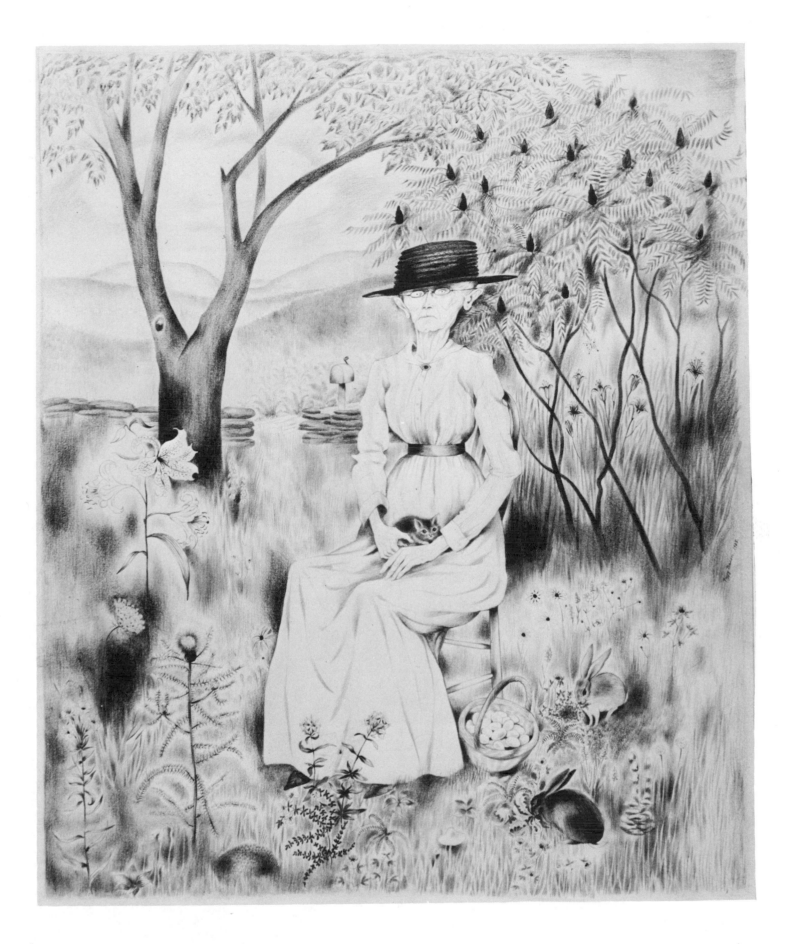

17. PEGGY BACON, *Blessed Damozel*, 1925

Pencil on paper, 18 x 14⅝ (45.7 x 37.1). Gift of Gertrude Vanderbilt Whitney, 31.481.

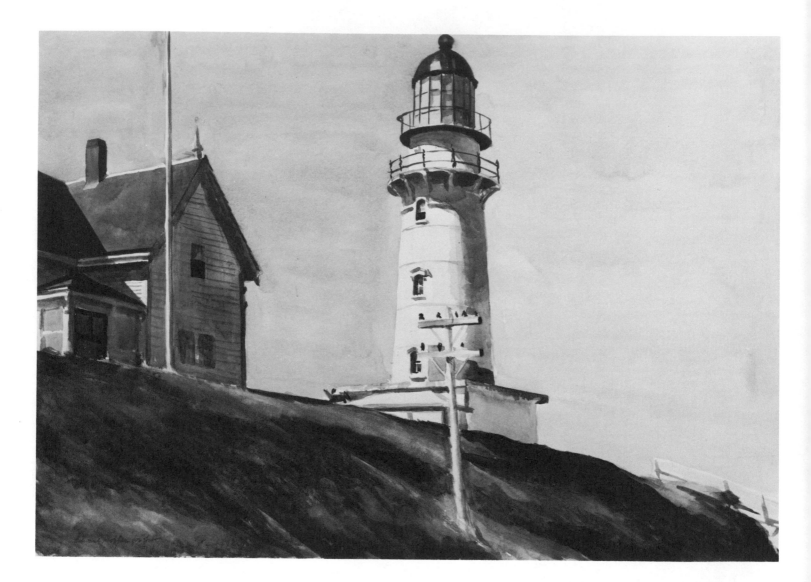

18. EDWARD HOPPER, *Light at Two Lights*, 1927

Watercolor on paper, 13¹⁵⁄₁₆ x 20 (35.4 x 50.8). Bequest of Josephine N. Hopper,
70.1094.

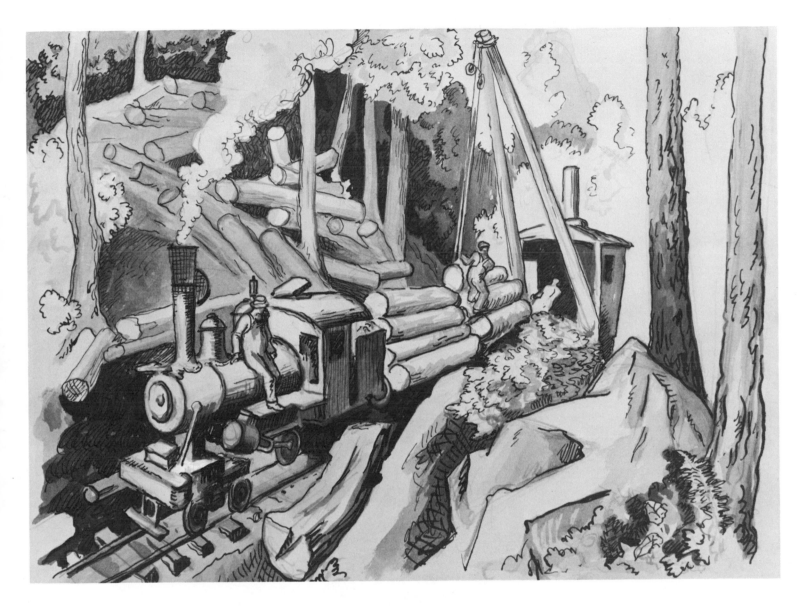

19. THOMAS HART BENTON, *Logging Train*, 1928
Ink on paper, 8¾ x 11¾ (22.3 x 29.8). Gift of Gertrude Vanderbilt Whitney, 31.491.

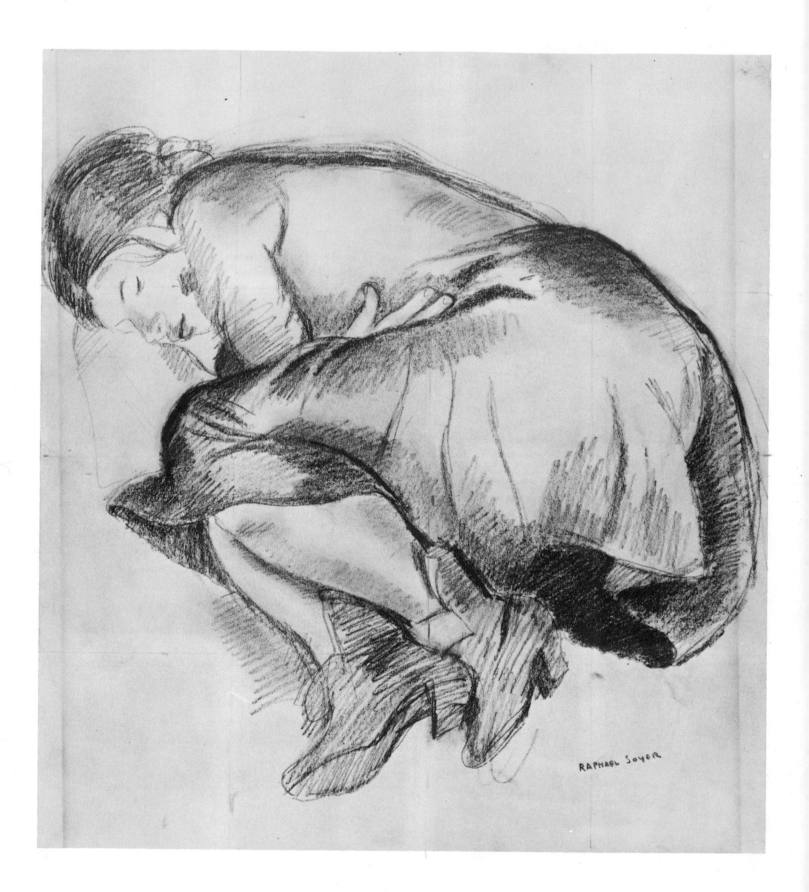

20. RAPHAEL SOYER, *Sleeping Girl*, n.d.
Pencil on paper, 17 x 14 (43.2 x 35.6). Gift of Gertrude Vanderbilt Whitney, 31.577.

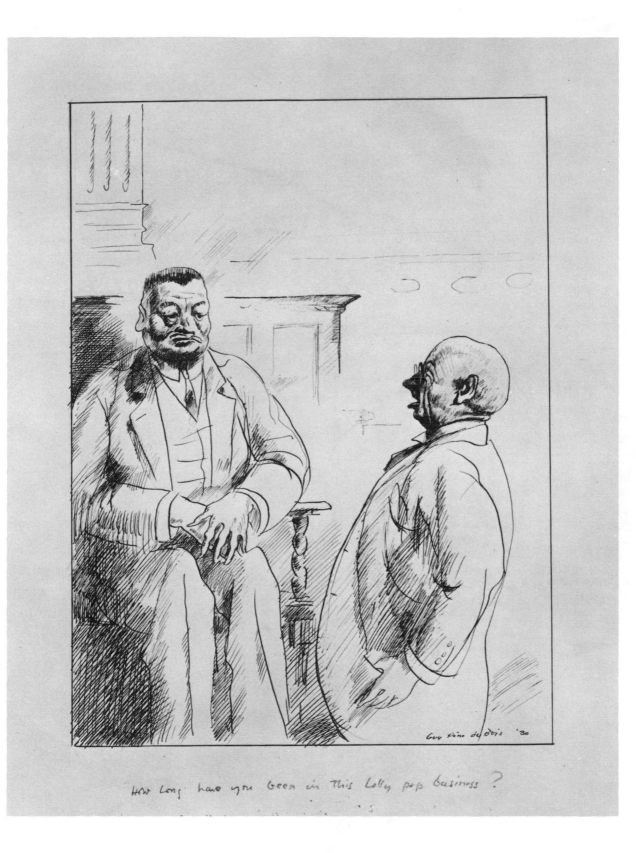

21. GUY PÈNE DU BOIS, *"How long have you been in this lolly-pop business?"* 1930
Ink on paper, 11¾ x 8⅝ (29.8 x 21.9). Gift of Gertrude Vanderbilt Whitney, 31.535.

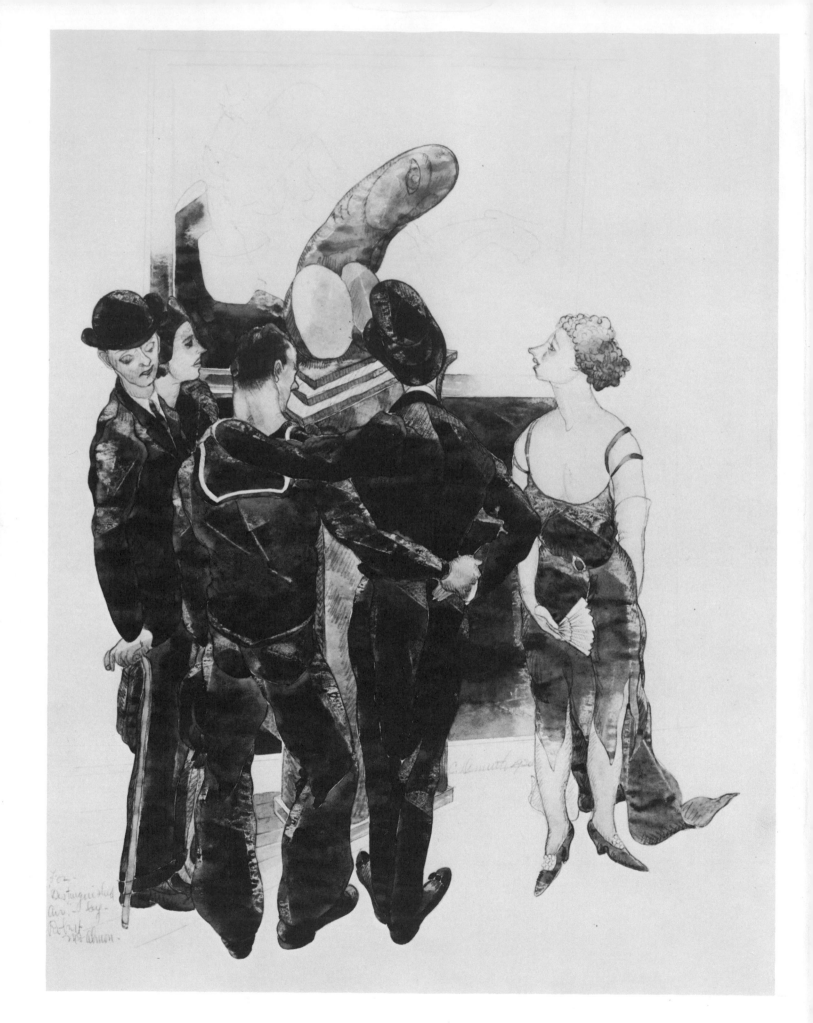

22. CHARLES DEMUTH, *Distinguished Air*, 1930

Watercolor and pencil on paper, 14 x 12 (35.5 x 30.5). Gift of the Friends of the Whitney Museum of American Art, Charles Simon (and purchase), 68.16.

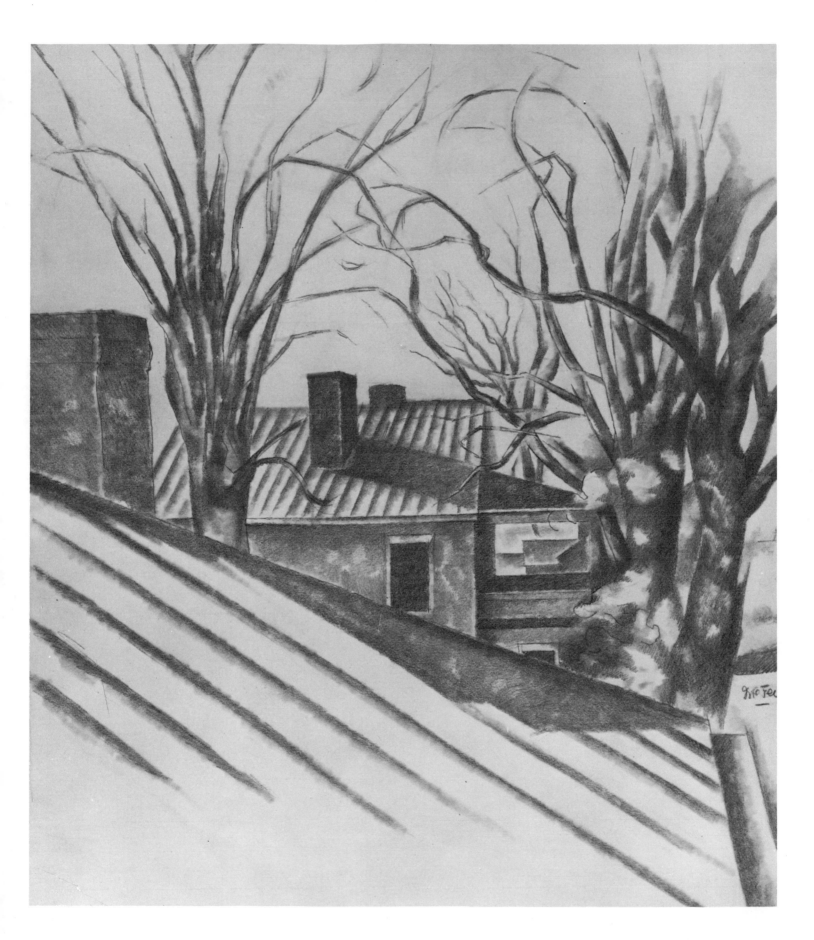

23. HENRY LEE MCFEE, *House Tops*, 1931
Pencil on paper, 19⅞ x 16⅞ (50.5 x 42.9). Purchase, 33.76.

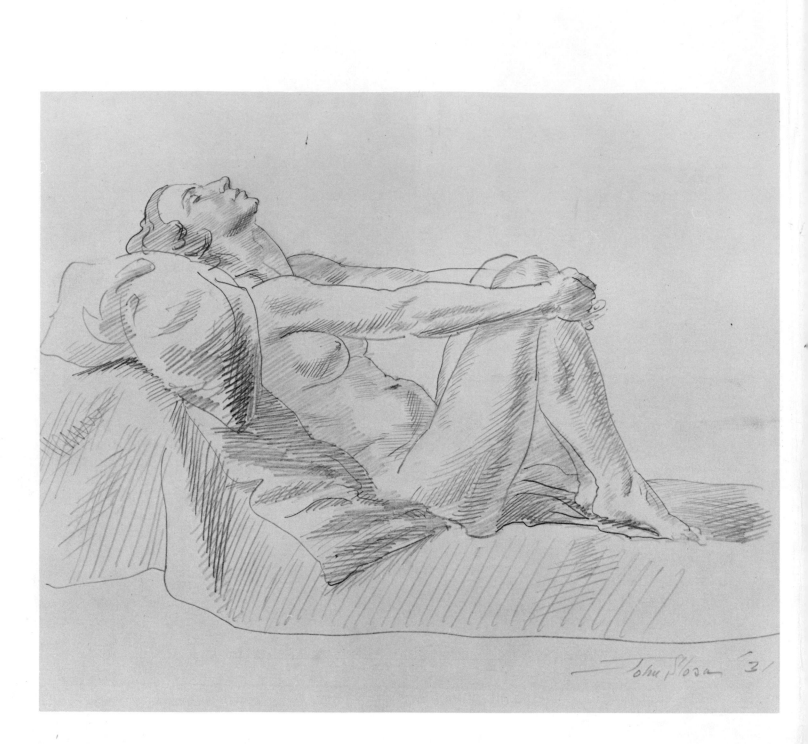

24. JOHN SLOAN, *Nude*, 1931
Pencil on paper, 7⅜ x 9 (18.8 x 23). Gift of Mrs. John Sloan, 51.42.

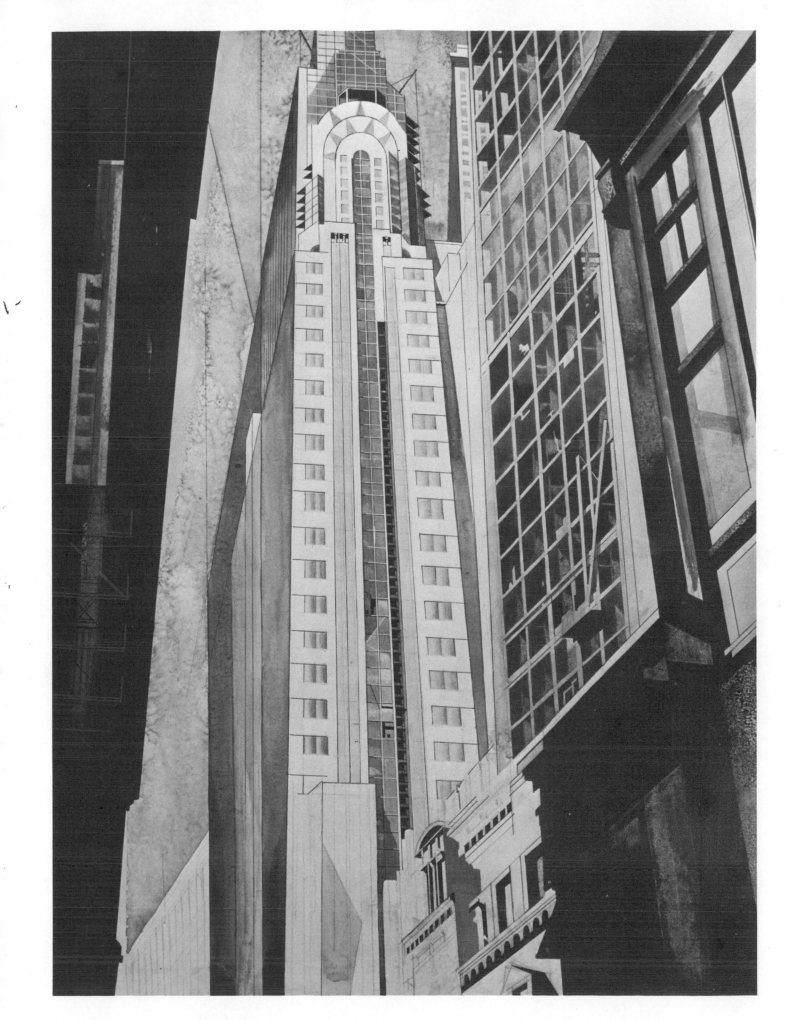

25. EARL HORTER, *The Chrysler Building Under Construction*, c. 1931
Ink and watercolor on paper, 20¼ x 14¾ (51.5 x 37.5). Gift of Mrs. William A.
Marsteller, 78.17.

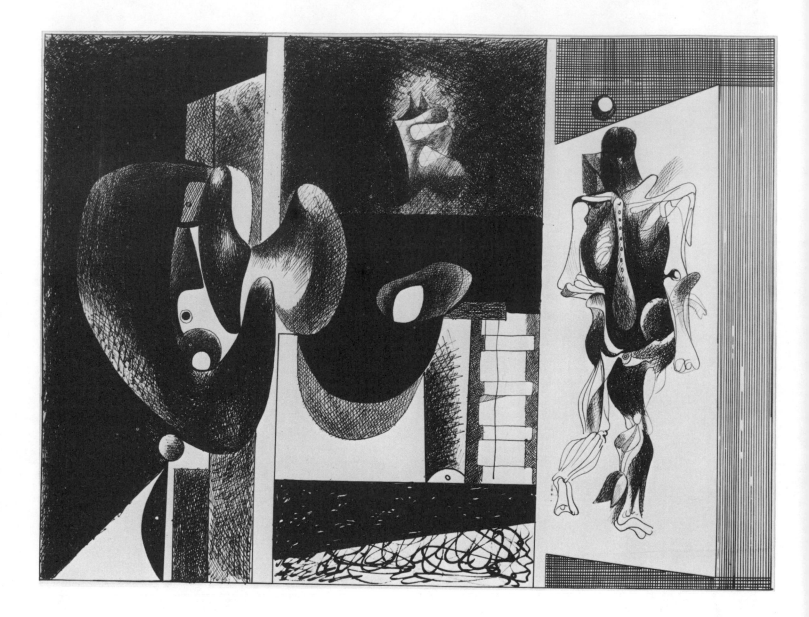

26. ARSHILE GORKY, *Nighttime, Enigma and Nostalgia*, c. 1931–32

Ink on paper, 24 x 31 (61 x 78.7). Promised 50th Anniversary Gift of Mr. and Mrs. Edwin A. Bergman, P.5.79.

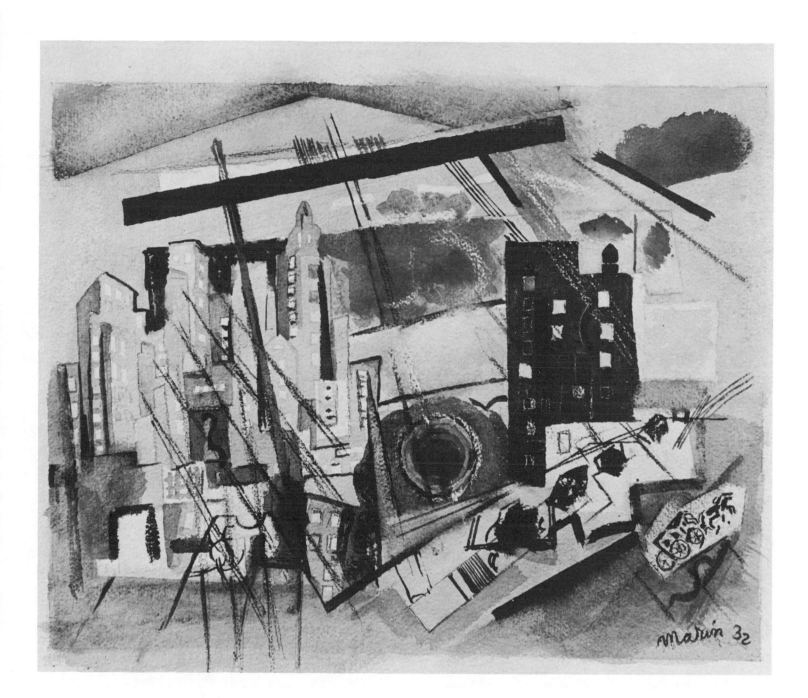

27. John Marin, *Region of Brooklyn Bridge Fantasy*, 1932
Watercolor on paper, 18¾ x 22¼ (47.6 x 56.5). Purchase, 49.8.

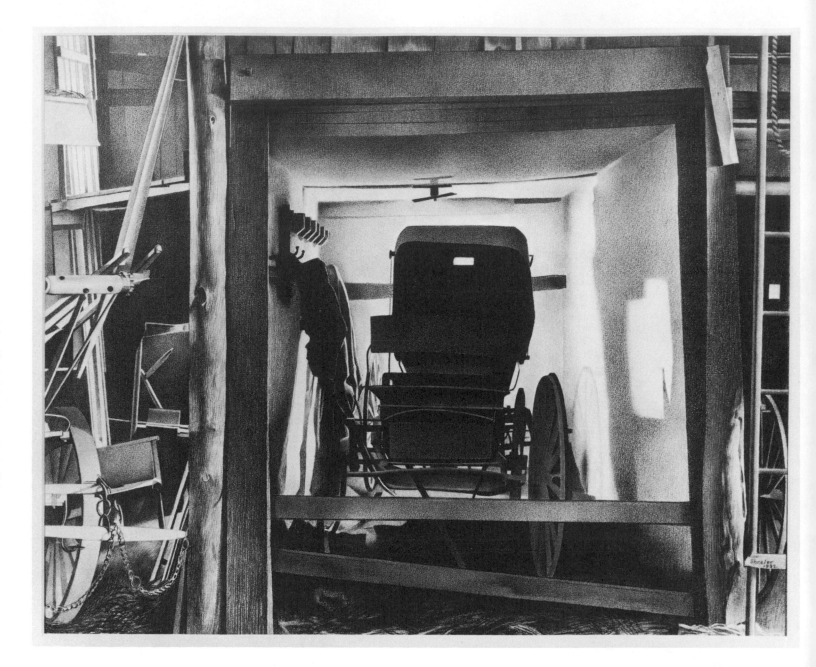

28. CHARLES SHEELER, *Interior, Bucks County Barn*, 1932
Conté on paper, 15 x 18¾ (38.1 x 47.6). Purchase, 33.78.

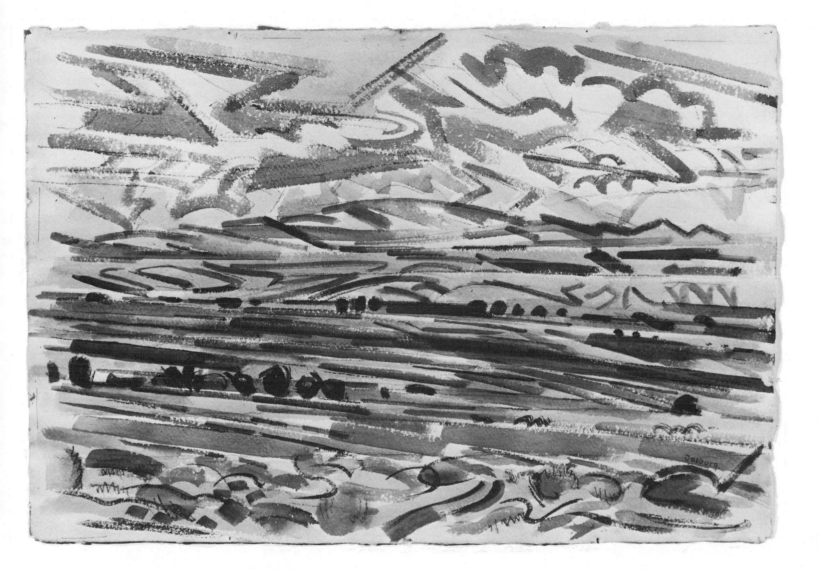

29. ANDREW DASBURG, *Summer Meadows*, 1932–33

Watercolor on paper, 13½ x 21⅜ (34.2 x 54.6). Lawrence H. Bloedel Bequest, 77.1.14.

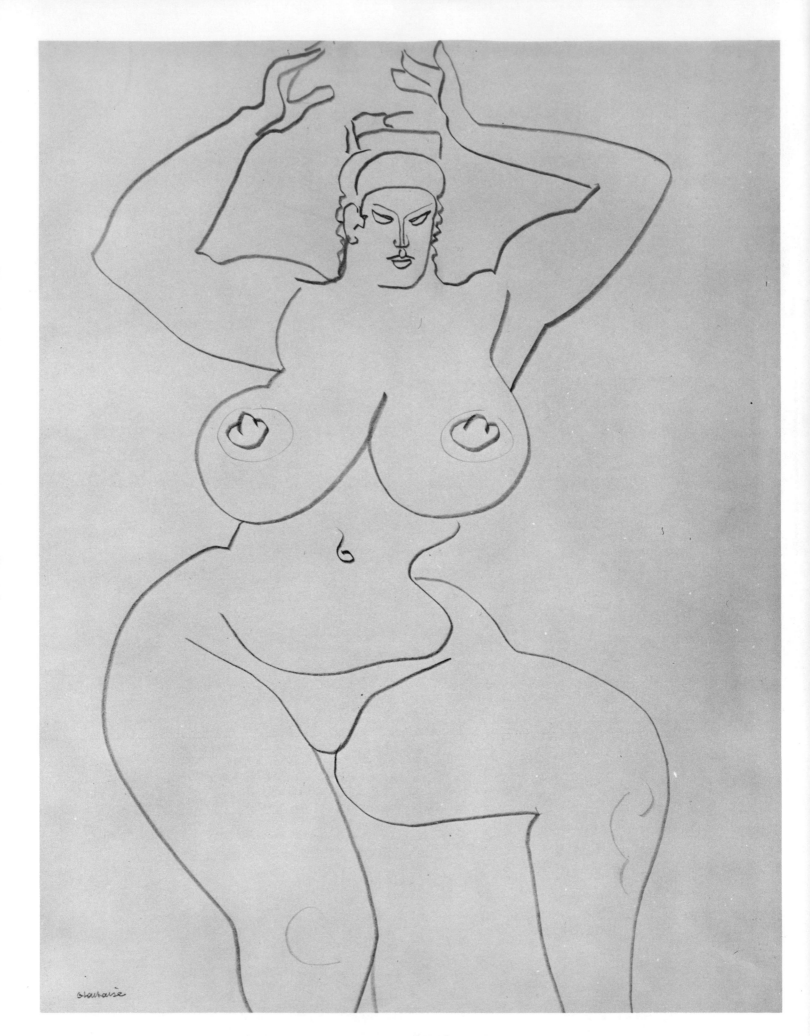

30. GASTON LACHAISE, *Seated Nude*, 1932–35
Pencil on paper, 23¾ x 18 (60.4 x 45.7). Purchase, 38.45.

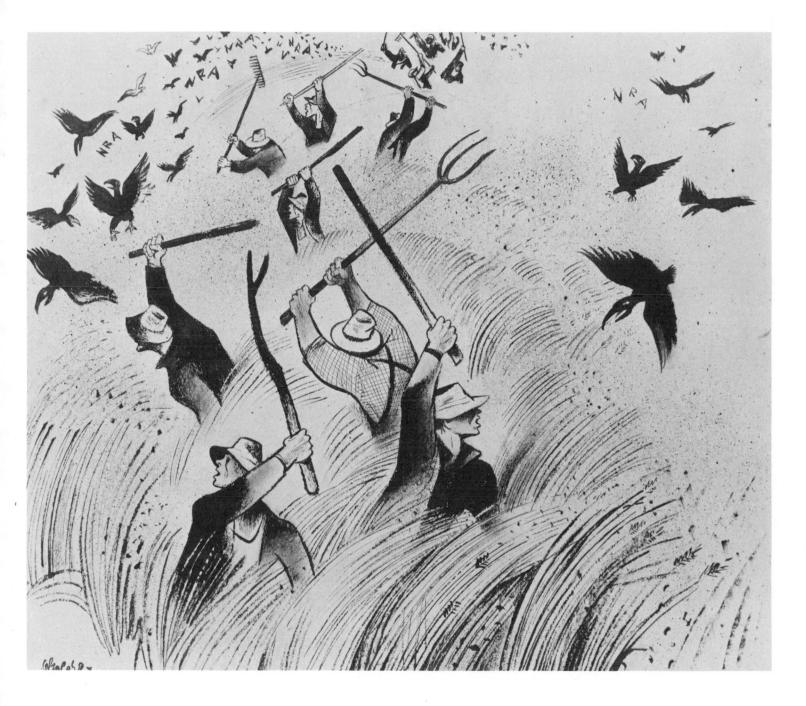

31. WILLIAM GROPPER, *Farmers' Revolt*, 1933
Ink on paper, 16 x 19 (40.6 x 48.3). Purchase, 33.73.

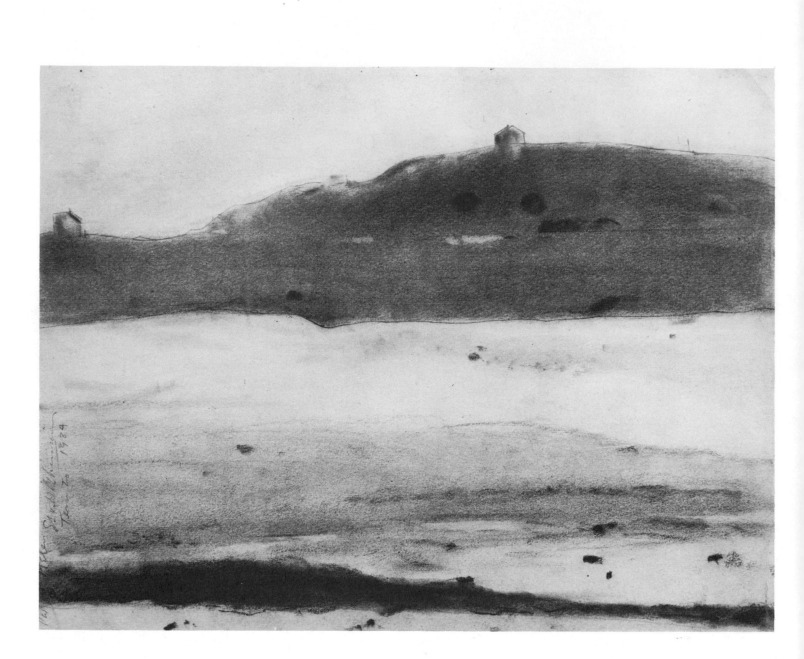

32. EDWIN DICKINSON, *Truro, the Pamet River*, 1934

Pencil on paper, 9 x 12 (22.8 x 31.2). Gift of the Joseph H. Hirshhorn Collection, 63.55.

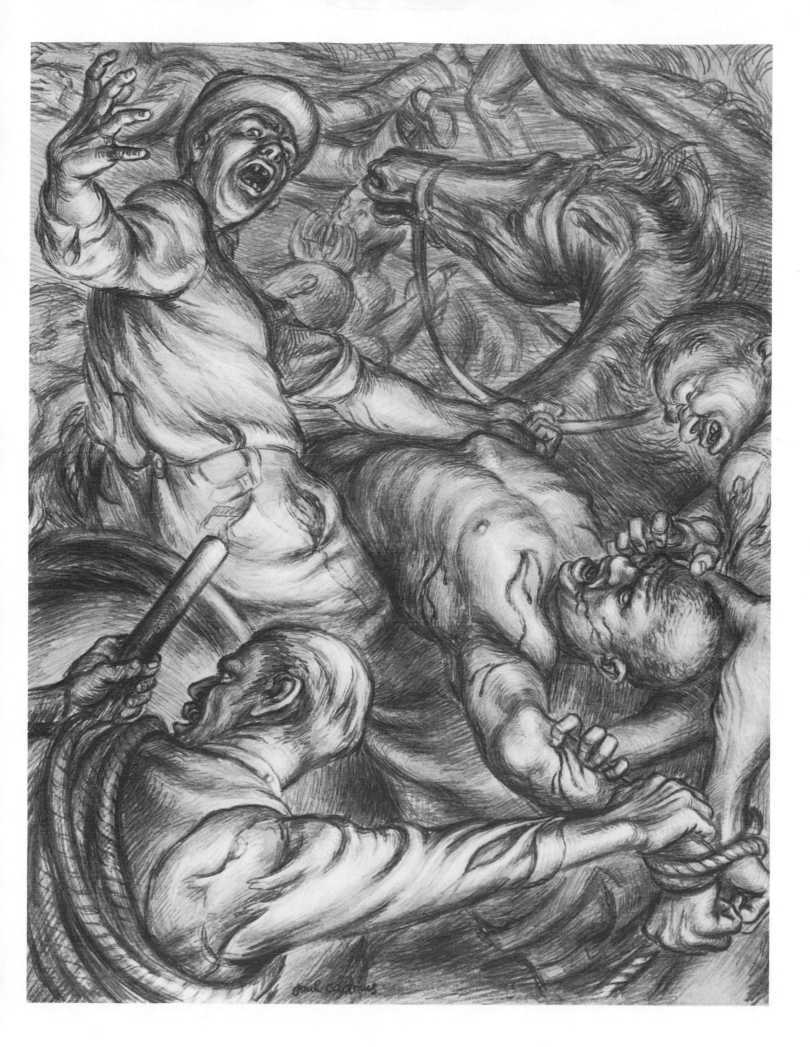

33. PAUL CADMUS, *To the Lynching!* 1935
Pencil and watercolor on paper, 20½ x 15¾ (52.1 x 40). Purchase, 36.32.

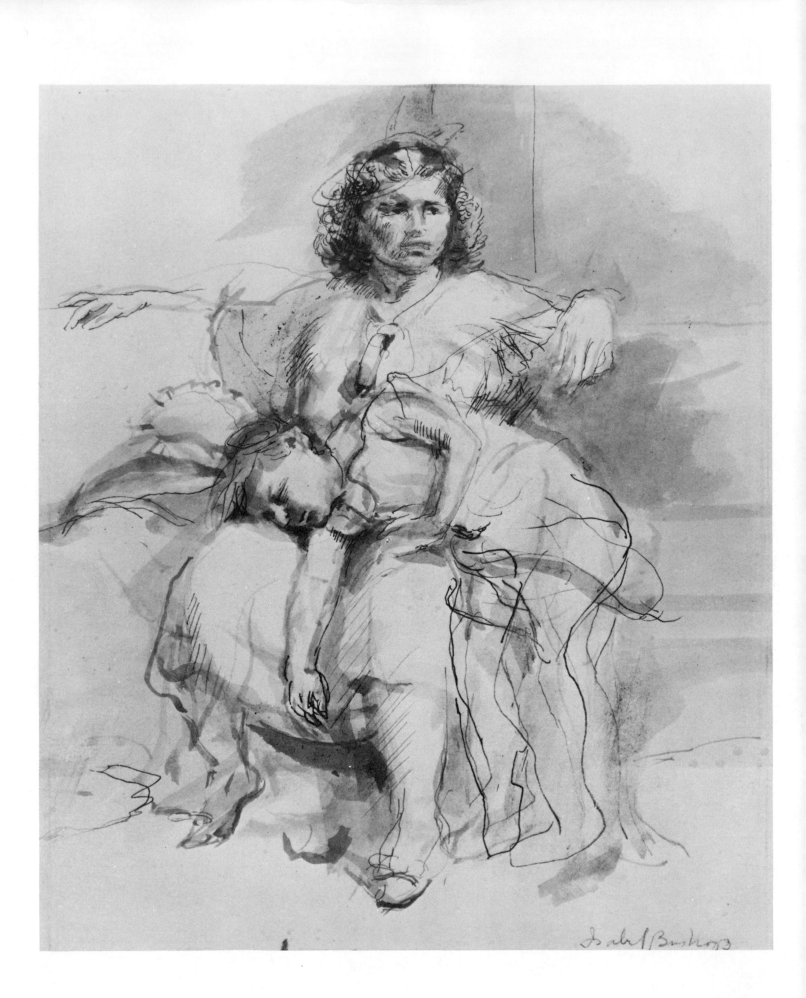

34. ISABEL BISHOP, *Waiting*, 1935
Ink on paper, 7⅛ x 6 (18.4 x 15.3). Purchase, 36.31.

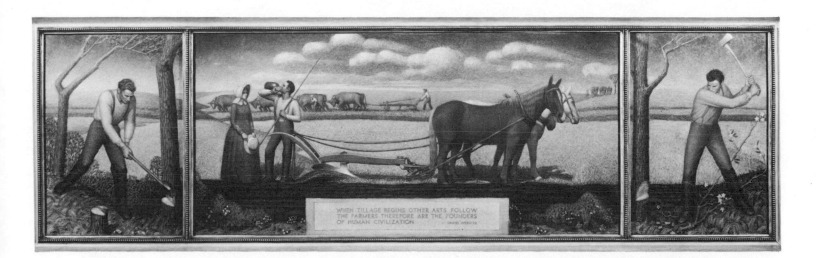

35. GRANT WOOD, Study for *Breaking the Prairie*, 1935–39

Colored pencil, chalk and pencil on butcher paper; triptych, 22¾ x 80¼ (57.8 x 203.2) overall. Promised gift of Mr. and Mrs. George Stoddard, P.2.76.

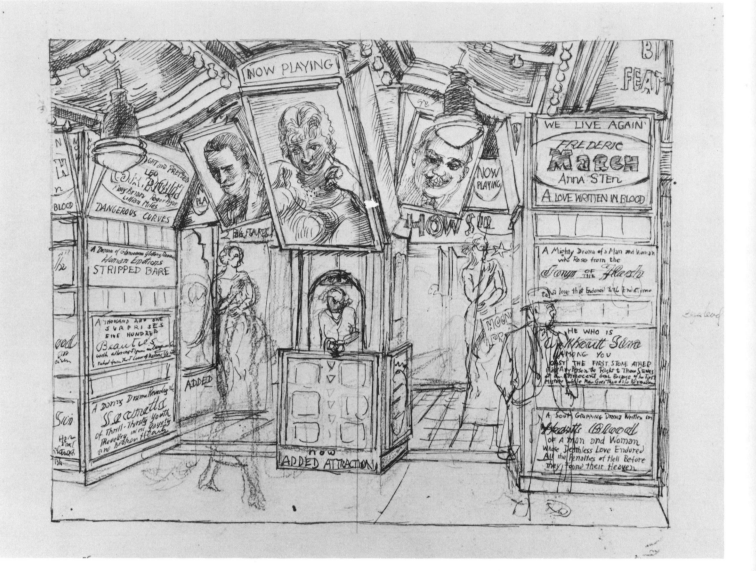

36. REGINALD MARSH, Study for *Twenty Cent Movie*, 1936

Ink and pencil on paper, 9½ x 12¹⁄₁₆ (23.7 x 30.7). Gift of Mr. and Mrs. Lloyd Goodrich, 73.1.

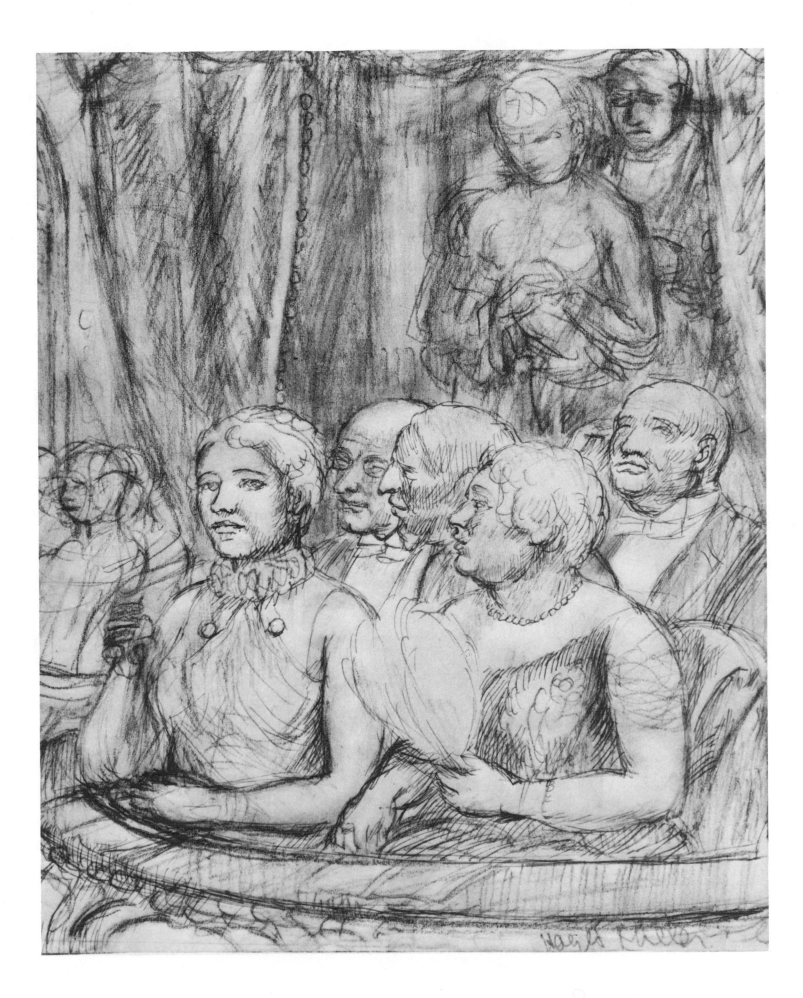

37. KENNETH HAYES MILLER, Study for *Box Party*, 1936
Pencil on paper, 6½ x 5¼ (16.5 x 13.2). Gift of Joseph H. Hirshhorn, 71.240.

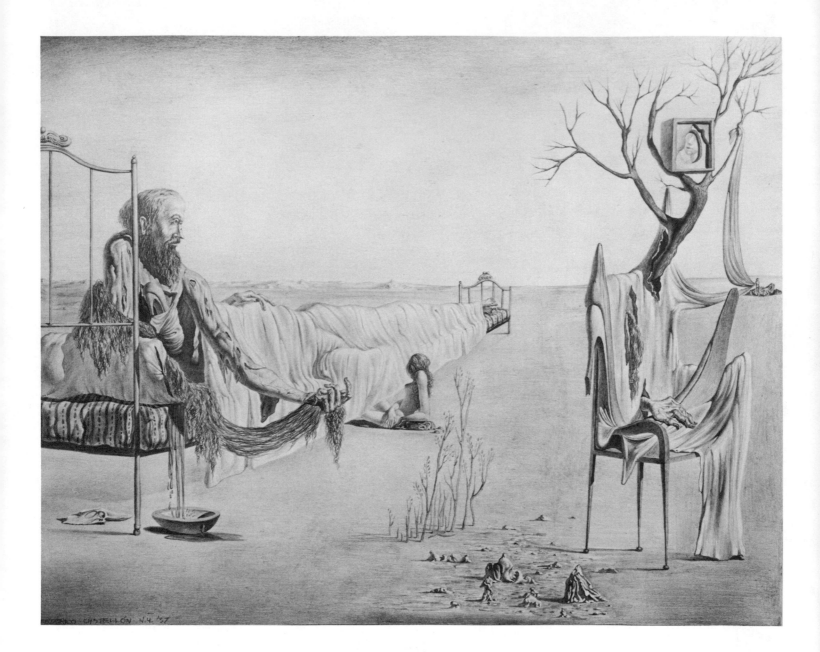

38. FEDERICO CASTELLÓN, *The Bed*, 1937

Graphite on paper, 10¼ x 13 (26 x 33). Gift of Mr. and Mrs. Benjamin Weiss, 78.38.

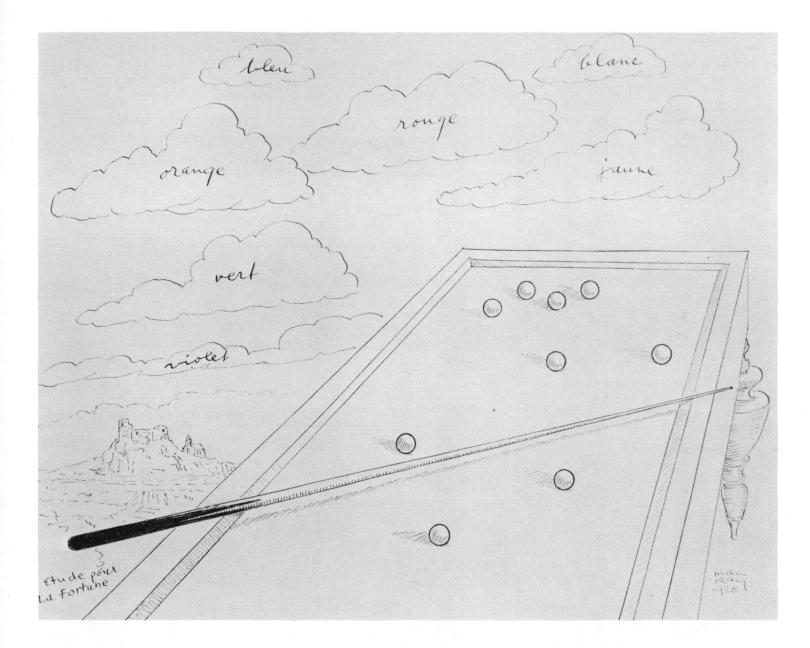

39. MAN RAY, *Etude pour La Fortune*, 1938
Ink on paper, 10¼ x 13¼ (26.1 x 33.7). Gift of the Simon Foundation, 74.81.

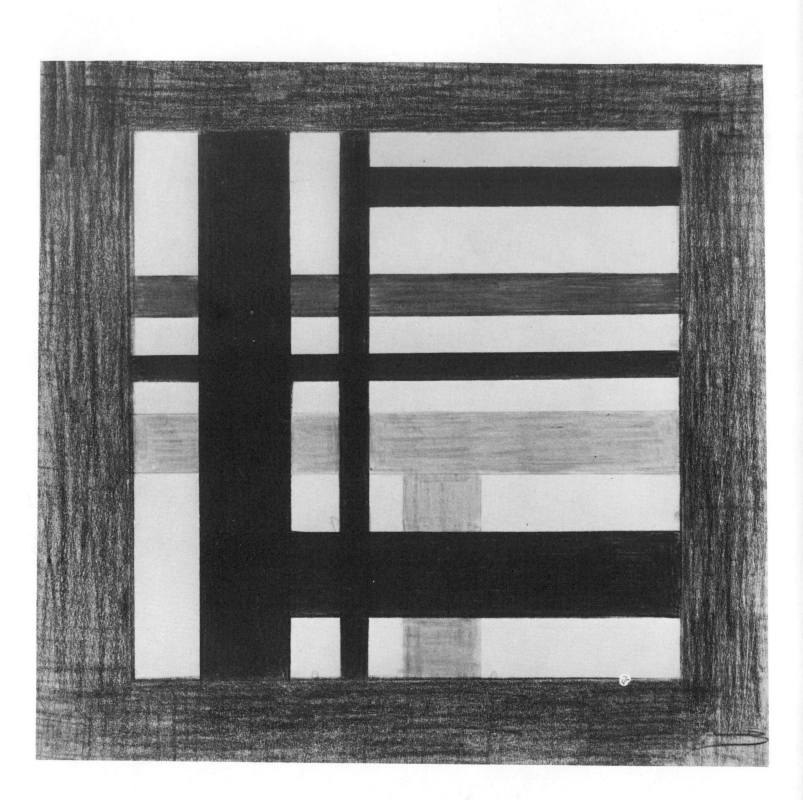

40. BURGOYNE DILLER, *Second Theme*, 1938

Pencil and crayon on paper, 12½ x 12¾ (31.8 x 32.4). The List Purchase Fund, 79.5.

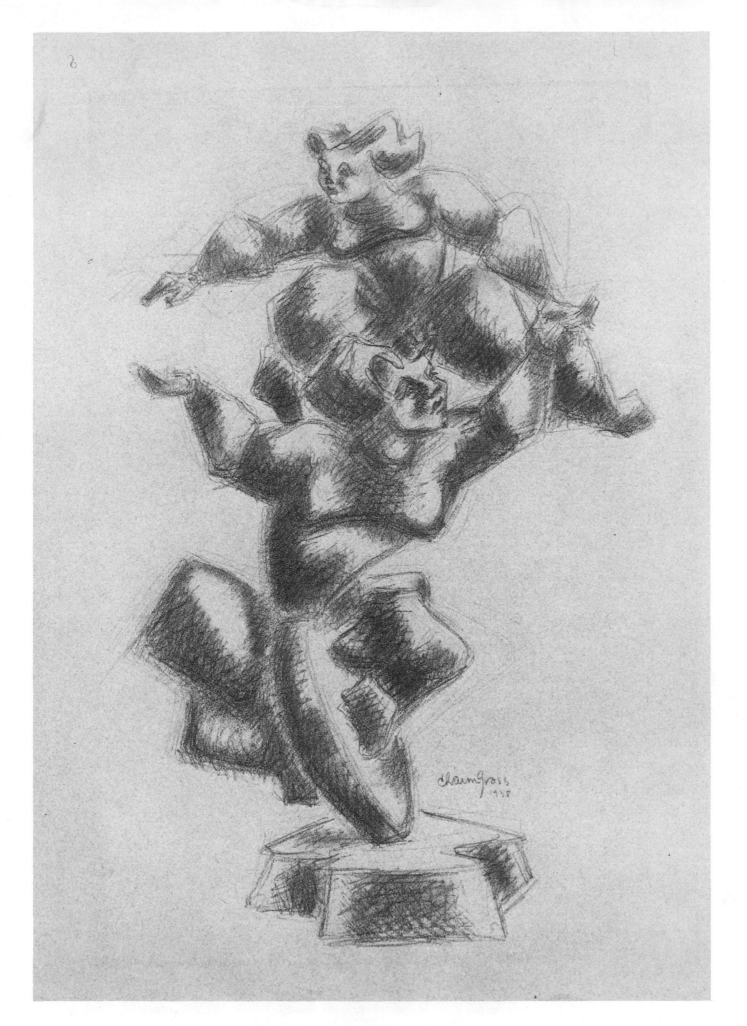

41. CHAIM GROSS, *Untitled (Two Figures)*, 1938
Graphite on paper, 24¹³/₁₆ x 17⅜ (63 x 44.3). Gift of Mr. and Mrs. Benjamin Weiss,
78.36.

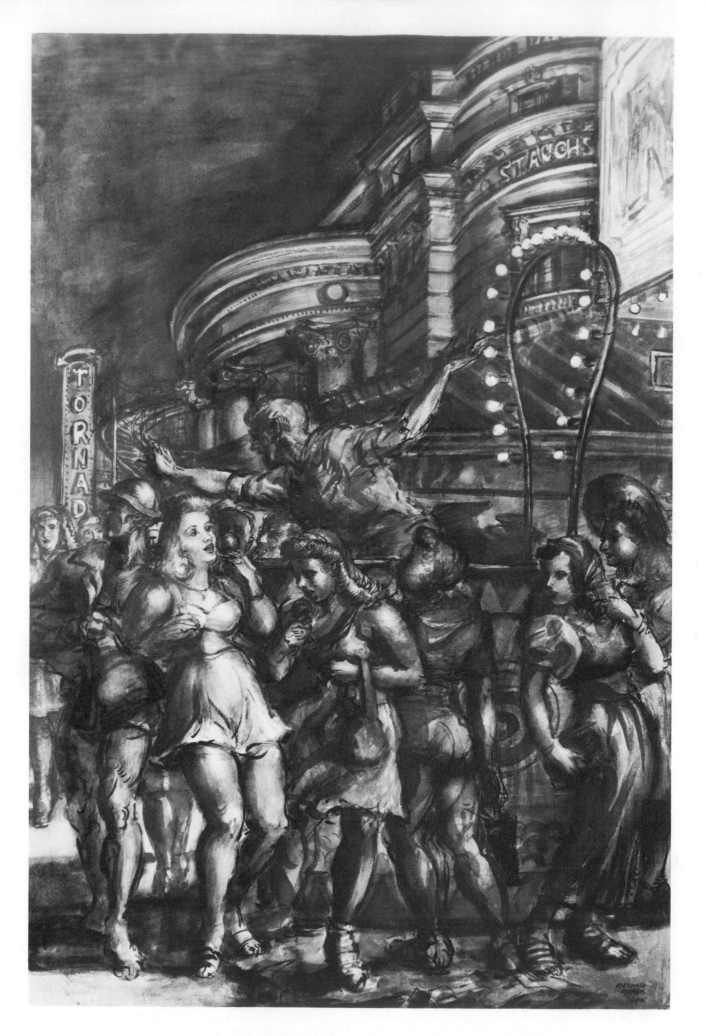

42. REGINALD MARSH, *New Dodgem*, 1940
Watercolor on paper, 40¼ x 26¾ (102.3 x 68). Anonymous gift, 53.21.

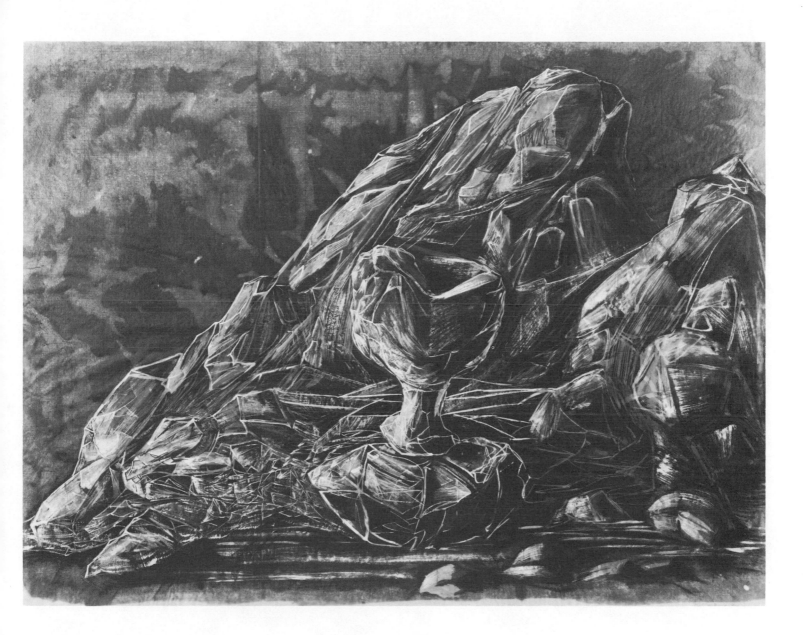

43. MORRIS GRAVES, *Journey*, 1943
Gouache and watercolor on paper, 22¼ x 30⅛ (56.5 x 76.5). Purchase, 45.14.

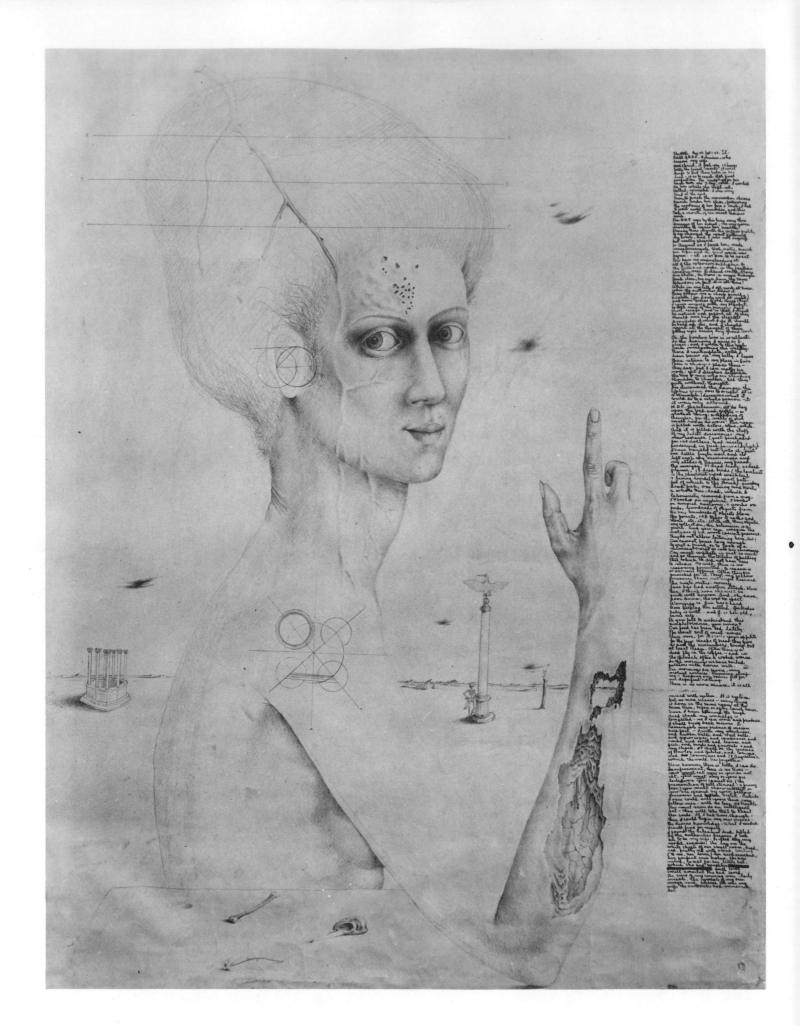

44A. JOHN WILDE, *Wedding Portrait*, 1943

Pencil on paper, 27¾ x 17¼ (70.5 x 43.8). Gift of the artist in memory of Helen Wilde, 70.75.

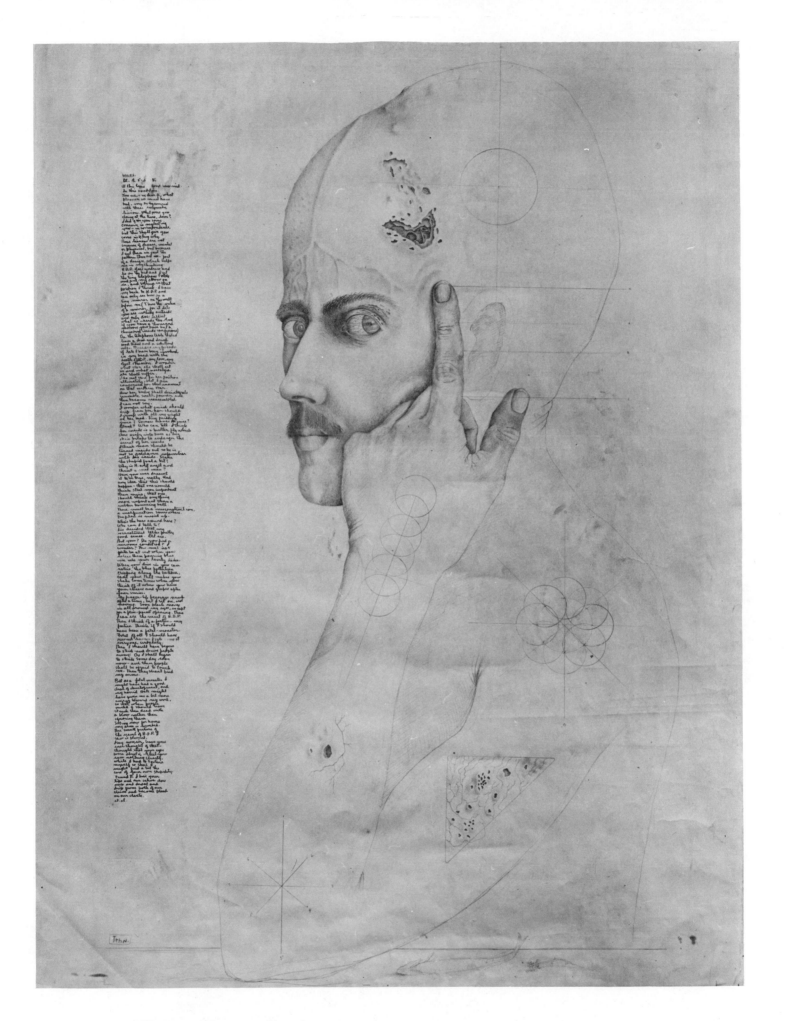

44B. JOHN WILDE, *Wedding Portrait*, 1943

Pencil on paper, 27¾ x 17¾ (70.5 x 45.1). Gift of the artist in memory of Helen Wilde, 70.74.

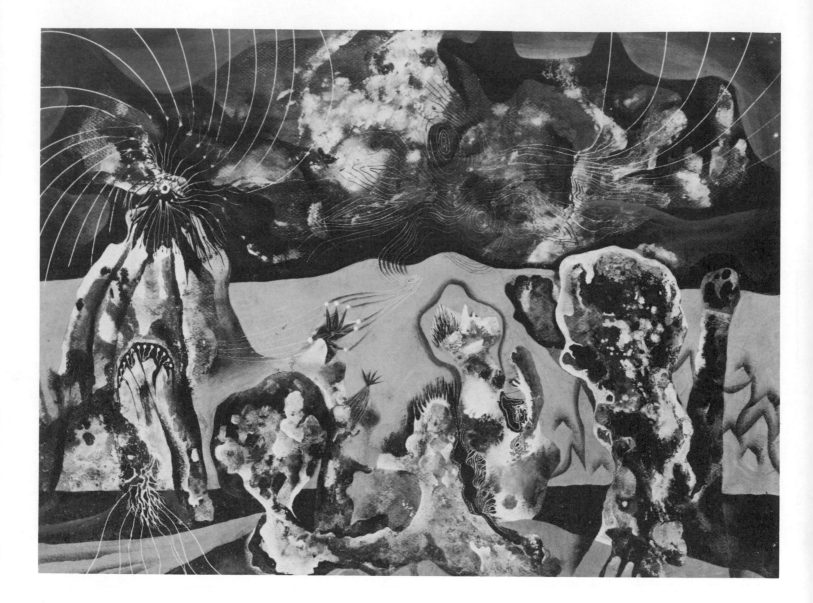

45. GEROME KAMROWSKI, *Emotional Seasons*, 1943

Gouache, collage and paper on wood, 21½ x 30⅛ (55.9 x 76.2). Gift of Charles Simon, 78.69.

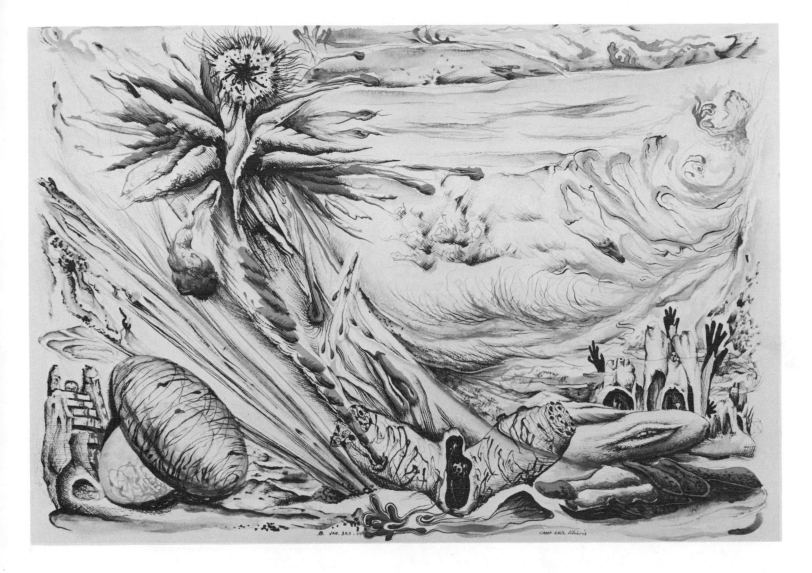

46. ALFONSO OSSORIO, *Red Star*, 1944
Watercolor and ink on paper, 13½ x 19¾ (34.3 x 50.2). Gift of the artist, 69.153.

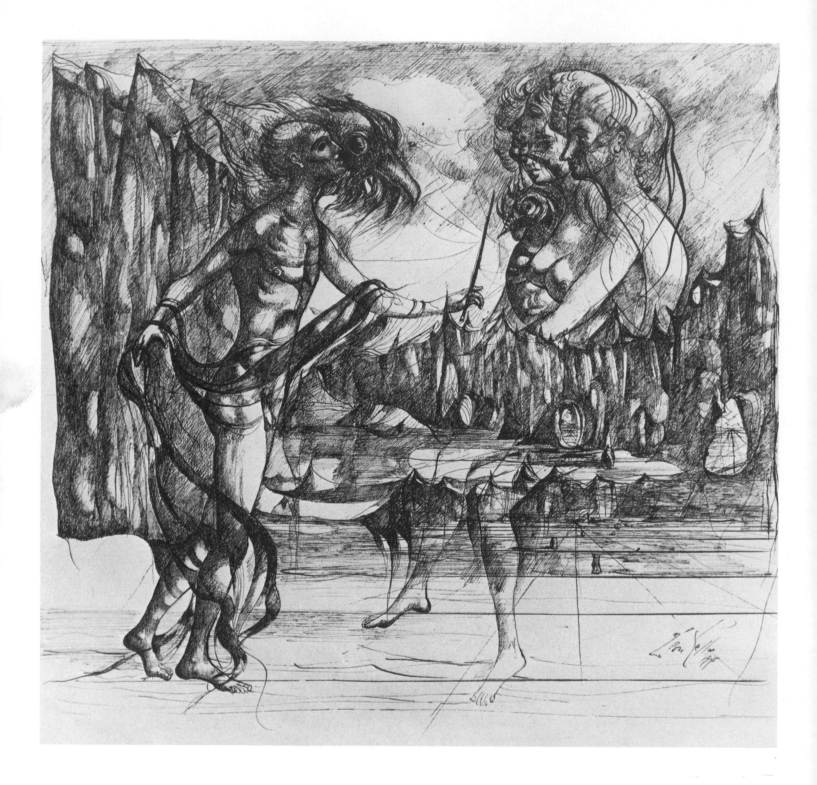

47. Leon Kelly, *Magic Bird*, 1945
Ink on paper, 9¼ x 9¾ (23.5 x 24.7). Purchase, 46.15.

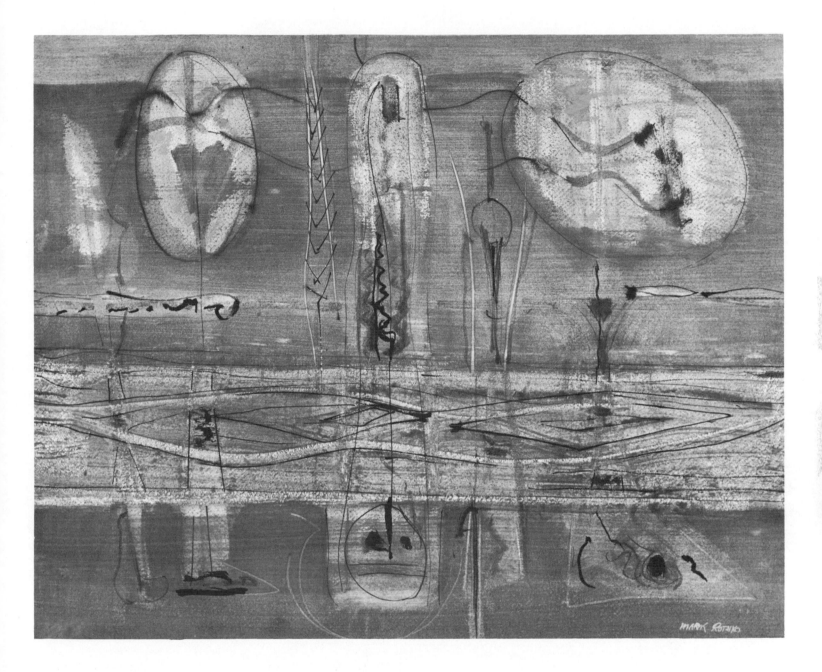

48. MARK ROTHKO, *Entombment I*, 1946
Gouache on paper, 20¾ x 25¾ (52.7 x 65.4). Purchase, 47.10.

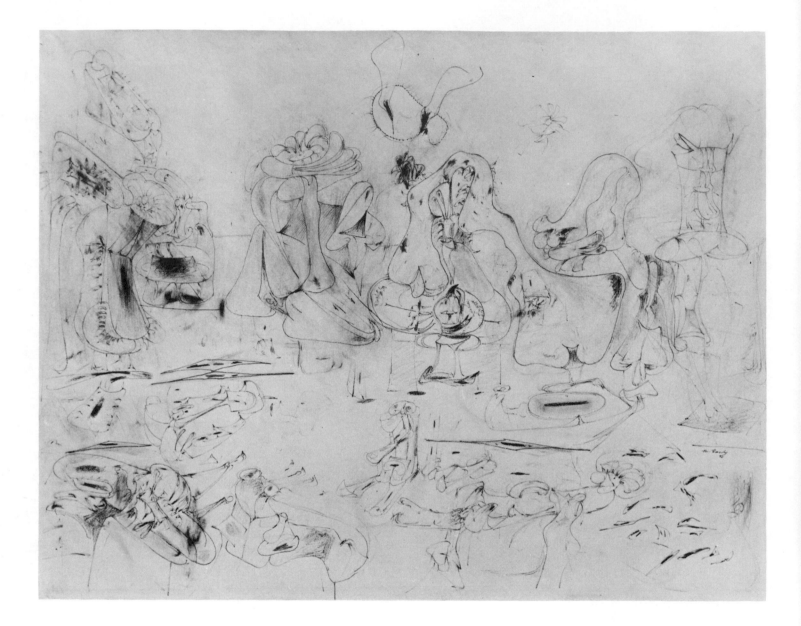

49. ARSHILE GORKY, Study for *Summation*, 1946

Crayon and pencil on paper, 18½ x 24½ (48.7 x 62). Gift of Mr. and Mrs. Wolfgang Schwabacher, 50.18.

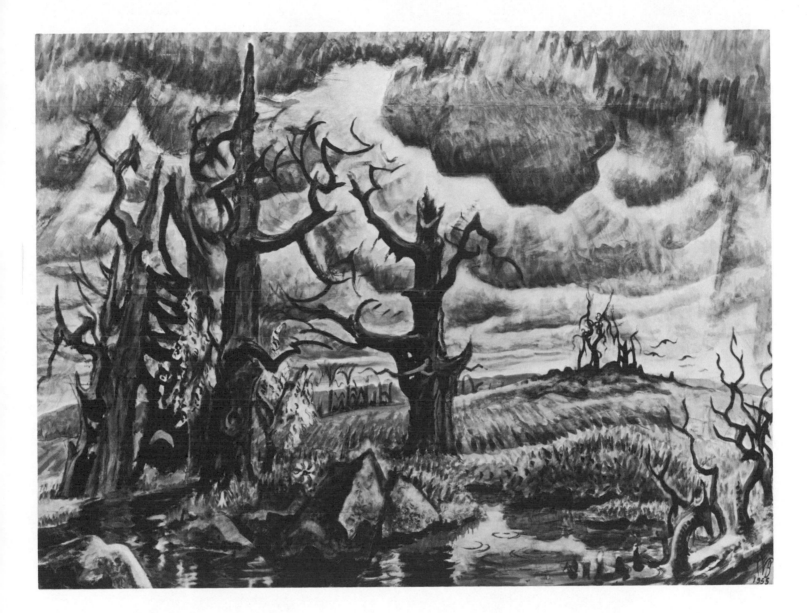

50. CHARLES BURCHFIELD, *An April Mood*, 1946 and 1955

Watercolor on paper, 40 x 54 (101 x 137.2). Gift of Mr. and Mrs. Lawrence A. Fleischman (and purchase), 55.39.

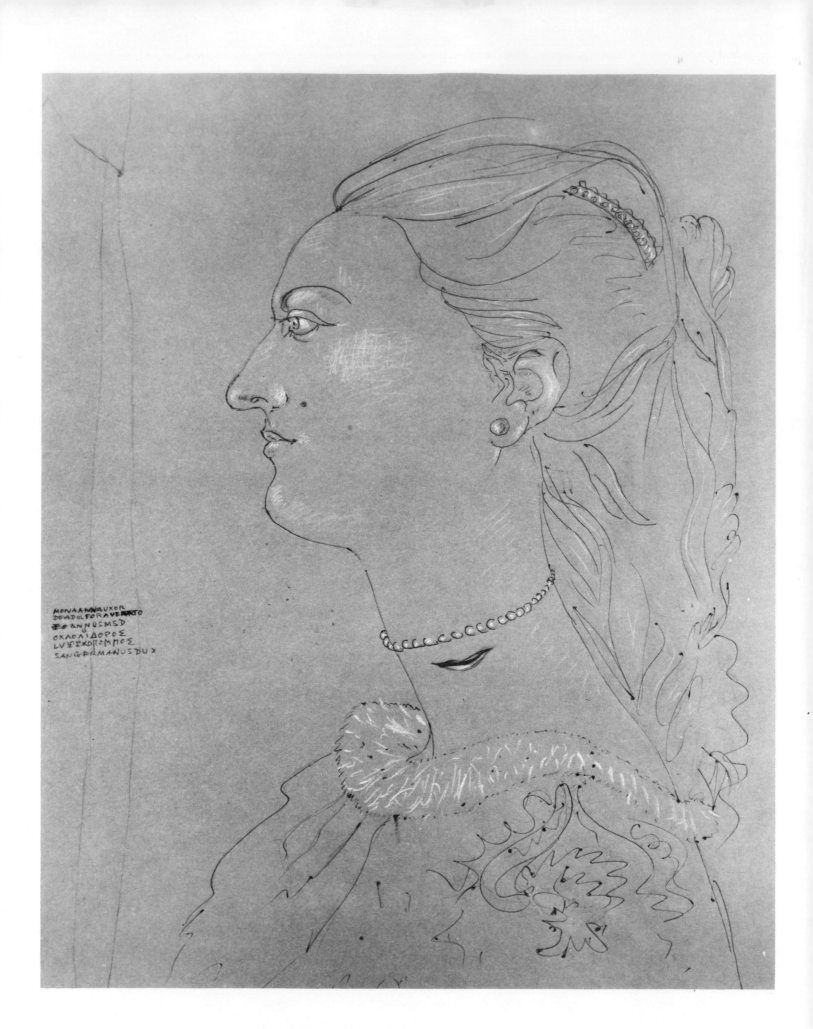

51. JOHN GRAHAM, *Mona Anna Uxor de Adolfo Ravenato*, 1947

Ink, pencil and chalk on paper, 22¼ x 17⅝ (56.5 x 44.7). Gift of the Friends of the
Whitney Museum of American Art, 60.65.

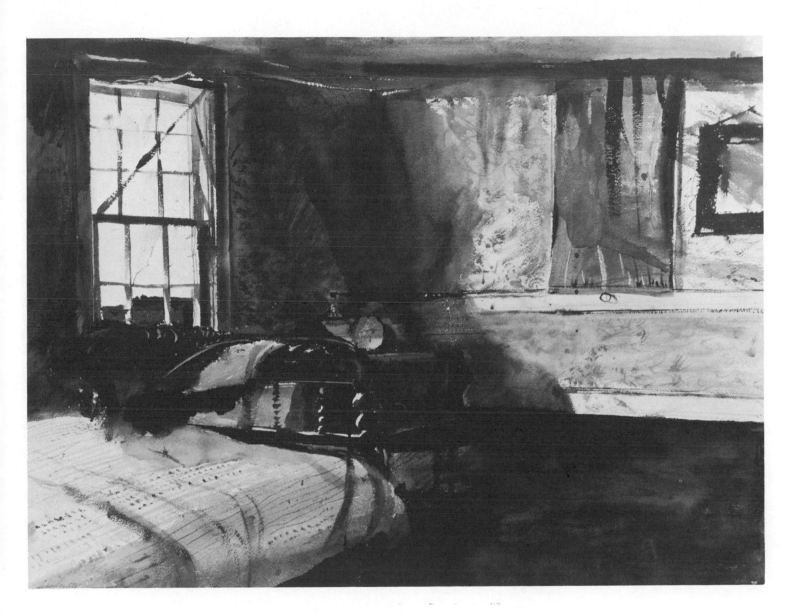

52. ANDREW WYETH, *Spool Bed*, 1947
Watercolor on paper, 21⅝ x 29⅝ (54.9 x 75.3). Purchase, 48.10.

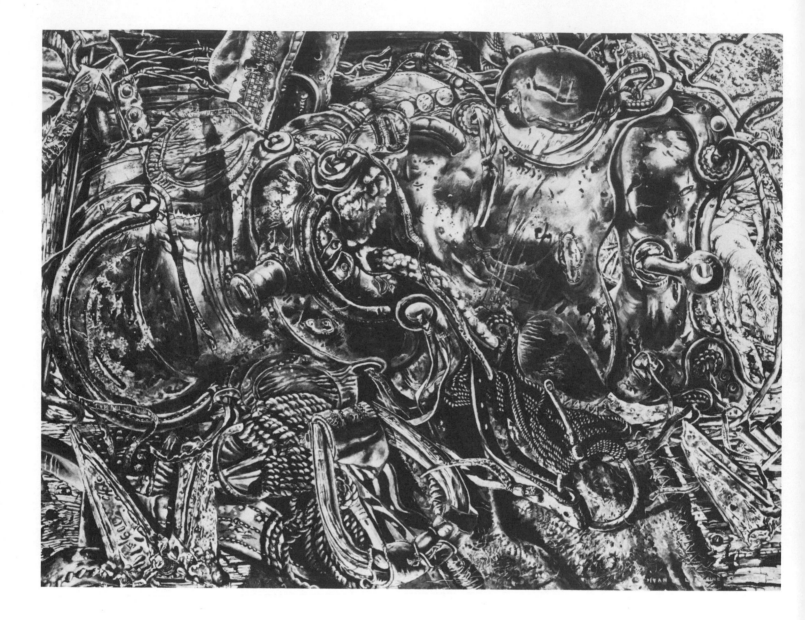

53. IVAN LE LORRAINE ALBRIGHT, *Roaring Fork, Wyoming,* 1948

Gouache on paper, 22½ x 30¾ (57.2 x 78). Gift of Mr. and Mrs. Lawrence A. Fleischman (and purchase), 62.30.

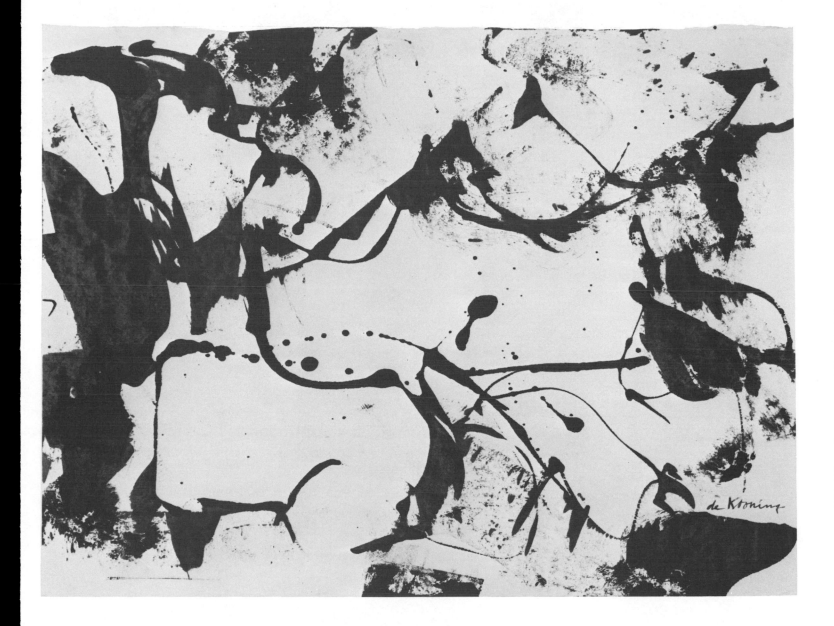

54. WILLEM DE KOONING, *Landscape, Abstract*, c. 1949

Oil on paper mounted on board, 19 x 25½ (48.3 x 64.8). Gift of Mr. and Mrs. Alan Temple, 68.96.

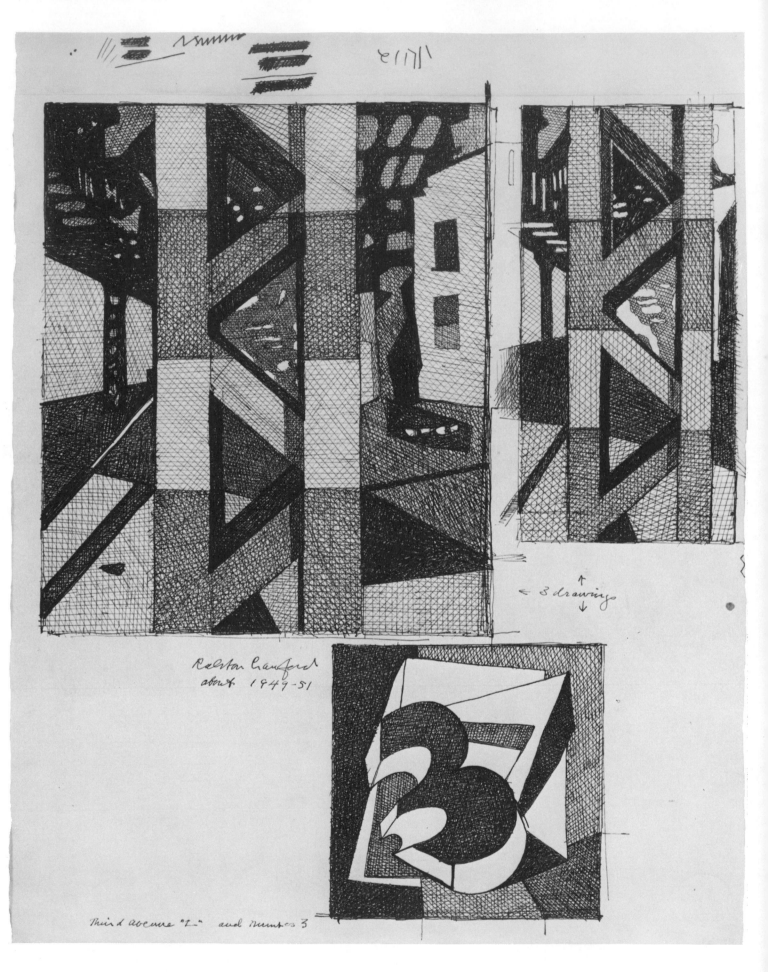

55. RALSTON CRAWFORD, *Untitled*, c. 1949–51

Ink on paper, 14½ x 11½ (36.9 x 29.2). Gift of Mr. and Mrs. Frederick M. Roberts in memory of their son, James Reed Roberts, 77.89.

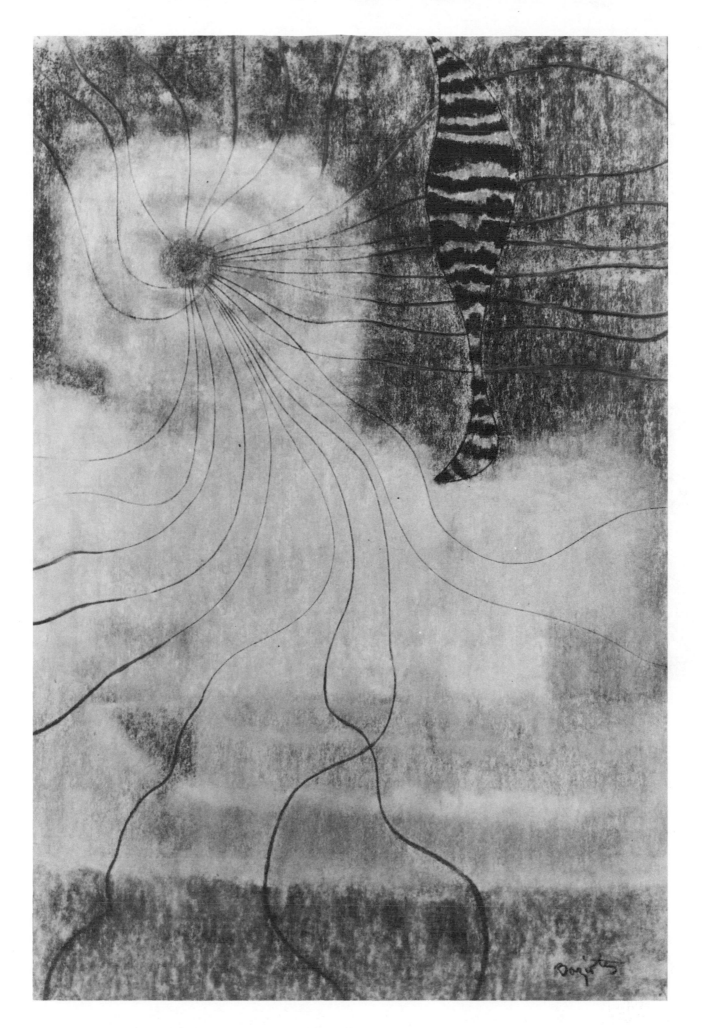

56. WILLIAM BAZIOTES, *Sea Forms*, 1951
Pastel on paper on masonite, 38⅛ x 25⅛ (96.9 x 63.8). Purchase, 52.19.

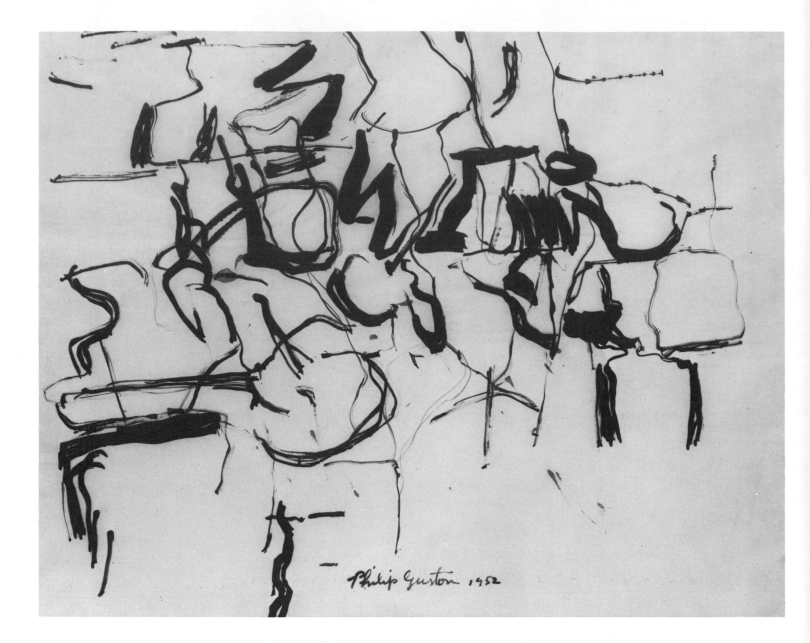

57. PHILIP GUSTON, *Ink Drawing*, 1952

Ink on paper, 18⅝ x 23⅝ (47.3 x 60). Gift of the Friends of the Whitney Museum of American Art, 61.23.

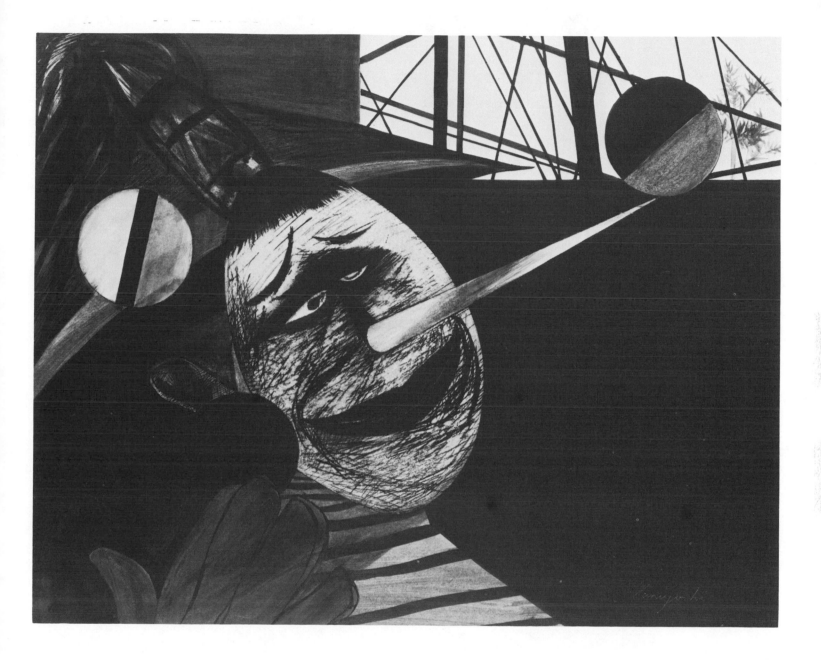

58. YASUO KUNIYOSHI, *Juggler*, 1952
Ink on cardboard, 22 x 28 (55.9 x 71.1). Purchase, 53.37.

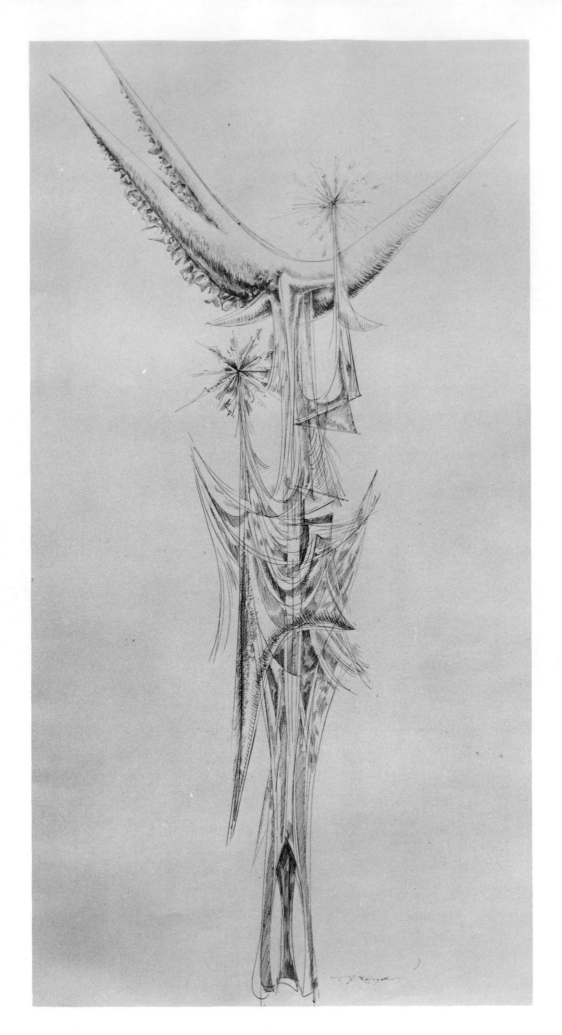

59. THEODORE ROSZAK, *Invocation*, 1952
Ink on paper, 39½ x 20⅞ (100.4 x 53). Neysa McMein Purchase Award, 77.29.

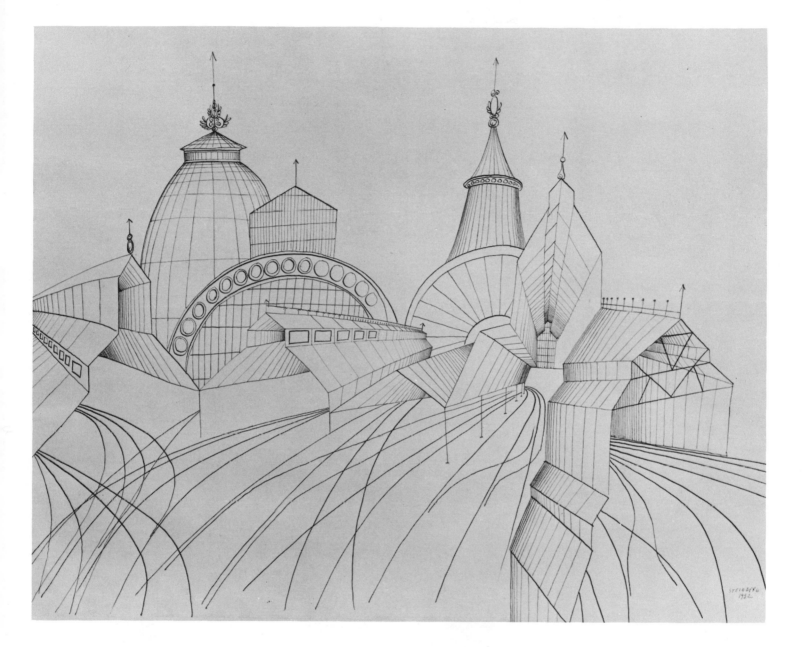

60. SAUL STEINBERG, *Railroad Station*, 1952

Ink on paper, 19½ x 24 (49.5 x 61). Gift of Mr. and Mrs. Carl L. Selden, 59.44.
© Saul Steinberg

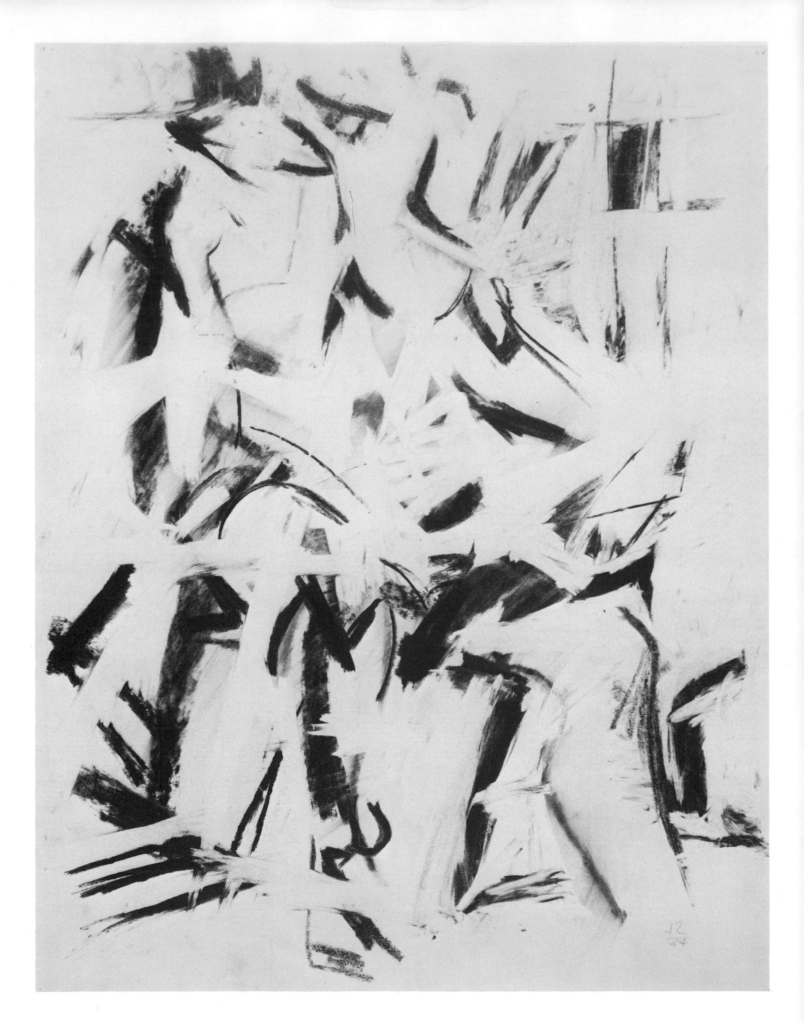

61. JACK TWORKOV, *Untitled*, 1954

Charcoal on paper, 25¾ x 19⅞ (65.4 x 50.5). Gift of Mr. and Mrs. Arthur
Wiesenberger, 66.115.

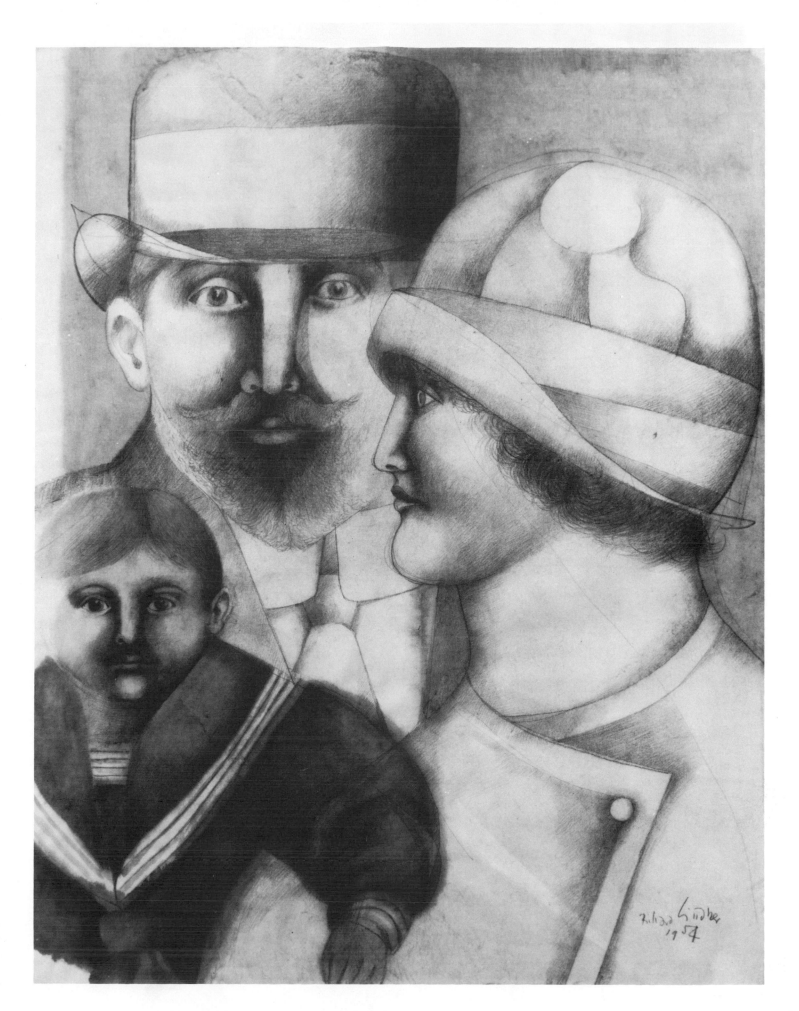

62. RICHARD LINDNER, *Sunday Afternoon*, 1954

Pencil and watercolor on paper, 25 x 19 (63.5 x 48.3). Gift of the Friends of the
Whitney Museum of American Art, 60.3.

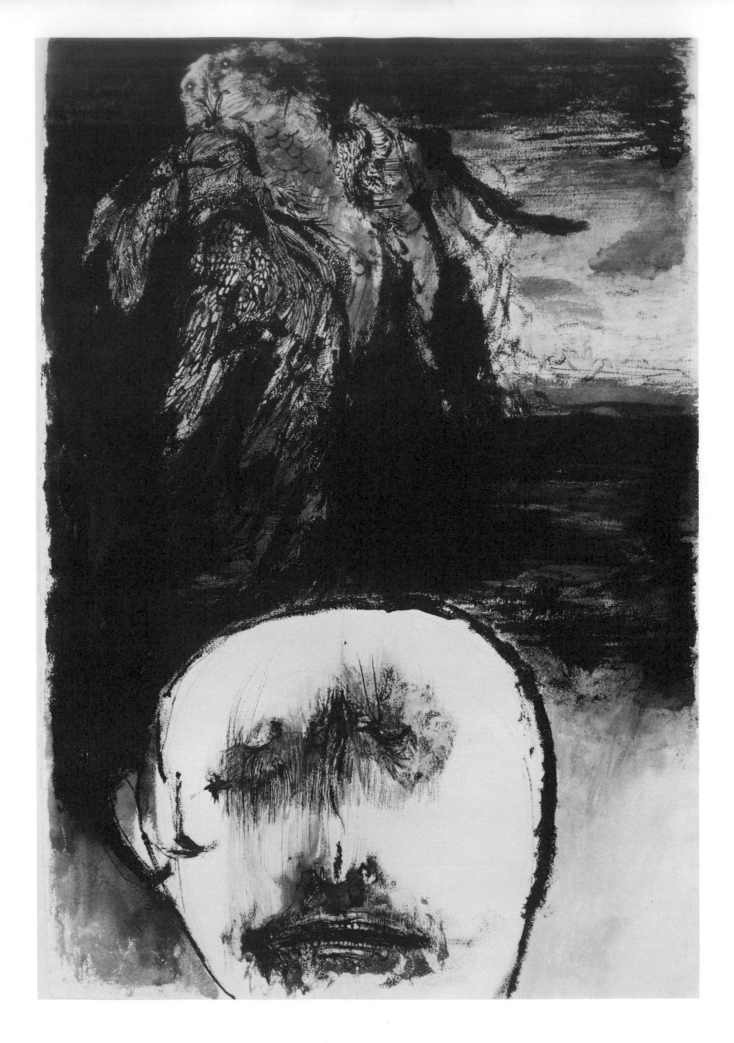

63. LEONARD BASKIN, *Tormented Man*, 1956
Ink on paper, 39½ x 26½ (100.4 x 67.3). Living Arts Foundation Fund, 57.52.

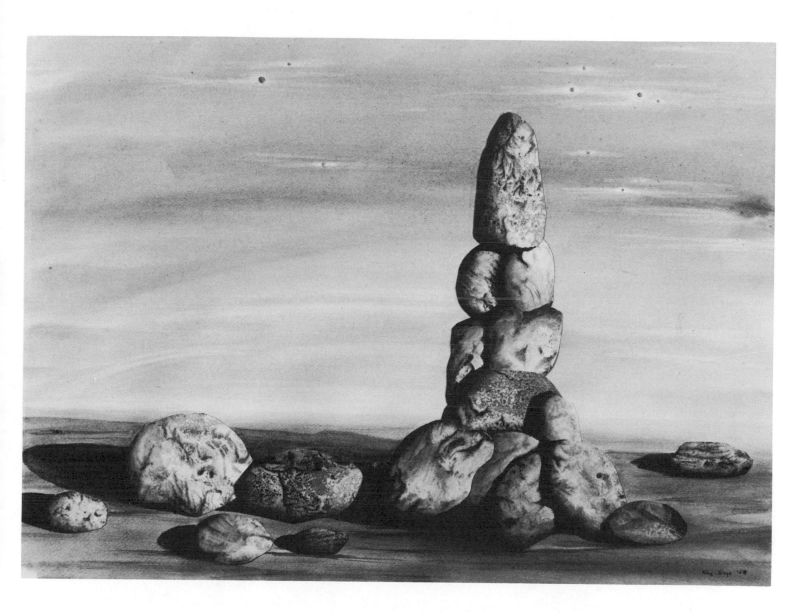

64. KAY SAGE, *Constant Variation*, 1958

Watercolor and collage on paper, 19⅛ x 26½ (48.3 x 67.4). Promised gift of Flora Whitney Miller, P.68.78.

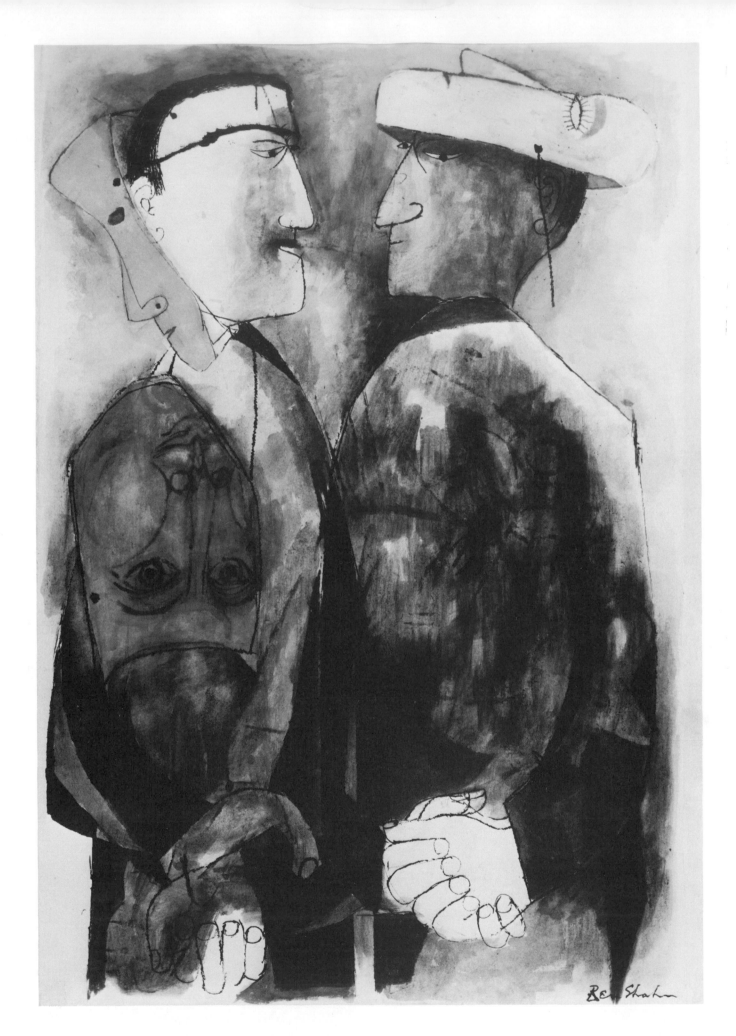

65. Ben Shahn, *Conversations*, 1958
Watercolor on paper, 39¼ x 27 (99.7 x 68.6). Gift of the Friends of the Whitney
Museum of American Art, 58.21.

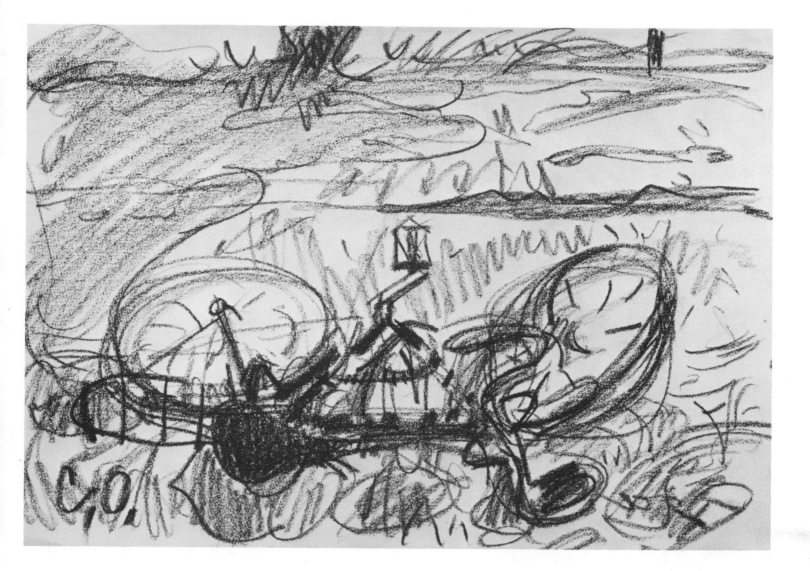

66. CLAES OLDENBURG, *Bicycle on Ground*, 1959

Crayon on paper, 12 x 17⅝ (30.5 x 44.8). Gift of the Lauder Foundation—Drawing Fund, 76.31.

67. GEORGIA O'KEEFFE, *Drawing IV*, 1959

Charcoal on paper, 18½ x 24½ (47 x 62.3). Gift of Chauncey L. Waddell in honor of
John I. H. Baur, 74.67.

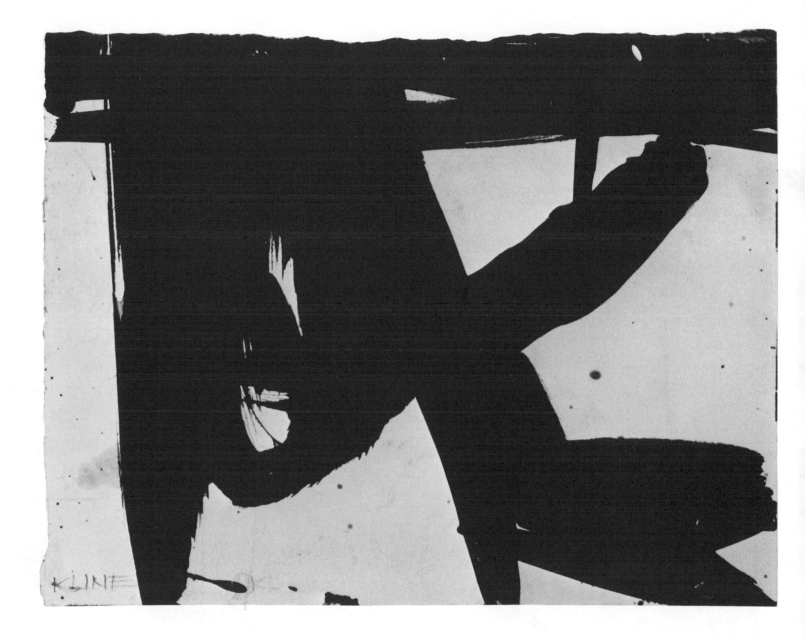

68. FRANZ KLINE, *Untitled*, 1960

Ink on paper, 8½ x 10½ (21.6 x 26.7). Gift of Mr. and Mrs. Benjamin Weiss, 78.53.

69. Jimmy Ernst, *Face*, 1960
Ink on paper, 22 x 29¾ (55.9 x 75.6). Purchase, 60.56.

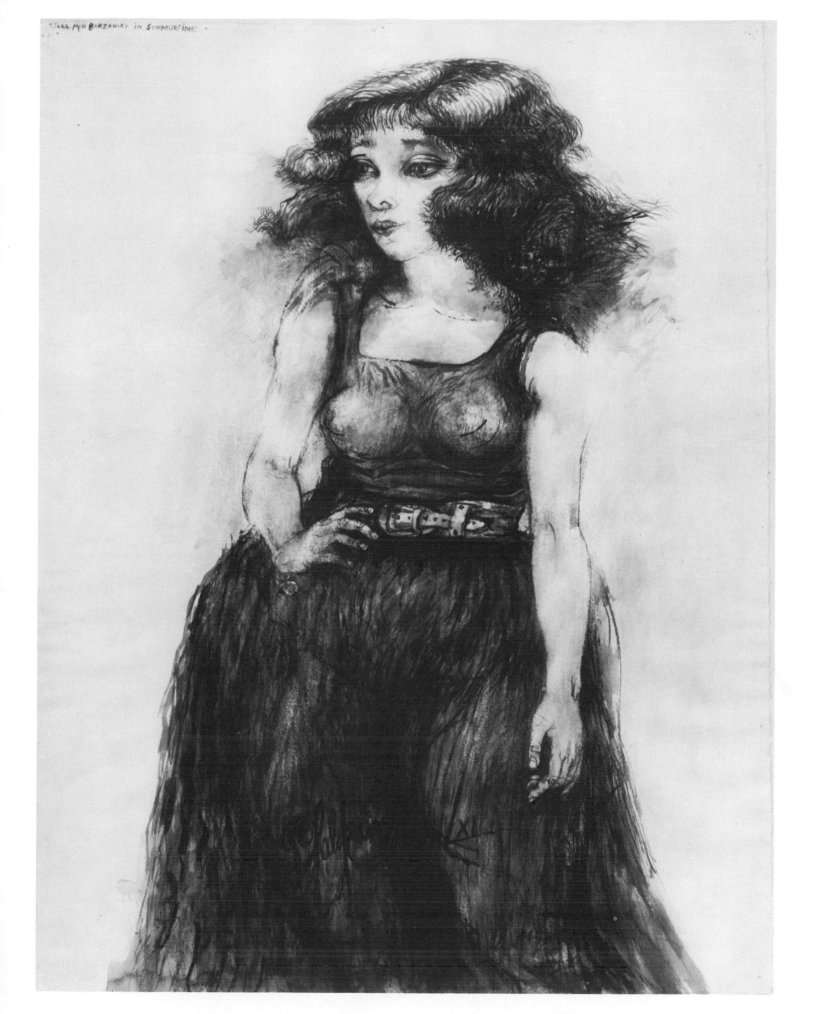

70. PHILIP EVERGOOD, *Miss Barzansky in Summurtime*, 1961

Ink on paper, 31 x 23 (78.7 x 58.4). Promised gift of Terry Dintenfass in honor of John I. H. Baur, P.9.74.

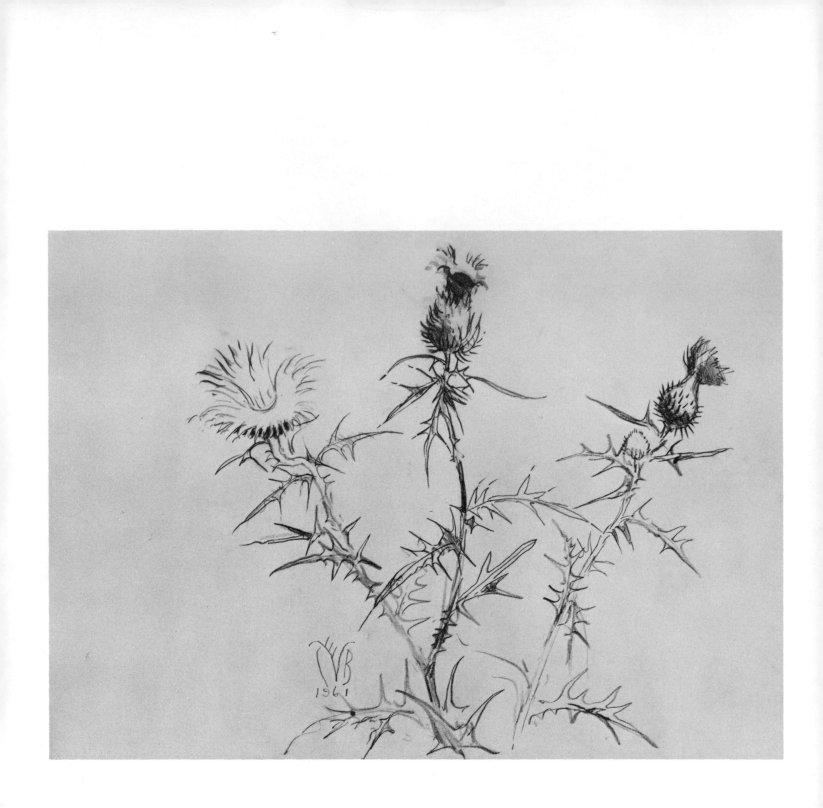

71. CHARLES BURCHFIELD, *Study of Thistle*, 1961
Crayon on bond paper, 13¼ x 18⅞ (33.6 x 48). Purchase, 65.39.

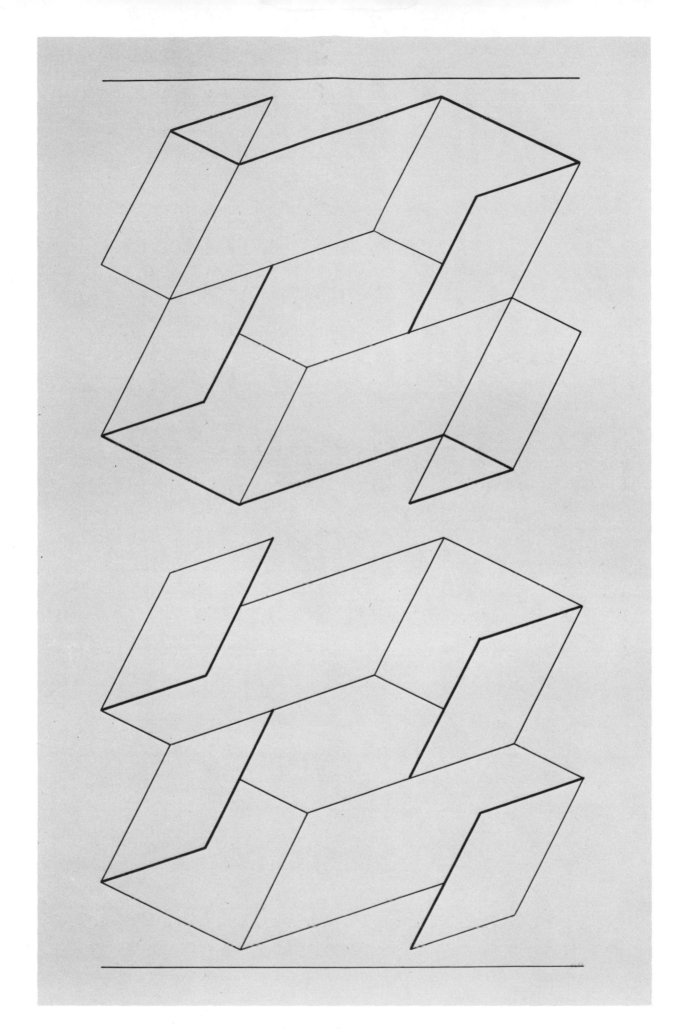

72. JOSEF ALBERS, *Reverse + Obverse*, 1962

Ink on paper, 22½ x 14 (57.2 x 35.5). Gift under the Ford Foundation Purchase Program, 63.13.

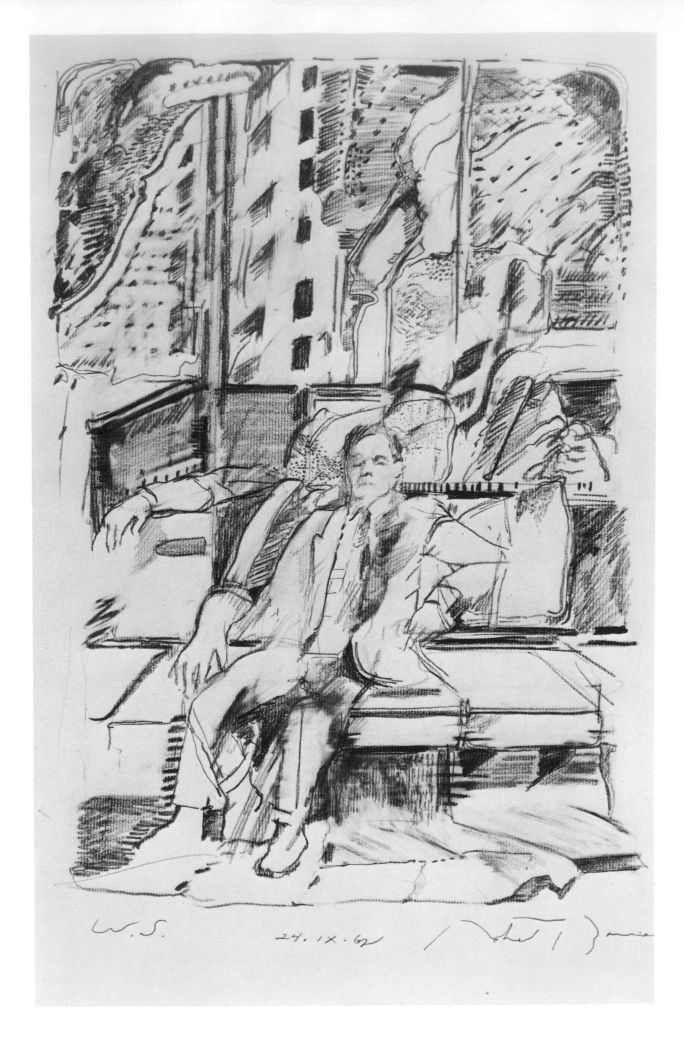

73. ROBERT BARNES, *W.S.*, 1962

Pencil on paper, 18¾ x 12½ (47.5 x 31.7). Gift of the Allan Frumkin Gallery, 63.1.

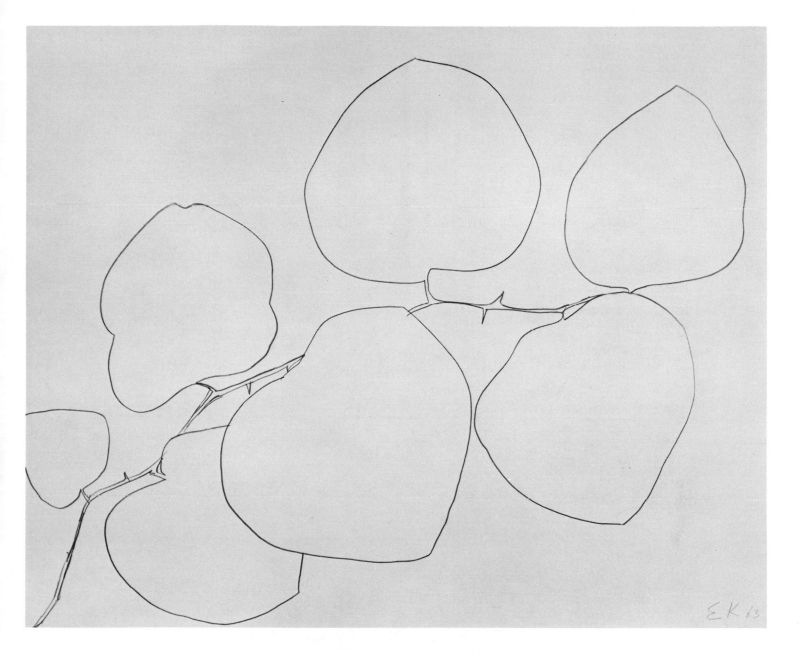

74. ELLSWORTH KELLY, *Briar*, 1963

Pencil on paper, 22⅜ x 28⅜ (57 x 72.3). Neysa McMein Purchase Award, 65.42.

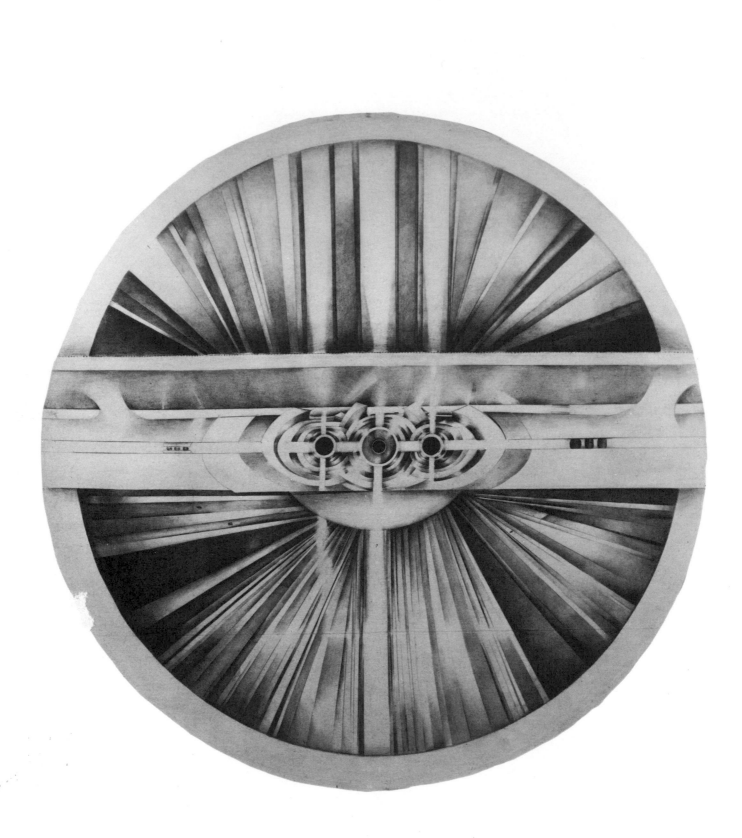

75. LEE BONTECOU, *Untitled*, 1963

Pencil and soot on muslin, 47¼ (119.4) diameter. Gift of the Friends of the Whitney
Museum of American Art, 64.12.

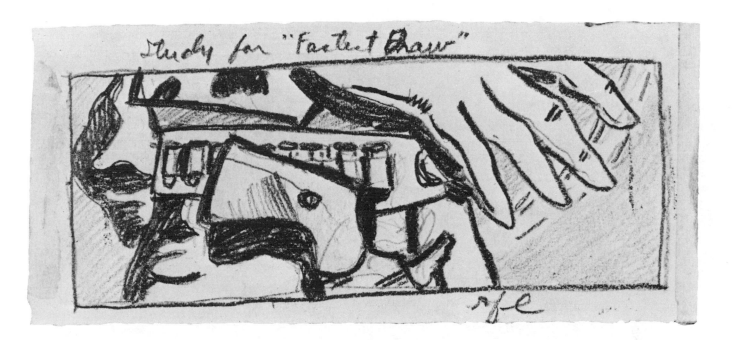

76. ROY LICHTENSTEIN, Study for *Fastest Draw*, 1963
Pencil on paper, 2½ x 5¾ (6.4 x 14.6). Gift of Karen and Arthur Cohen, 75.35.

77. WALTER MURCH, Study for *The Birthday*, 1963

Pencil, wash and crayon on paper, 23 x 17½ (58.4 x 44.5). Neysa McMein Purchase
Award, 64.6.

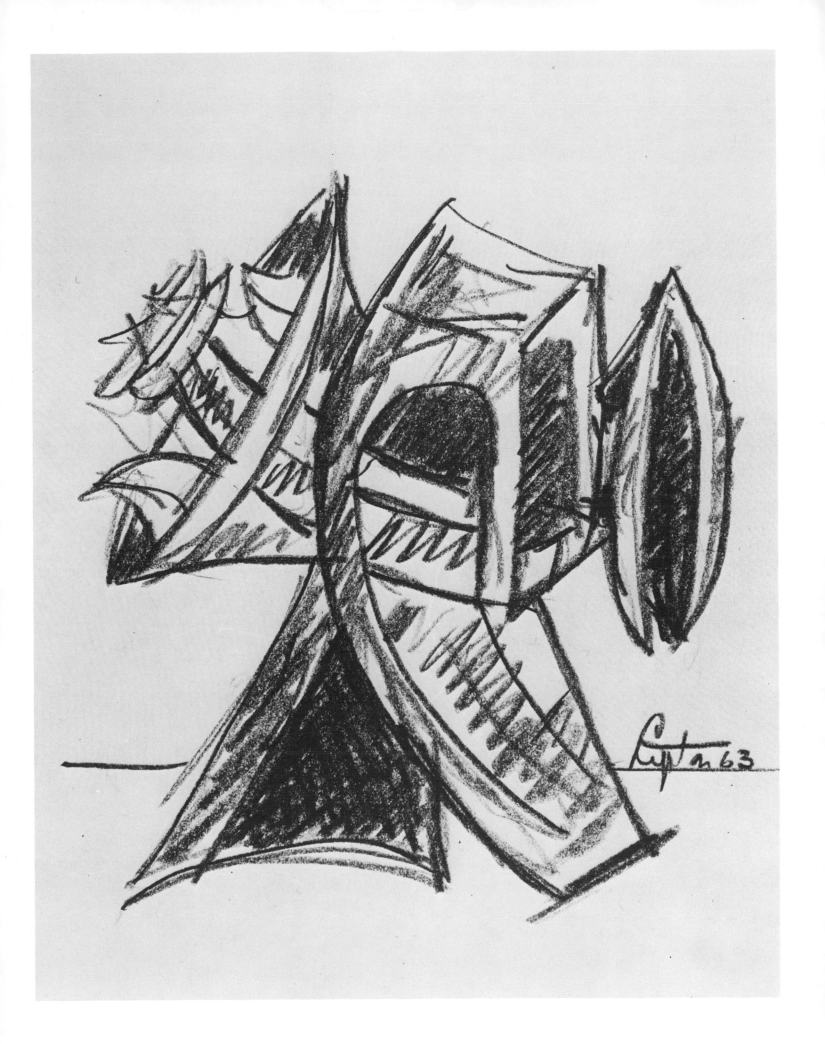

78. SEYMOUR LIPTON, *Untitled*, 1963
Crayon on paper, 11 x 8½ (28 x 21.6). Gift of the artist, 77.61.

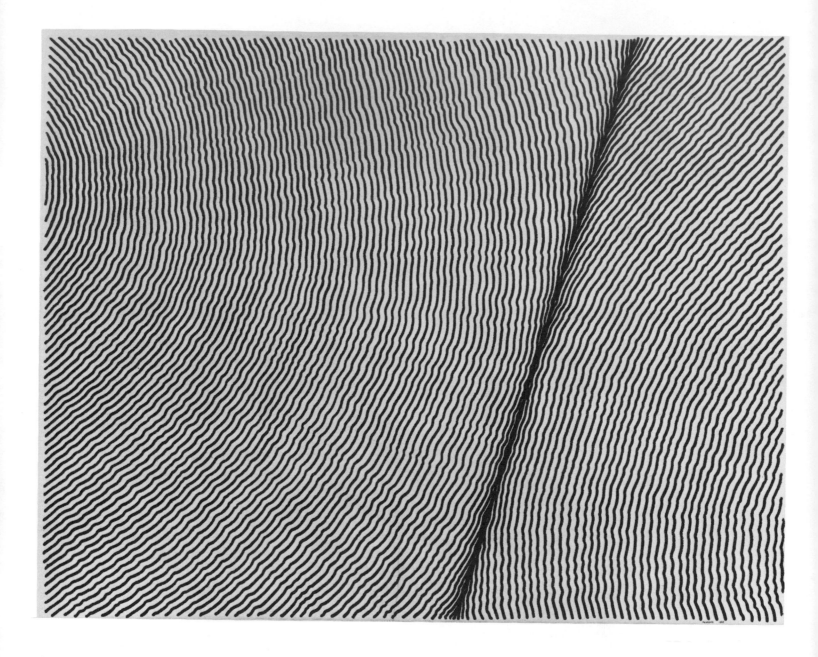

79. HENRY PEARSON, *Ethical Movement*, 1965
Ink on paper, 15⅝ x 20¼ (39.7 x 52.1). Purchase, 65.46.

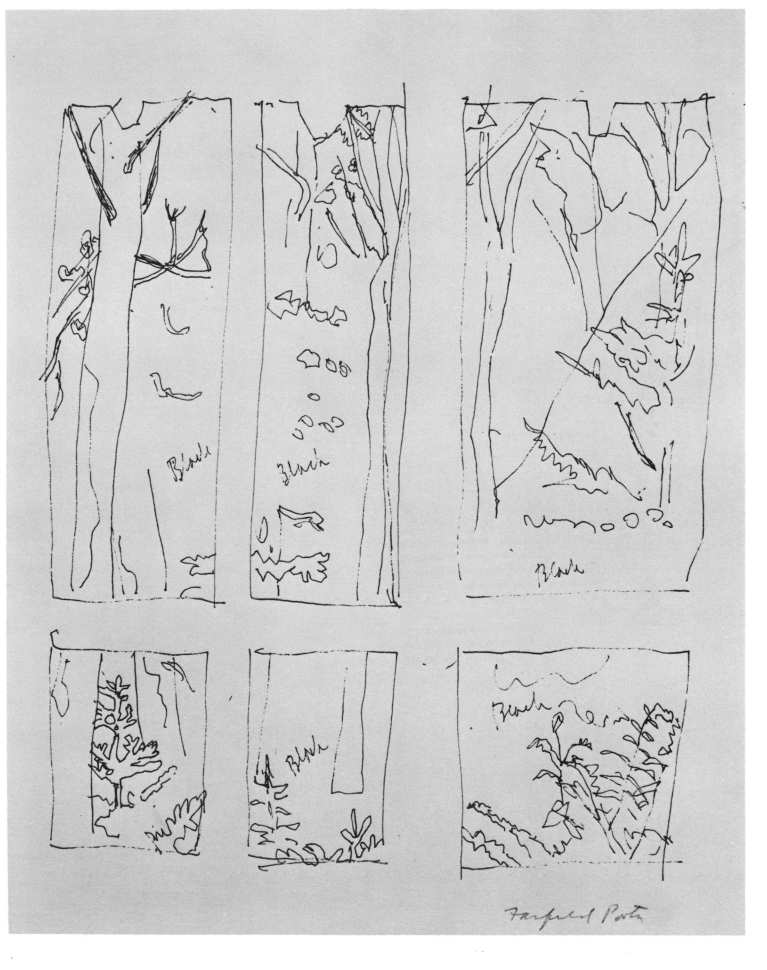

80. Fairfield Porter, *Study*, n.d.
Ink on paper, 13½ x 10¼ (34.3 x 26.1). Gift of Alex Katz, 77.58.

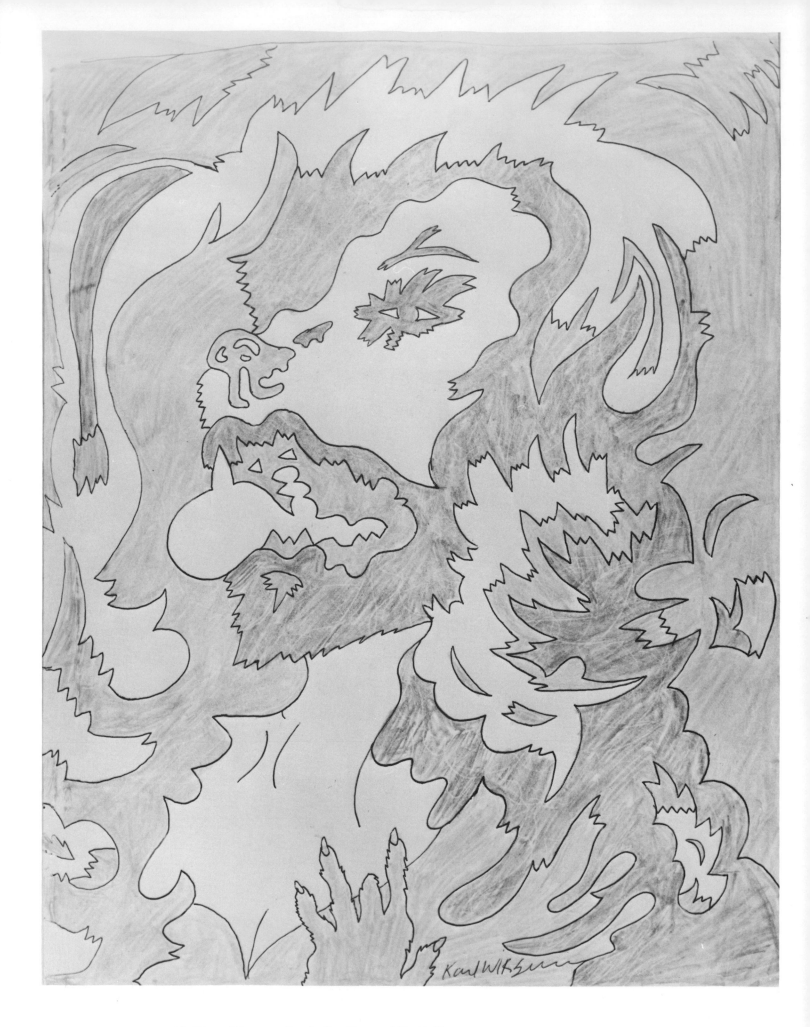

81. KARL WIRSUM, Study for *Doggerel II*, 1966

Crayon with ball-point pen on paper, 13⅞ x 11 (35.7 x 28). Gift of Marjorie Dell, 68.63.

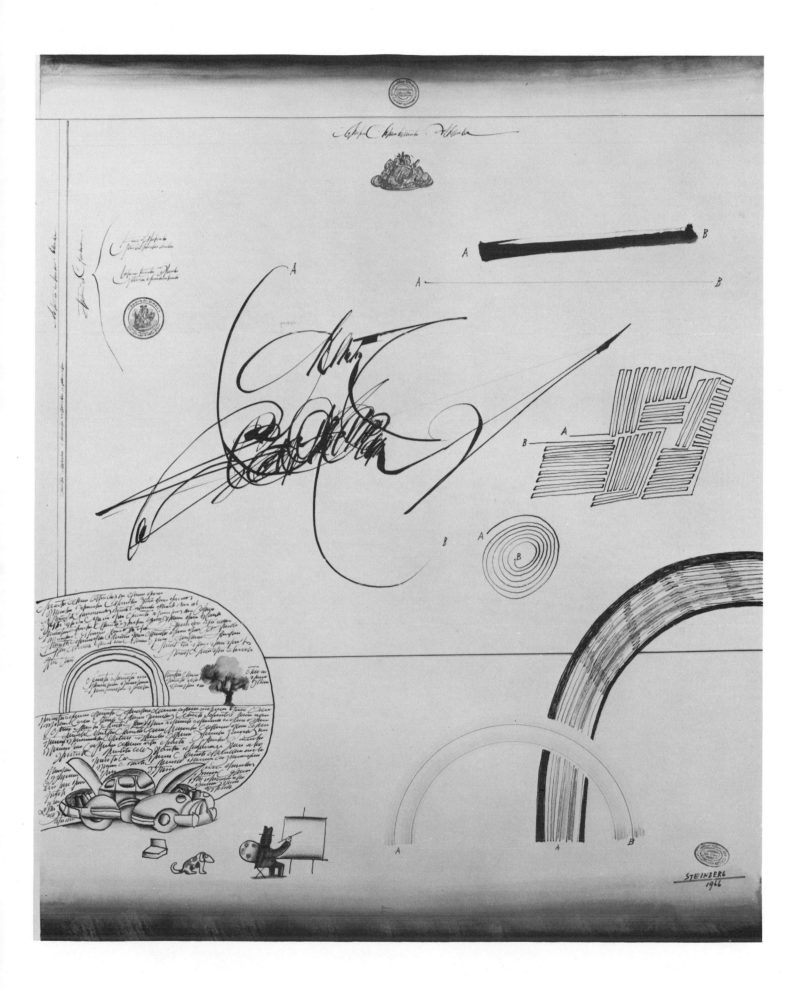

82. SAUL STEINBERG, *Government Regulations on Autobiography*, 1966

Ink, pastel and watercolor on paper, 28 x 22 (71.2 x 55.8). Gift of the artist, 68.77.
© Saul Steinberg

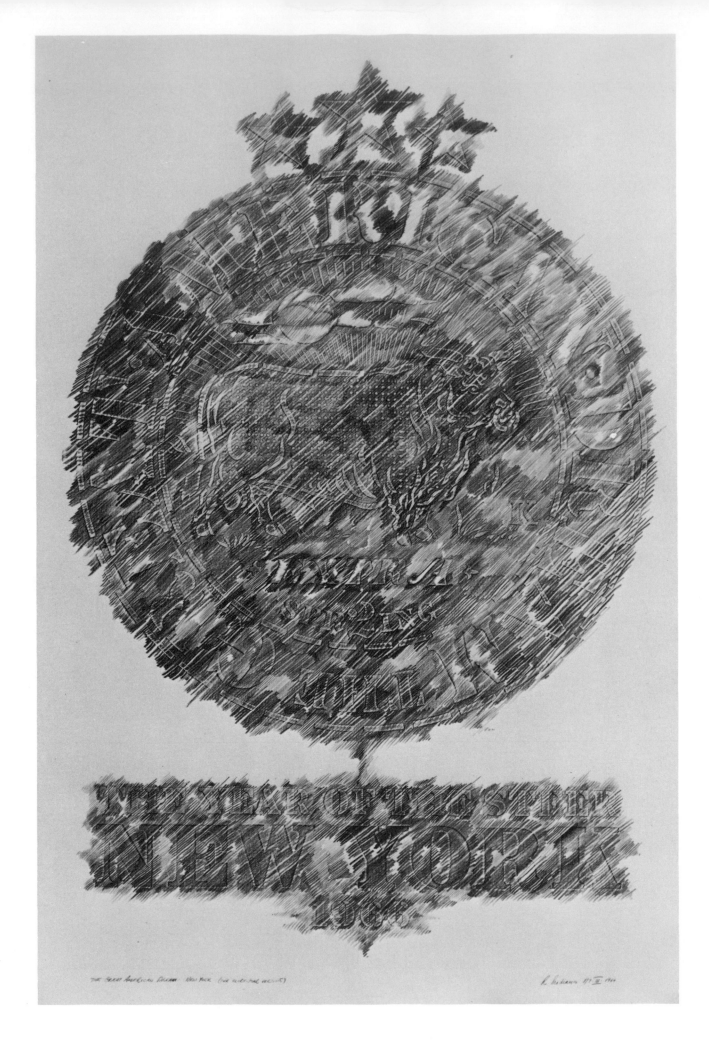

83. ROBERT INDIANA, *The Great American Dream: New York*, 1966
Crayon and frottage on paper, 39½ x 26 (100.3 x 66). Gift of Norman Dubrow, 77.98.

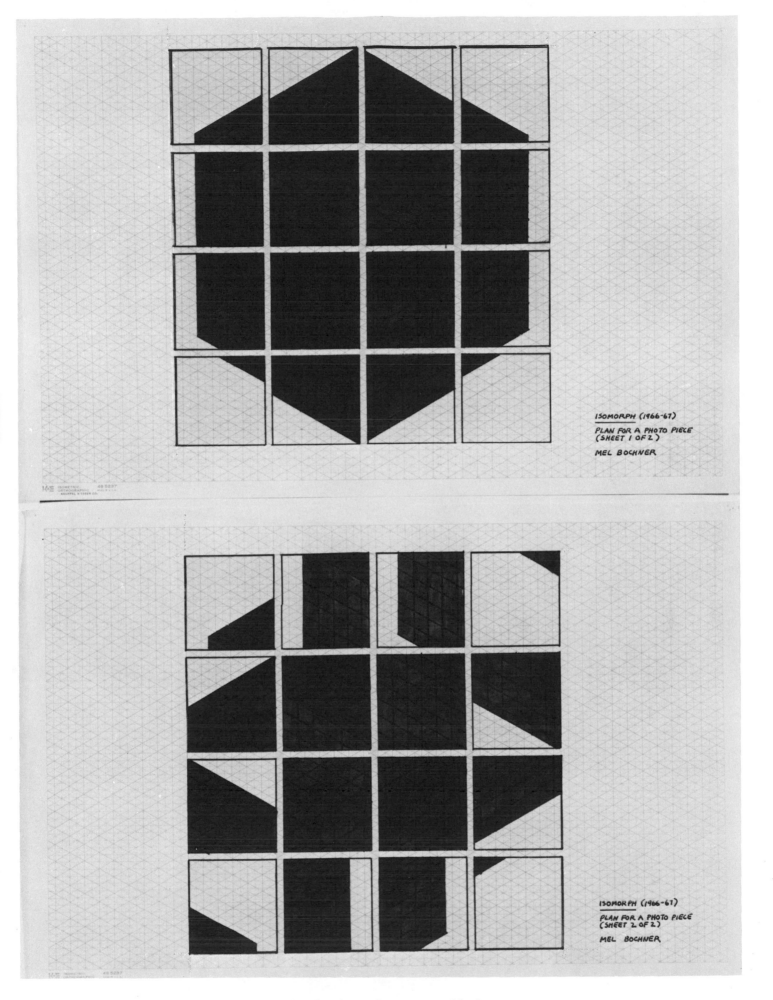

84. MEL BOCHNER, *Isomorph (Plan for a Photopiece)*, 1966–67

Ink on graph paper; two sheets, each 13 x 19 (33 x 48.3). Gift of Norman Dubrow,
77.101.

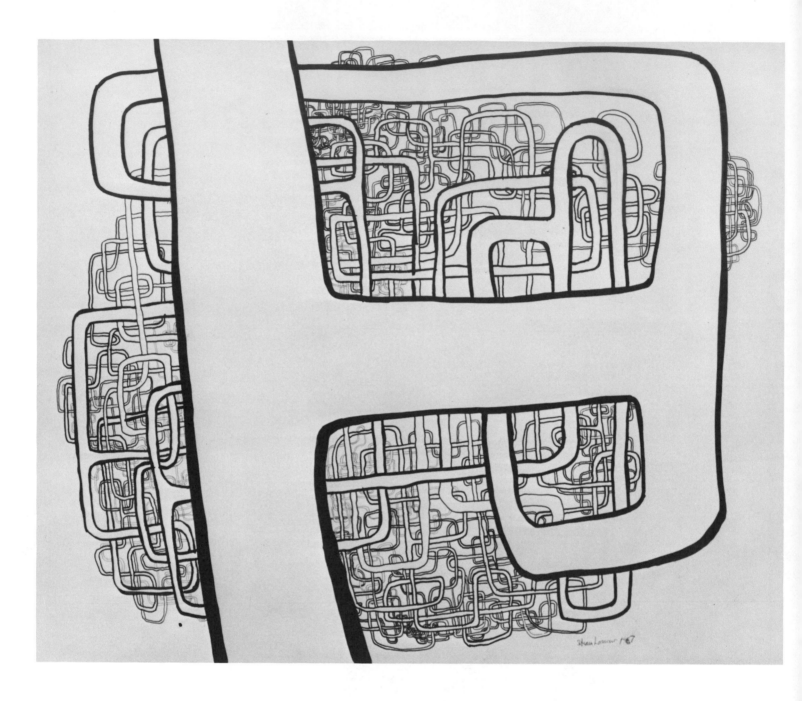

85. IBRAM LASSAW, *Untitled*, 1967
Ink on paper, 13⅜ x 16 (34 x 40.6). Neysa McMein Purchase Award, 77.30.

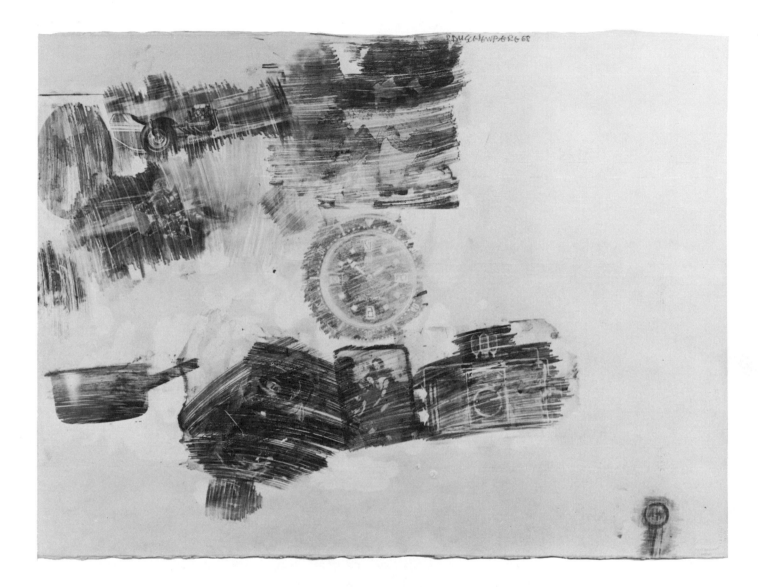

86. ROBERT RAUSCHENBERG, *Untitled*, 1968

Magazine transfer, pencil and gouache on paper, 22¼ x 29⅞ (56.5 x 75.9). Purchased with the aid of funds from the National Endowment for the Arts, 72.134.

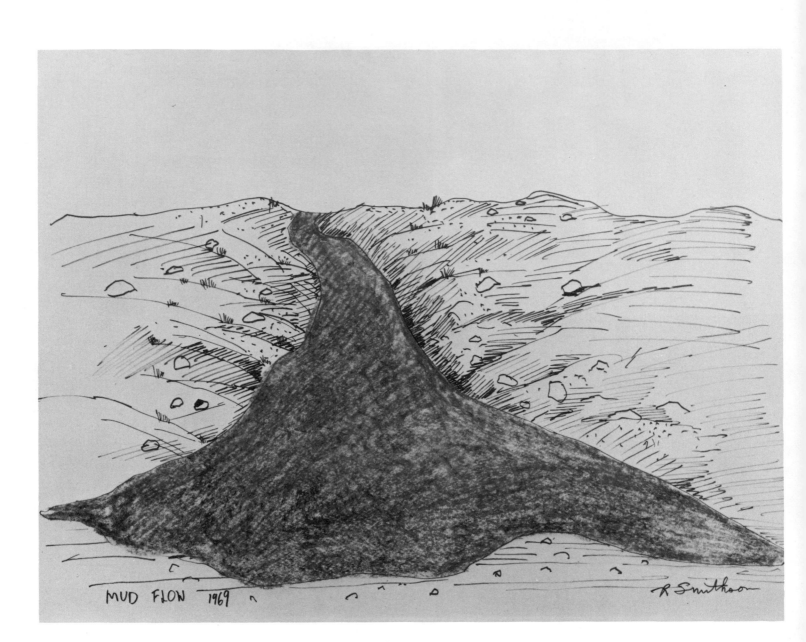

87. ROBERT SMITHSON, *Mud Flow*, 1969

Crayon and felt pen on paper, 17½ x 23¾ (44.5 x 60.4). Gift of Norman Dubrow, 77.99.

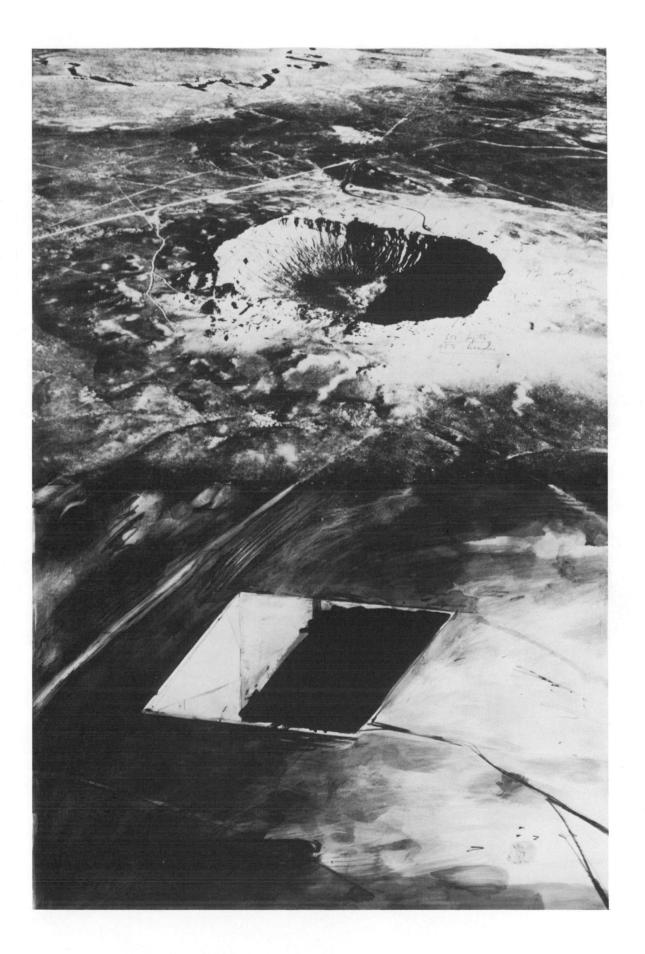

88. MICHAEL HEIZER, *Untitled*, 1969

Photograph, pencil and watercolor on paper, 39 x 30 (99 x 76.2). Promised gift of
Norman Dubrow, P.74.78.

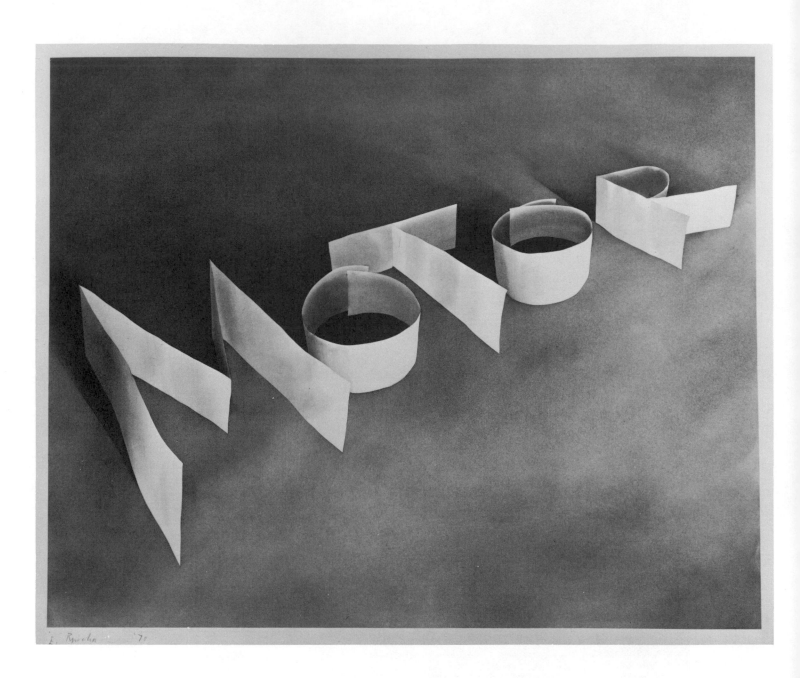

89. ED RUSCHA, *Motor*, 1970

Gunpowder on paper, 23 x 29 (58.5 x 73.7). Gift of the Lauder Foundation—Drawing Fund, 77.78.

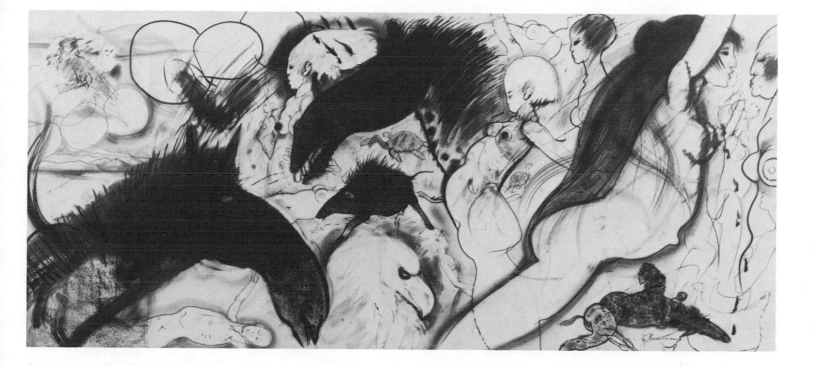

90. ROBERT BEAUCHAMP, *Untitled*, 1971

Graphite on paper, 36 x 79¾ (91.4 x 202.5). The List Purchase Fund, 72.23.

91. JOE BRAINARD, *Love*, 1972

Pastel on paper, 13¾ x 10¾ (34.9 x 27.3). Gift of Marilyn Cole Fischbach and A. Aladar Marberger, 77.92.

92. RICHARD SERRA, *Untitled*, 1972–73

Lithographic crayon on paper, 37¾ x 49¾ (95.9 x 126.4). Gift of Susan Morse Hilles,
74.10.

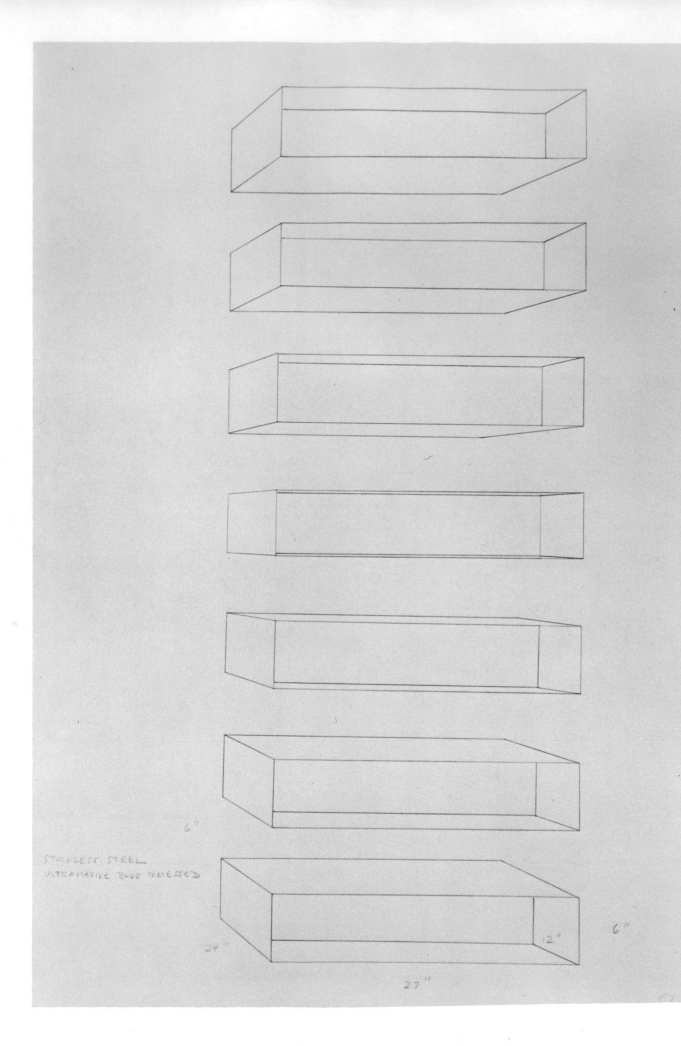

93. Donald Judd, *Stainless Steel, Blue Recessed*, 1973
Pencil on paper, 30 x 22 (76.2 x 55.8). Gift of Mrs. Agnes Saalfield, 78.21.

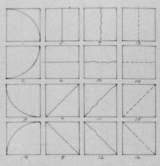

94. SOL LeWITT, *All Crossing Combinations of Arcs, Straight Lines, Not-Straight Lines, and Broken Lines*, 1973

Ink on paper, 19⅛ x 19⅛ (48.6 x 48.6). Promised gift of Norman Dubrow, P.76.78.

95. ALEX KATZ, *2:30 II*, 1973
Pencil on paper, 24½ x 33½ (62.2 x 84.5). Neysa McMein Purchase Award, 73.73.

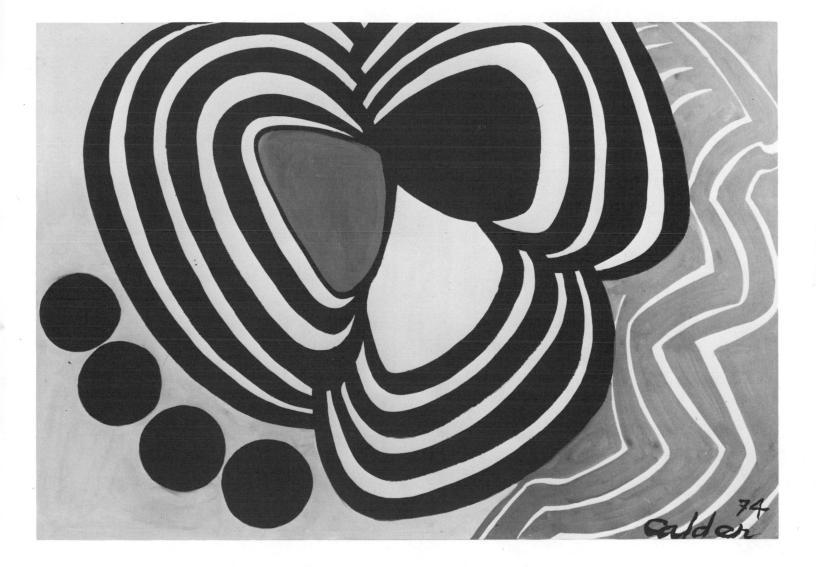

96. ALEXANDER CALDER, *Four Black Dots*, 1974

Gouache on paper, 29½ x 43 (74.3 x 109.3). Gift of the Howard and Jean Lipman Foundation, Inc., 74.94.

97. RICHARD TUTTLE, *Sirakus*, 1974
Ink on paper, 14 x 11 (35.6 x 28). The List Purchase Fund, 74.21.

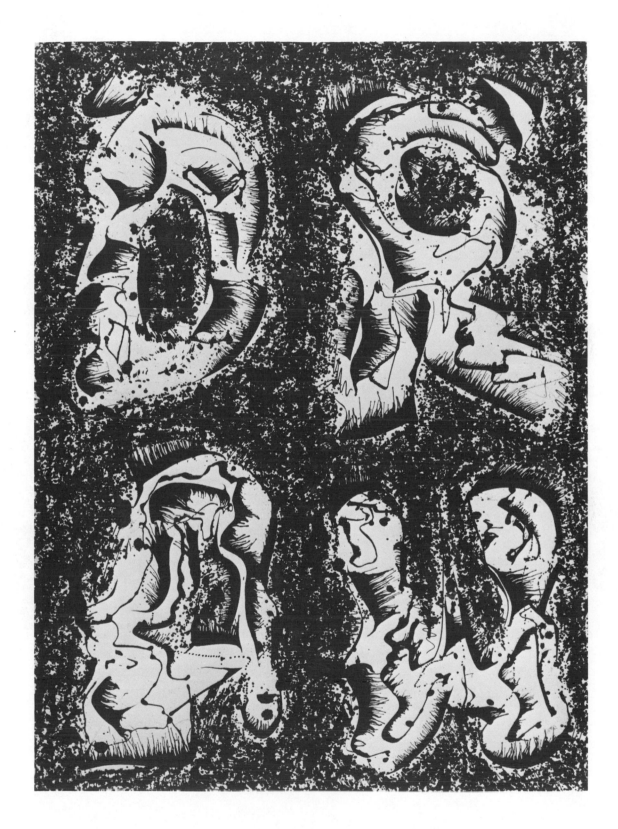

98. LUCAS SAMARAS, *Extra Large Drawing #2*, 1975
Ink on paper, 30¼ x 22 (76.8 x 55.9). Gift of the Crawford Foundation, 77.69.

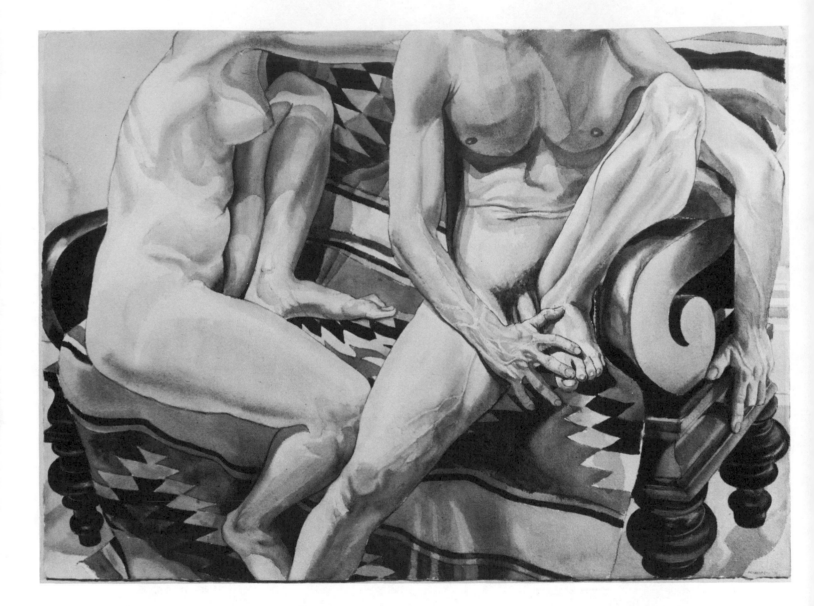

99. PHILIP PEARLSTEIN, *Male and Female Models on Greek Revival Sofa*, 1976
Watercolor on paper, 29½ x 41 (75 x 104.1). Gift of the Louis and Bessie Adler
Foundation, Inc., 77.6.

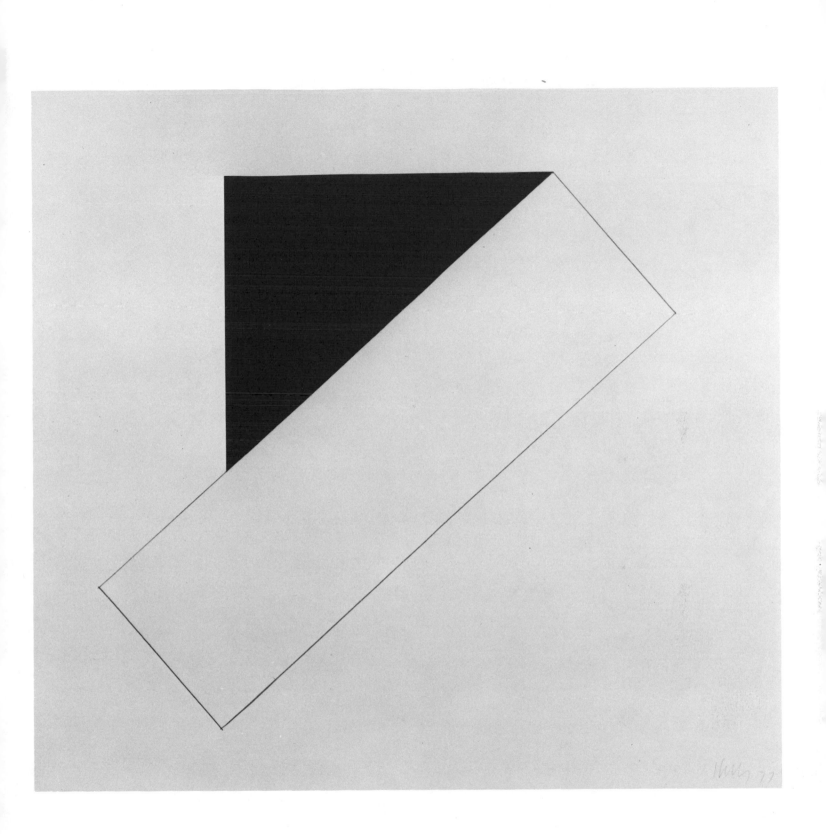

100. ELLSWORTH KELLY, *Black Triangle with White*, 1977

Collage and ink on paper, 31½ x 34½ (80 x 87.6). Gift of Philip Morris Incorporated, 78.100.

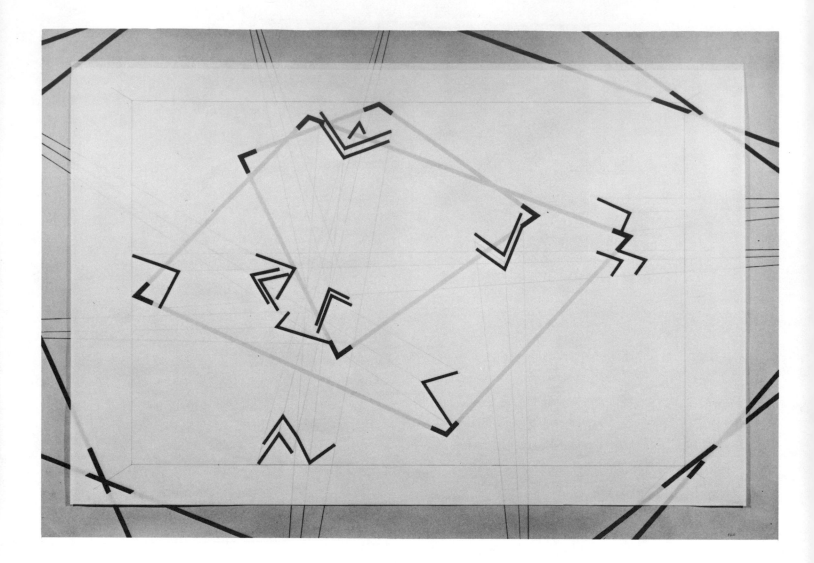

101. BARRY LE VA, *Installation Study for Any Rectangular Space: Accumulated Vision: Boundaries Designated (Configurations Indicated)*, 1977

Ink and pencil on construction and tracing paper, 42 x 62½ (106.6 x 158.8). The List Purchase Fund, 77.71.

102. WILLIAM T. WILEY, *Nothing Conforms*, 1978

Watercolor on paper, 29½ x 22½ (76.5 x 57.2). Neysa McMein Purchase Award (and purchase), 79.25.

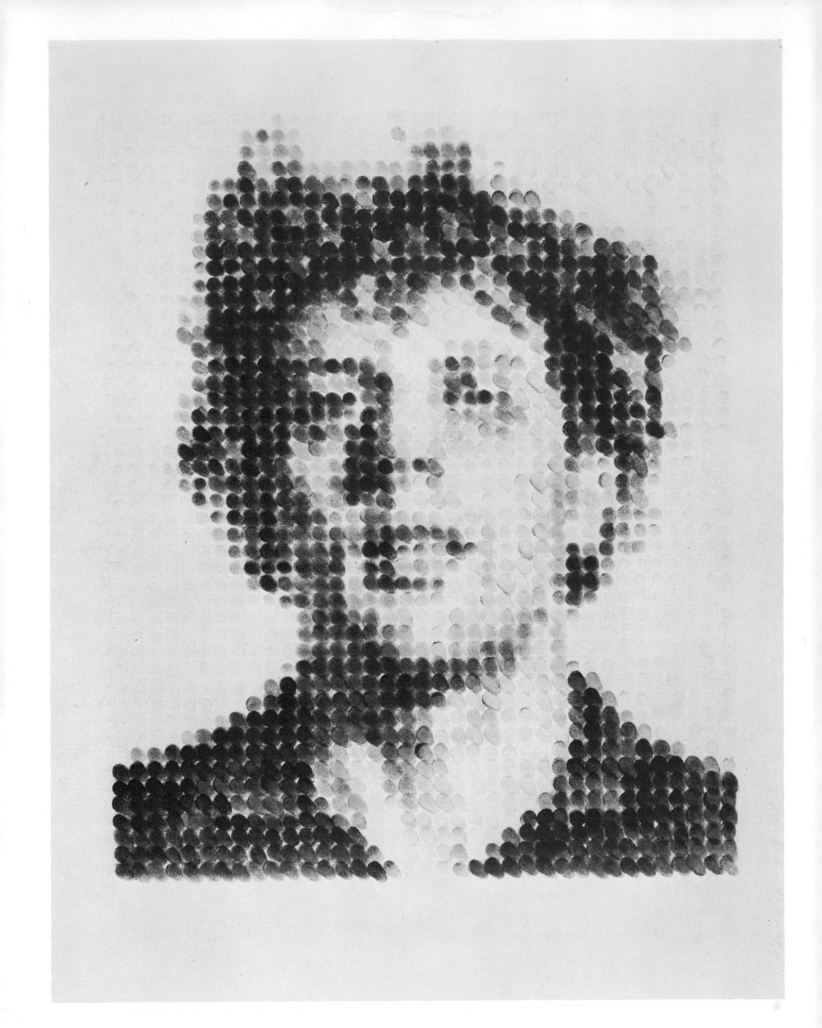

103. CHUCK CLOSE, *Phil/Fingerprint II*, 1978
Stamp-pad ink and pencil on paper, 29¾ x 22¼ (75.5 x 56.5). Anonymous gift, 78.55.

104. H. C. WESTERMANN, *The Sweetest Flower*, 1978

Watercolor on paper, 22⅛ x 31 (56.3 x 78.7). Gift of the Lauder Foundation—Drawing Fund, 78.102.

COMMENTARY

Each work has been supplied with a "Bibliography and Exhibitions" list incorporating books, articles, exhibition catalogues and references to exhibitions having no accompanying publication. The author's catalogues of Whitney Museum drawing exhibitions are cited in shortened form, as follows: Paul Cummings, *20th Century American Drawings: Five Years of Acquisitions* (New York: Whitney Museum of American Art, 1978), as Cummings, *Acquisitions*; Paul Cummings, *Twentieth-Century Drawings from the Whitney Museum of American Art* (New York: Whitney Museum of American Art, 1979), unpaginated, as Cummings, *Drawings*. Page numbers in books and catalogues indicate a specific reference to the drawing in question.

The dimensions of each drawing are given first in inches, then in centimeters, and indicate sheet size; height precedes width. The accession number of a work refers to the year of acquisition and, after a decimal point, to the sequence of its addition to the Permanent Collection during that year. For example, 58.9 means the work was the ninth work acquired in 1958. Promised gifts are noted with the letter P and the order of the two figures is reversed.

1. GEORGE LUKS
Williamsport, Pa., 1867–New York City, 1933

Maurice Prendergast, c. 1904
Pencil on paper, 10 x 6¾ (25.4 x 17.2). Unsigned. Gift of Mr. and Mrs. Edward W. Root, 42.38.

BIBLIOGRAPHY AND EXHIBITIONS: Benjamin de Casseres, "The Fantastic George Luks," *New York Herald Tribune*, September 19, 1933, p. 11. *Catalog of an Exhibition of the Work of George Benjamin Luks*, texts by Arthur F. Egner, John Sloan, Lloyd Goodrich, Benjamin de Casseres, Guy Pène du Bois (Newark, N.J.: The Newark Museum, 1934). Ira Glackens and Joseph S. Trovato, *George Luks*, exhibition catalogue (Utica, N.Y.: Munson-Williams-Proctor Institute, 1973). Mahonri Sharp Young, *The Eight* (New York: Watson-Guptill Publications, 1973).

George Luks, a provocative teacher, also worked as an illustrator. He produced numerous small pencil drawings of street scenes, interiors and occasionally portraits, such as that of his fellow artist Maurice Prendergast. Both Luks and Prendergast were members of The Eight, a group of artists who joined together in the early years of this century in opposition to the conservative academicism of American art. By capturing a likeness and suggesting the subject's personality through forcefully drawn, tight hatching, Luks demonstrates The Eight's rejection of idealism and the group's espousal of journalistic realism. In this serious mood, Luks establishes his darker tones in lines of unequivocal strength, allowing the luminosity of the page to render the highlights. The variety in the length, value, texture and movement of each line sustains our interest.

2. EDWARD HOPPER
Nyack, N.Y., 1882–New York City, 1967

Dome, 1906–7 or 1909
Conté, wash, charcoal and pencil on paper, 21⅜ x 19⅞ (54.5 x 50.5). Unsigned. Bequest of Josephine N. Hopper, 70.1434.

BIBLIOGRAPHY AND EXHIBITIONS: Alfred H. Barr, Jr., *Edward Hopper: Retrospective Exhibition* (New York: The Museum of Modern Art, 1933). Lloyd Goodrich, *Edward Hopper* (Harmondsworth, England: Penguin Books, 1949). Lloyd Goodrich, *Edward Hopper Retrospective Exhibition* (New York: Whitney Museum of American Art, 1950). Lloyd Goodrich, *Edward Hopper*, exhibition catalogue (New York: Whitney Museum of American Art, 1964). Lloyd Goodrich, *Edward Hopper: Selections from the Hopper Bequest to the Whitney Museum of American Art* (New York: Whitney Museum of American Art, 1971). Gail Levin, *Edward Hopper: The Art and the Artist*, exhibition catalogue (New York: W. W. Norton & Company in association with the Whitney Museum of American Art, 1980), pl. 87.

Like so many Americans before him, Edward Hopper traveled to Europe to enrich his art education. In Paris in 1906–7 and again in 1909 and 1910, he worked outdoors, developing his innate responses to architectural structures and studying the play of light on buildings. "The most exact

transcription possible of my most intimate impressions of nature" was his stated aim. The light in Paris "was different from anything I had ever known. The shadows were luminous—more reflected light. Even under the bridges. I've always been interested in light, more than most contemporary painters." Hopper established the outlines of his buildings with a soft, running line, separating the rooftops from the hard light of the sky. Within the huge bulk of these architectural forms are delicate suggestions of the windows and rooftops of smaller buildings. This is an extraordinary study in the use of varied black textures to set a mood and thereby to present us with the artist's gloomy feelings about the City of Light. Carved from a block of closed darkness, this weighty, bulking shape presages another side of Hopper soon to emerge.

3. GLENN O. COLEMAN
 Springfield, Oh., 1887–Long Beach, N.Y., 1932

Street Bathers, c. 1906
Crayon on paper, 11 x 15¾ (28 x 40). Signed l.r.: Glenn O. Coleman. Purchase, 32.44.

BIBLIOGRAPHY AND EXHIBITIONS: C. Adolph Glassgold, *Glenn O. Coleman*, American Artists Series (New York: Whitney Museum of American Art, 1932). Elizabeth McCausland, "Paintings of Manhattan by Late Glenn Coleman," *Springfield* [Ohio] *Sunday Union and Republican*, March 23, 1941, p. 6e. Cummings, *Drawings*.

Among the most popular and influential artists at the turn of the century were newspaper and magazine illustrators, although their glory was soon to be supplanted by the bland, ubiquitous and anonymous photograph. Glenn O. Coleman was a draftsman whose selections of subject matter and technique were often influenced by illustrators. There is a naïve charm in this fine, humorous drawing of urban street life. The artist's tendency to generalize individual features obscures specific personalities. Not as keen an observer as Hopper, nor as commanding in his line, Coleman continued a tradition based on illustration rather than invent a new one.

4. MARSDEN HARTLEY
 Lewiston, Me., 1877–Ellsworth, Me., 1943

Sawing Wood, c. 1908
Pencil on paper, 12 x 8⅞ (30.5 x 22.5). Signed l.r.: ⓂⒽ. Gift of Mr. and Mrs. Walter Fillin, 77.39.

BIBLIOGRAPHY AND EXHIBITIONS: M. Knoedler & Co. and Paul Rosenberg & Co., New York, "Drawings and Paintings by Marsden Hartley," December 11–30, 1944. Columbus Gallery of Fine Arts, Columbus, Ohio, "Marsden Hartley Drawings," April 8–30, 1946. Elizabeth McCausland, *Marsden Hartley* (Minneapolis, Minn.: University of Minnesota Press, 1952). William J. Mitchell, *Ninety-Nine Drawings by Marsden Hartley*, exhibition catalogue (Washington, D. C.: Smithsonian Institution Traveling Exhibition Service, 1970). H. Harvard Arnason, *Marsden Hartley, 1877–1943*, exhibition catalogue (Greenvale, N.Y.: C. W. Post Art Gallery, 1977). Cummings, *Acquisitions*, p. 26. Cummings, *Drawings*. Barbara Haskell, *Marsden Hartley*, exhibition catalogue (New York: Whitney Museum of American Art in association with New York University Press, 1980).

In the autumn of 1908, Marsden Hartley produced a series of drawings depicting woodcutting scenes, using a hooked line derived from the short, rapid brushstroke developed by the Impressionists. This very brusque modern drawing, which rejects the traditional plasticity of the continuous tonal surface and the silhouette line, nonetheless offers a cohesive plastic image. In the shallow space created here, short lines of varied tone are energetically strewn across the page, suggesting the effects of snow or motion or the repetitiveness of labor. The tonal and textural modulations within each stroke demonstrate variety in the speed and pressure of application, thereby enlivening the page.

5. ABRAHAM WALKOWITZ
 Tyumen, Russia, 1878–Brooklyn, N.Y., 1965

Isadora Duncan, n.d.
Watercolor and ink on paper, 12¹⁵⁄₁₆ x 8½ (32.9 x 21.6). Signed l.l.: A. Walkowitz. Gift of Mr. and Mrs. Benjamin Weiss, 78.15.

BIBLIOGRAPHY AND EXHIBITIONS: *One Hundred Drawings by Abraham Walkowitz*, texts by Henry McBride, John Weichsel, Charles Vildrac, Willard Huntington Wright (New York: B. W. Huebsch, 1925). Abraham Walkowitz, *Isadora Duncan in Her Dances*, texts by Maria Theresa, Carl Van Vechten, Mary Fanton Roberts, Shaemas O'Sheel, Arnold Genthe (Girard, Kans.: Haldeman-Julius Publications, 1945). Isaac Lichtenstein, *Ghetto-Motifs: Abraham Walkowitz* (New York: Machmadim Art Editions, 1946). *Art from Life to Life by Abraham Walkowitz*, texts by Walter Pach, Bernard Myers, Carl Van Vechten (Girard, Kans.: Haldeman-Julius Publications, 1951). Martica Sawin, *Abraham Walkowitz, 1878–1965* (Salt Lake City, Ut.: Utah Museum of Fine Arts, University of Utah, 1975). Cummings, *Acquisitions*, pp. 49, 60.

Obsession frequently stimulates the artist to greater invention, but sometimes he becomes catatonic before his Muse—as Abraham Walkowitz did after seeing Isadora Duncan dance in Paris in 1906–7. From then on, the artist remained bewitched by her simple, fleshly dances, which he interpreted in several hundred drawings produced during the next sixty years. He soon forsook Isadora's facial characteristics and the image became just the echo of a dream revisited. Walkowitz's flaccid lines move gently over the page, exploring the icon of a remembered experience rather than a specific personality. His use of a wash of watercolor brings color to the page, defining the background and costume. The lyrical charm of his drawings delights us and almost belies his youthful skills as a knowl-

edgeable draftsman, although evidence of that talent remains in the modeling and maintenance of proportion.

6. ELIE NADELMAN
Warsaw, Poland, 1882–New York City, 1946

Standing Figure, Draped, 1910
Ink on paper, 15¾ x 9¾ (40 x 24.8). Signed u.r.: Elie Nadelman. Richard and Dorothy Rodgers Fund (and purchase), 76.1.

BIBLIOGRAPHY AND EXHIBITIONS: William Murrell, ed., *Elie Nadelman*, Younger Artists Series (Woodstock, N.Y.: William M. Fisher, 1923). Lincoln Kirstein, *Elie Nadelman Drawings* (New York: Hacker Art Books, 1970). Lincoln Kirstein, *Elie Nadelman* (New York: The Eakins Press, 1973). John I. H. Baur, *The Sculpture and Drawings of Elie Nadelman*, exhibition catalogue (New York: Whitney Museum of American Art, 1975). Cummings, *Acquisitions*, p. 36. Cummings, *Drawings*.

Elie Nadelman arrived in the United States in 1914, age thirty-two, destined to become one of the most accomplished decorative sculptors of the twentieth century. He stated a preference for the freshness of the curved line over the Cubist straight line because, when the arcs were used in opposition, they produced harmony and equilibrium. The bold arcs that serve as his contours remind us of the tapered line employed in reproductive engravings. There is a sense of command in these external, free-swinging arcs that contain the delicate, short hooked lines which coalesce into planes to define shadows, figure and drapery. In addition, the lines stimulate rhythms within the smaller areas and insinuate a potential bronze surface. The suggestion of movement is strengthened because the figure is caught in the act of taking a step. This is a typical Nadelman pen drawing—refined, stylish and decorative: drawing remains the artist's abstract comment on form rather than the investigation of an individual.

7. EVERETT SHINN
Woodstown, N.J., 1876–New York City, 1953

Under the Elevated, n.d.
Charcoal and pastel on paper, 21¼ x 27 (54 x 68.6). Signed l.r.: E. Shinn. Gift of Mr. and Mrs. Arthur G. Altschul, 71.230.

BIBLIOGRAPHY AND EXHIBITIONS: Virginia E. Lewis, *Everett Shinn, 1876–1953* (Pittsburgh, Pa.: University of Pittsburgh, 1959). *Everett Shinn, 1876–1953*, exhibition catalogue, texts by Edith DeShazo, Charles T. Henry, Ira Glackens, Bennard B. Perlman (Trenton, N.J.: New Jersey State Museum, 1973). Mahonri Sharp Young, *The Eight* (New York: Watson-Guptill Publications, 1973). Edith DeShazo, *Everett Shinn, 1876–1953* (New York: Clarkson N. Potter, 1974).

Writer, theatrical personality, illustrator and bon vivant, Shinn drew in a variety of styles. The one seen here is less permeated than the others by eighteenth-century French influences. His straight, quickly applied lines contrast sharply with Coleman's soft, rounded shapes, although both styles represent viable positions at the same historical moment. Shinn's image seems an edited version of a snapshot, and his selectivity in stressing or rejecting elements—an impossibility for the camera's undifferentiating eye—increases the psychological drama acted out by the figures. Shinn's intelligent, skillfully executed drawings always catch the eye, whatever our interest in his content, subject or technique.

8. ARTHUR G. DOVE
Canandaigua, N.Y., 1880–Centerport, N.Y., 1946

Abstraction, Number 2, c. 1911
Charcoal on paper, 20⅝ x 17½ (52.6 x 44.5). Unsigned. Purchase, 61.50.

BIBLIOGRAPHY AND EXHIBITIONS: *Arthur G. Dove, 1880–1946: A Retrospective Exhibition* (Ithaca, N.Y.: Andrew Dickson White Museum of Art and Cornell University, 1954). Frederick S. Wight, *Arthur G. Dove* (Berkeley, Calif., University of California Press, 1958). Barbara Haskell, *Arthur Dove*, exhibition catalogue (Boston, Mass.: New York Graphic Society for the San Francisco Museum of Art, 1974).

Dove went abroad for eighteen months from 1907 to the autumn of 1909, when he returned to New York City. In Europe, he painted in vivid Fauve colors and exhibited at the Salon d'Automne in 1908 and 1909. Among the first Americans to transform sensuous responses to nature into abstract compositions, Dove evolved a conceptual position that later led him toward symbolized abstraction. Because the artist's experience is so clearly manifest in his work, one learns more about Dove than about nature by studying his art. He rejected the refined skills of commercial art, in which he had been trained, and searched instead for a graphic expression that would replicate his internal experiences. His radiant, forceful lines, with their Futurist implications, persisted for another two decades. The bold forms, dynamic designs and the use of charcoal as a hard line contrasted with a soft tonal wash are important features of Dove's work. Dove impresses us through the enigmatic transformation of his felt responses.

9. WILLIAM ZORACH
Eurburg, Lithuania, 1887–Bath, Me., 1966

Nevada Falls, Yosemite Valley, 1920
Pencil on paper, 18¾ x 11⅞ (47.6 x 30.2). Signed l.r.: William Zorach 1920. Inscribed l.l.: Nevada Falls Yosemite. Anonymous gift, 59.40.

BIBLIOGRAPHY AND EXHIBITIONS: John I. H. Baur, *William Zorach*, exhibition catalogue (New York: Frederick A. Praeger for the Whitney Museum of American Art, 1959). Donelson F. Hoopes, *William Zorach: Paintings, Watercolors, and Drawings, 1911–1922*, exhibition catalogue (Brooklyn, N.Y.: The Brooklyn Museum, 1968).

Before he became a sculptor, Zorach was a painter and watercolorist influenced by the modern tendencies he had discovered during a trip to Paris in 1910–11. In the summer of 1920, he visited Yosemite National Park. There he completed a series of small drawings and watercolors of the waterfalls and mountains and experimented with the use of a line not unlike Modigliani's, though rather more abrupt. The major forms of the great landmark are set out in rhythmic lines flowing freely across the page, and occasionally touched with darker tones for balance and definition reminiscent of the Fauve or Cubist palettes. The unpretentious charm of the delicate, assured lines that appear in these Sierra Madre works manifests the simplest and most abstract expression of this artist. The sense of scale, the falling water and the exuberant design belie the modest size of the drawing.

10. ARTHUR B. DAVIES
 Utica, N.Y., 1862–New York City, 1928

Crouching Nude, Number 1, n.d.
Chalk and charcoal on paper, 12¼ x 9⅝ (31.1 x 24.4).
Signed l.l.: Arthur B. Davies. Purchase, 31.516.

BIBLIOGRAPHY AND EXHIBITIONS: *Arthur B. Davies: Essays on the Man and His Art*, texts by Duncan Phillips, Dwight Williams, Royal Cortissoz, Frank Jewett Mather, Jr., Edward W. Root, Gustavus A. Eisen (Washington, D.C.: Phillips Memorial Gallery in association with Riverside Press, 1924). *Catalogue of a Memorial Exhibition of the Works of Arthur B. Davies* (New York: The Metropolitan Museum of Art, 1930). Martin S. Ackerman and Diane L. Ackerman, eds., *Arthur B. Davies: Essays on His Art*, texts by Dwight Williams, Royal Cortissoz, Frank Jewett Mather, Jr. (New York: Arco Publishing Company, 1974).

Arthur B. Davies, the major figure in the organization of the Armory Show of 1913, was a Romantic painter of mythological scenes, unicorns and damsels set in the greensward of a peaceful kingdom. Davies produced many drawings that relate generally to the subject matter of his paintings. This nude female figure circumscribed in charcoal is enriched with white chalk which sets the tonal values of the musculature and gives the figure a warm substantiality. Chalk lightly rubbed on the surface modulates the form and its light tone irradiates the figure. An erotic charm pervades Davies' figures and in this drawing the individualized treatment of the facial features and torso suggests a specific personality. The fullness of the figure demonstrates what Royal Cortissoz noted is Davies' interest in the classical Greek treatment of the figure and in the theory of "inhalation," which is supposed to animate the figure. The slightly turned head and the raised arms, poised as if in mid-gesture, also imply movement.

11. JOSEPH STELLA
 Muro Lucano, Italy, 1877–New York City, 1946

Louis Eilshemius, c. 1920
Pencil on paper, 28⅜ x 21⅝ (72.1 x 54.9). Signed l.r.: Joseph Stella. Gift of Gertrude Vanderbilt Whitney, 31.581.

BIBLIOGRAPHY AND EXHIBITIONS: William H. Gerdts, *Drawings of Joseph Stella* (Newark, N.J.: Rabin & Kruger Gallery, 1962). The American Federation of Arts, New York, "Self-Portraits and Portraits," October 1962–May 1963. John I. H. Baur, *Joseph Stella*, exhibition catalogue (New York: Whitney Museum of American Art in association with Shorewood Publications, 1963). Irma B. Jaffe, *Joseph Stella* (Cambridge, Mass.: Harvard University Press, 1970). John I. H. Baur, *Joseph Stella* (New York. Praeger Publishers, 1971).

Joseph Stella, trained in the academic drawing methods of turn-of-the-century Italy, continued this old tradition into the first quarter of the twentieth century in this profile portrait of his friend, the painter Louis Eilshemius, drawn about 1920. The image, centered on the page, is constructed with a definite silhouette outline, careful hatching, and the effective use of the sheet for highlights. Stella grasped a likeness easily. The artist's considerable skills are demonstrated in the selectivity of his eye, the control of his hand and the judicious application of materials. Stella's ability to suggest the semblance of flesh is accomplished by subtle shifts of tonal emphasis over the delicate surface. The drawing's clarity reminds one of a photographic image, but it is more powerful because of the artist's selective eye.

12. EDWARD HOPPER
 Nyack, N.Y., 1882–New York City, 1967

Study for *Evening Wind*, 1921
Conté and charcoal on paper, 10 x 13¹⁵⁄₁₆ (25.4 x 35.4).
Signed l.l.: Edward Hopper to my wife Jo. Bequest of Josephine N. Hopper, 70.343.

BIBLIOGRAPHY AND EXHIBITIONS: Alfred H. Barr, Jr., *Edward Hopper: Retrospective Exhibition* (New York: The Museum of Modern Art, 1933). Lloyd Goodrich, *Edward Hopper* (Harmondsworth, England: Penguin Books, 1949). Lloyd Goodrich, *Edward Hopper Retrospective Exhibition* (New York: Whitney Museum of American Art, 1950). Lloyd Goodrich, *Edward Hopper*, exhibition catalogue (New York: Whitney Museum of American Art, 1964). Lloyd Goodrich, *Edward Hopper: Selections from the Hopper Bequest to the Whitney Museum of American Art* (New York: Whitney Museum of American Art, 1971). Gail Levin, *Edward Hopper: The Complete Prints,* exhibition catalogue (New York: W. W. Norton & Company in association with the Whitney Museum of American Art, 1979), pl. 78. Gail Levin, *Edward Hopper: The Art and the Artist*, exhibition catalogue (New York: W. W. Norton & Company in association with the Whitney Museum of American Art, 1980.

It has been suggested by Alfred H. Barr, Jr., that this drawing and the print for which it is a study were inspired by a work Hopper might have seen and admired in the Armory Show: John Sloan's etching *Night Windows*, a view

of a man seated on a tenement roof watching a woman undressing in a building across the way while, below him, his wife hangs out the laundry. If this is so, the two artists' most obvious affinity was their interest in voyeurism.

Hopper's drawings reflect the efficiency that marked his commercial art, though the humanistic investigations in his fine art were more profound. The rigid architectural elements contrast with the soft forms of the woman's body, the bed clothes and the billowing curtain. Hopper always had difficulty drawing the nude female figure; he seems to have recoiled before woman's polymorphous nature, preferring the rigid forms of architecture or the varied, less pliable forms of nature. The woman, whose attention is caught by the curtains billowing inside the room, turns in recognition of what may be the arrival of Zeus, that most famous of nocturnal visitors, in his guise as the evening wind.

13. YASUO KUNIYOSHI
Okayama, Japan, 1889–New York City, 1953

Farmer's Daughter with Three Cows, 1922
Ink on paper, 12¾ x 18¾ (32.4 x 47.7). Signed l.l.: Yasuo Kuniyoshi 22. Gift of Mrs. Edith Gregor Halpert, 57.1.

BIBLIOGRAPHY AND EXHIBITIONS: William Murrell, *Yasuo Kuniyoshi*, Younger Artists Series (Woodstock, N.Y.: William M. Fisher, 1922). *Yasuo Kuniyoshi* (New York: American Artists Group, 1945). Lloyd Goodrich, *Yasuo Kuniyoshi*, exhibition catalogue (New York: The Macmillan Company for the Whitney Museum of American Art, 1948). Asuo Imaizumi and Lloyd Goodrich, *Kuniyoshi*, exhibition catalogue (Tokyo: The National Museum of Modern Art, 1954). Roy C. Craven and Lloyd Goodrich, *Yasuo Kuniyoshi*, exhibition catalogue (Gainesville, Fla.: University Gallery, University of Florida, 1969). *Yasuo Kuniyoshi, 1889–1953*, exhibition catalogue, texts by Donald B. Goodall, Paul Jenkins, Alexander Brook, Hideo Tomiyama (Austin, Tex.: University Art Museum, University of Texas, 1975). Cummings, *Drawings*.

Jules Pascin, the French painter who resided in New York from 1914 to 1928, exerted a sustaining influence on a generation of American artists—among them his friend Yasuo Kuniyoshi, whose charming ink drawing of 1922 depicts a dairy maid and her charges. Born, according to the Japanese calendar, in the year of the cow, Kuniyoshi stated that his fate was influenced by the bovine world. Although he thought cows were both decorative and ugly, for years he nevertheless painted them. Kuniyoshi was a friend of Hamilton Easter Field, the first important collector of American folk art. Those often crude but charming creations manifest some of the same naïve charm as this ink drawing. Starting from the visual facts before him, Kuniyoshi would then work away from his subject, thereby combining reality and imagination. This delicate drawing, in which ink is employed in both a linear and a painterly way, was made in the year of the artist's first one-man exhibition, when he was twenty-nine years old; it does not foretell the transformation that would come later in life.

Kuniyoshi's 1952 drawing *Juggler* (58), executed after World War II had inflicted many inhumanities on him, is a dramatic contrast to this early work.

14. LOUIS LOZOWICK
Ludvinovka, Russia, 1892–South Orange, N.J., 1973

New York, c. 1923
Carbon pencil on paper 12½ x 10 (31.7 x 25.4). Signed l.l.: Louis Lozowick. Richard and Dorothy Rodgers Fund, 77.15.

BIBLIOGRAPHY AND EXHIBITIONS: William C. Lipke, *Abstraction and Realism, 1923–1943: Paintings, Drawings, and Lithographs of Louis Lozowick*, exhibition catalogue (Burlington, Vt.: Robert Hull Fleming Museum, University of Vermont, 1971). John Bowlt, *Louis Lozowick, American Precisionist: Retrospective*, exhibition catalogue (Long Beach, Calif.: Long Beach Museum of Art, 1978). Cummings, *Acquisitions*, p. 44. Cummings, *Drawings*.

Lozowick emigrated from Russia to the United States as a teenager. Before returning to Europe in 1920 for four years, he traveled across America to gain a sense of the country and its people. The results of this journey appeared in a series of paintings, made from memory, representing the artist's impressions of the cities he visited. New York was the subject of a painting, a drawing and a lithograph.

Lozowick reshapes the bridges and skyscrapers into rhythmic patterns that evoke the motion and energy of city life. The image he offers us is his depiction of a felt response to the metropolitan stimulus rather than an attempt at a realistic portrayal of architecture, bridges or streets. The pictorial elements move through the drawing's foreground and plunge into the rising wall of vertical forms that represents the city's towers. A wide range of tones introduces light, space and depth; line is stated as edge. In 1923, when Lozowick issued a lithograph based on the design of this drawing, he reversed the tonal values, making the lights darks. For a brief moment, Lozowick was one of the most modern American artists.

15. ROCKWELL KENT
Tarrytown Heights, N.Y., 1882–Plattsburg, N.Y., 1971

The Kathleen, 1923
Ink on paper, 6½ x 7 (16.5 x 17.8). Unsigned. Gift of Gertrude Vanderbilt Whitney, 31.548.

BIBLIOGRAPHY AND EXHIBITIONS: Merle Armitage, *Rockwell Kent* (New York: Alfred A. Knopf, 1932). *Rockwell Kent: The Early Years*, exhibition catalogue, texts by Rockwell Kent, Richard V. West and Carl Zigrosser (Brunswick, Me.: Bowdoin College Museum of Art, 1969). Mahonri Sharp Young, *American Realists: Homer to Hopper* (New York: Watson-Guptill Publications, 1977). Cummings, *Drawings*.

The drawings of Rockwell Kent have influenced generations of American artists and illustrators since their first

appearance in his illustrated travel books, advertisements and the humorous works signed "Hogarth, Jr.," published in *Vanity Fair.* The balanced, reserved quality of the drawings reflects Kent's training as an architect; their painterliness recalls his studies with William Merritt Chase; the sense of form reminds one of his profound admiration for William Blake. Kent wanted his work to demonstrate "how beautiful I've found the world to be." This drawing, made with brush and ink during travels through the Strait of Magellan, was published in the artist's book *Voyaging.* The soft line laid down by the brush is gently varied in width, its tonal densities displaying the multiple qualities of black's "color." The varying spaces between the lines in the hatching introduce light and shadow for modeling. The resulting graphic variety defines the images and enhances interest in the work.

16. JAN MATULKA
 Prague, Czechoslovakia, 1890–Jackson Heights, N.Y., 1972

Cubist Still Life with Guitar, c. 1923
Conté and pencil on paper, 14⅝ x 11⅝ (36.9 x 29.8). Signed l.l.: Matulka. Lawrence H. Bloedel Bequest, 77.1.32.

BIBLIOGRAPHY AND EXHIBITIONS: Cummings, *Acquisitions,* p. 34. *Jan Matulka, 1890–1972,* exhibition catalogue, texts by Patterson Sims, Merry A. Foresta, Dorothy Dehner, Janet A. Flint (Washington, D.C.: Smithsonian Institution Press for the National Collection of Fine Arts and the Whitney Museum of American Art, 1980), p. 47.

A student of Hans Hofmann in Munich, Jan Matulka taught briefly at the Art Students League, where he expounded the concepts of Cubism and modernism. In this still life with a guitar, he has transformed the light, delicate Cubist facet by enlargement and simplification in his move toward abstraction. These enlarged, simplified areas increase one's sensation of depth and suggest Constructivist influences. Matulka was concerned with building a unified composition derived from elements of the still life. In this image, he uses a simple, nearly impersonal drawing gesture, reducing the indications of personality usually communicated by the line. What he states is his ability to conceptualize and to render his ideas without reliance upon the skillful gesture of the hand alone.

17. PEGGY BACON
 b. Ridgefield, Conn., 1895

Blessed Damozel, 1925
Pencil on paper, 18 x 14⅝ (45.7 x 37.1). Signed c.r.: Peggy Bacon 1925. Gift of Gertrude Vanderbilt Whitney, 31.481.

BIBLIOGRAPHY AND EXHIBITIONS: William Murrell, *Peggy Bacon,* Younger Artists Series (Woodstock, N.Y.: William M. Fisher, 1922). Roberta K. Tarbell, *Peggy Bacon: Personalities and Places,* exhibition catalogue (Washington, D.C.: Smithsonian Institution Press for the National Collection of Fine Arts, 1975). Cummings, *Drawings.*

One of the few successful women satirists of twentieth-century American life, Peggy Bacon was associated with a group of artists who emerged from the Art Students League just after World War I. *Blessed Damozel* is a classic image of tough, resilient, righteous spinsterhood. The drawing quality reflects Bacon's and the group's interest in their friend Yasuo Kuniyoshi's work, in folk art and in the tonalities of paintings by Renoir and Pascin. This survivor surrounded by her friends, the wild flowers and the animals, confronts the viewer through steel-rimmed glasses. The accuracy of the delineated fragments heightens the fantasy. Visual interest is sustained by the use of tonal forms contrasted with line forms. Rejecting Cubist advances, Bacon and her friends subscribed to the last Romantic vestiges of the by-then genteel tradition of Impressionism.

18. EDWARD HOPPER
 Nyack, N.Y., 1882–New York City, 1967

Light at Two Lights, 1927
Watercolor on paper, 13¹⁵⁄₁₆ x 20 (35.4 x 50.8). Signed l.l.: Edward Hopper for J. H. Bequest of Josephine N. Hopper, 70.1094.

BIBLIOGRAPHY AND EXHIBITIONS: Alfred H. Barr, Jr., *Edward Hopper: Retrospective Exhibition* (New York: The Museum of Modern Art, 1933). Lloyd Goodrich, *Edward Hopper* (Harmondsworth, England: Penguin Books, 1949). Lloyd Goodrich, *Edward Hopper Retrospective Exhibition* (New York: Whitney Museum of American Art, 1950). Lloyd Goodrich, *Edward Hopper,* exhibition catalogue (New York: Whitney Museum of American Art, 1964). Lloyd Goodrich, *Edward Hopper: Selections from the Hopper Bequest to the Whitney Museum of American Art* (New York: Whitney Museum of American Art, 1971). Gail Levin, *Edward Hopper: The Art and the Artist,* exhibition catalogue (New York: W. W. Norton & Company in association with the Whitney Museum of American Art, 1980), pl. 190.

A watercolor from Edward Hopper's middle period, *Light at Two Lights* depicts a place in Maine that Hopper frequently visited in summer. In contrast with the earlier drawing (12), the present work shows the artist's use of the watercolor brush to designate both edges and surfaces. The large shapes of the house, the lighthouse, and the cliff are all drawn with thoughtful control. Watercolor often falls into the purview of painting because of its plasticity in stating either line or tonal wash.

Hopper supported himself for years by making commercial art, an activity he abhorred, yet one in which he was skilled, though not inventive. For his fine art, he fought these commercial skills, whereas a less talented individual might have succumbed to their formulas. This is especially apparent when it meant adapting observed reality to the needs of the picture. The persistent dark mood that is such a basic part of Hopper's expression is exemplified in the flat, shadowed tones of the house and the hillside. The weight of the colors in the lower portion of the picture is in sharp contrast to the open, bright sky. The search for

light and atmosphere constantly aroused the artist's attention. Nevertheless, foreboding colors often mark his spirit, and joy is rarely present in the work of this lonely American.

19. THOMAS HART BENTON
Neosho, Mo., 1889–Kansas City, Mo., 1975

Logging Train, 1928
Ink on paper, 8¾ x 11¾ (22.3 x 29.8). Unsigned. Gift of Gertrude Vanderbilt Whitney, 31.491.

BIBLIOGRAPHY AND EXHIBITIONS: Thomas Hart Benton, *Benton Drawings* (Columbia, Mo.: University of Missouri Press, 1968). Thomas Hart Benton, *An American in Art: A Professional and Technical Autobiography* (Lawrence, Kans.: University Press of Kansas, 1969). Matthew Baigell, *Thomas Hart Benton* (New York: Harry N. Abrams, 1974). Cummings, *Drawings*.

As a mature artist, Benton rebelled against the modernist commitments of his youth. Cartoon sketches made during his Navy service in World War I had brought him longed-for approbation. Thereafter, his drawings became mannered and stylized. For ten years, beginning in 1924, Benton traveled the country, sketching the world of the rural worker and the poor. During this time, he evolved a practical working method that consisted of making a quick pencil sketch during the day and, in the evening, adding tonal washes and ink lines to define the scene. Although he stated that "every detail of every picture is a thing I myself have seen and drawn," his work seems to have been accomplished by a trained but slovenly hand. For the next several decades, there was little stylistic development. Benton relied upon his formula to set down what he saw in a loose, unconsidered manner or, later in life, in a tight, crabbed line.

20. RAPHAEL SOYER
b. Tombou, Russia, 1899

Sleeping Girl, n.d.
Pencil on paper, 17 x 14 (43.2 x 35.6). Signed l.r.: Raphael Soyer. Gift of Gertrude Vanderbilt Whitney, 31.577.

BIBLIOGRAPHY AND EXHIBITIONS: Lloyd Goodrich, *Raphael Soyer*, exhibition catalogue (New York: Whitney Museum of American Art, 1967). Joseph K. Foster, *Raphael Soyer: Drawings and Watercolors* (New York: Crown Publishers, 1968). Janet Flint, *Raphael Soyer: Drawings and Watercolors*, exhibition catalogue (Washington, D.C.: Smithsonian Institution Press for the National Collection of Fine Arts, 1977).

"The content of my art is people—men, women and children, within their daily setting. I choose to be a realist and a humanist in art," wrote Soyer. The warm, tender ambience that infuses this figure in repose does not distract one from the mass of lines often executed with little concern for their actual purpose. Is their function only to render plasticity, pattern, shape, form, light? The artist chose to develop his concern with amiable subject matter while relying on a graphic syntax established early in his career.

21. GUY PÈNE DU BOIS
Brooklyn, N.Y., 1884–Boston, Mass., 1958

"How long have you been in this lolly-pop business?" 1930
Ink on paper, 11¾ x 8⅝ (29.8 x 21.9). Signed l.r.: Guy Pène du Bois '30. Gift of Gertrude Vanderbilt Whitney, 31.535.

BIBLIOGRAPHY AND EXHIBITIONS: Royal Cortissoz, *Guy Pène du Bois*, American Artists Series (New York: Whitney Museum of American Art, 1931). *Guy Pène du Bois: Painter, Draftsman and Critic* (New York: The Graham Gallery, 1979).

Critic, writer and artist, Guy Pène du Bois studied with William Merritt Chase and the illustrator T. A. Steinlen and at the Académie de la Grande Chaumière, Paris. His literary and social interests prevailed over his commitment to the visual arts; everyone at all social levels was a potential target for his satirizing pen. In this courtroom scene, two successful businessmen—inquisitor and witness—face each other over the profundities of a trivial question. With a few lines, du Bois has established the courtroom furniture and the general dress and station of the men. But it is in the carefully drawn heads and the finely wrought faces of the protagonists that the artist makes his comment. A droopy-eyed witness confronts the bald, bespectacled interrogator.

Du Bois was not concerned with refining his line, other than to have it carry the message and to set the stage. What did interest him were the individualized heads, especially the faces. But to present his point of view effectively, the heads had to be set in an atmosphere of unmodulated forms. The wiry, efficient line is scratchy, and one soon realizes that du Bois knew what he was doing.

22. CHARLES DEMUTH
Lancaster, Pa., 1883–Lancaster, Pa., 1935

Distinguished Air, 1930
Watercolor and pencil on paper, 14 x 12 (35.5 x 30.5). Signed l.r.: C. Demuth 1930. Gift of the Friends of the Whitney Museum of American Art, Charles Simon (and purchase), 68.16.

BIBLIOGRAPHY AND EXHIBITIONS: William Murrell, *Charles Demuth*, American Artists Series (New York: Whitney Museum of American Art, 1931). Andrew Carduff Ritchie, *Charles Demuth*, exhibition catalogue (New York: The Museum of Modern Art, 1950). The Downtown Gallery, New York, "Charles Demuth," May 20–June 7, 1958. Larry Curry, *Eight American Masters of Watercolor*, exhibition catalogue (Los Angeles, Calif.: Los Angeles County Museum of Art, 1968). Emily Farnham, *Charles Demuth: Behind a Laughing Mask* (Norman, Okla.: University of

Oklahoma Press, 1971). Thomas E. Norton, ed., *Homage to Charles Demuth, Still Life Painter of Lancaster*, essays by Alvord L. Eiseman, Sherman E. Lee, Gerald S. Lestz, valedictory by Marsden Hartley (Ephrata, Pa.: Science Press, 1978). Cummings, *Drawings*.

Demuth's *Distinguished Air*, a pencil drawing heightened with watercolor, was inspired by Robert McAlmon's *Distinguished Air: Grim Fairy Tales*, a collection of stories—mostly with homosexual subject matter—published in 1925 in Paris by William Bird. The blatant results of a chance meeting in an art gallery, before a phallic Brancusi, and the psychological implications of interplay between the characters initially distract one from the appreciation of a masterful rendering. The fine pencil line traces the image, while the watercolor, added later, with its carefully controlled edges, defines the forms. The use of mottled color introduces a nonrealistic element. Seemingly casual, each line accomplishes a specific job economically. It sustains the finery and foppery by being endowed with a whimsical reality drawn from the conceits of Demuth's own life.

23. HENRY LEE MCFEE
St. Louis, Mo., 1886–Claremont, Calif., 1953

House Tops, 1931
Pencil on paper, 19⅞ x 16⅞ (50.5 x 42.9). Signed c.r.: McFee. Purchase, 33.76.

BIBLIOGRAPHY AND EXHIBITIONS: Virgil Barker, *Henry Lee McFee*, American Artists Series (New York: Whitney Museum of American Art, 1931). Cummings, *Drawings*.

When artists adapt stylistic conventions, the result is often a loss of inventive power. Cézanne, Cubism and Renoir were once concurrent influences in American art, but American painters, lacking intimate association with the sources of their inspiration, became followers. McFee attempted to synthesize the planes of Cézanne with the continuously tonal surface of Renoir. The short, choppy brushstrokes of the Cubist facet become long tonal striations as they are shorn of their individuality. The merits of this drawing are nevertheless considerable because it represents an accomplished synthetic variant. Cézanne would have retained the individuality of each stroke; McFee, however, accumulated the strokes into clusters to produce tonal planes and a softer image. McFee makes a general statement; Cézanne's line was specific, stronger, more explanatory and thus more revealing.

24. JOHN SLOAN
Lock Haven, Pa., 1871–Hanover, N.H., 1951

Nude, 1931
Pencil on paper, 7⅜ x 9 (18.8 x 23). Signed l.r.: John Sloan '31. Gift of Mrs. John Sloan, 51.42.

BIBLIOGRAPHY AND EXHIBITIONS: A. E. Gallatin, ed., *John Sloan* (New York: E. P. Dutton & Co., 1925). *John Sloan* (New York: American Artists Group, 1945). Lloyd Good-

rich, *John Sloan, 1871–1951*, exhibition catalogue (New York: Whitney Museum of American Art, 1952). Van Wyck Brooks, *John Sloan: A Painter's Life* (New York: E. P. Dutton & Co., 1955). David Scott and E. John Bullard, *John Sloan, 1871–1951*, exhibition catalogue (Washington, D.C.: National Gallery of Art, 1971).

Sloan, a popular printmaker, illustrator of books and teacher at the Art Students League, was also president of the Society of Independent Artists from 1918 through 1942. This life drawing betrays the printmaker's line—spare, even, unmodulated, nonpainterly. Sloan's interest in the nude began in 1931, while he was teaching. The drawings he made during this time were done "to keep a couple of pages ahead of the students." The outline is of primary concern to Sloan in the rendering of the figure; the tonal areas are less well observed and understood. And while the outline proclaims the artist's knowledge, the internal lines in the hatching or crosshatching are often cursorily set down and are strangely directed or misdirected, frequently moving against each other and the shapes they are meant to articulate. The line gives the sensation of having been pushed, like those made by a printmaker.

25. EARL HORTER
Philadelphia, Pa., 1891–Philadelphia, Pa., 1940

The Chrysler Building Under Construction, c. 1931
Ink and watercolor on paper, 20¼ x 14¾ (51.5 x 37.5). Unsigned. Gift of Mrs. William A. Marsteller, 78.17.

BIBLIOGRAPHY AND EXHIBITIONS: Henry C. Pitz, *Earl Horter: Watercolors, Oils, Drawings, Prints*, exhibition catalogue (Philadelphia, Pa.: The Philadelphia Art Alliance, 1954). Henry C. Pitz, "Earl Horter: The Man and His Work," *American Artist*, 20 (April 1956), pp. 20–26+. Cummings, *Acquisitions*, pp. 33, 38. Cummings, *Drawings*.

Horter's *The Chrysler Building Under Construction* of about 1931 is reminiscent of the 1926 lithograph *Delmonico Hotel* by his close friend Charles Sheeler. With its dramatic, jutting perspective forms playing against the sky, Horter's work is an example of Precisionism at its most accomplished. The Precisionists, by simplifying the planes in their paintings, refining the edges within the images, reducing the plastic tonal influence of light and increasing the patterning suggested by their subject, anticipated the hard-edge abstract painting of several decades later. The rigid lines of this geometric structure combine with the mottled, painterly watercolor to establish the visual tensions which accentuate the expressiveness of the drawing.

26. ARSHILE GORKY
Khorkom, Armenia, 1904–Sherman, Conn., 1948

Nighttime, Enigma and Nostalgia, c. 1931–32
Ink on paper, 24 x 31 (61 x 78.7). Unsigned. Promised 50th Anniversary Gift of Mr. and Mrs. Edwin A. Bergman, P.5.79.

BIBLIOGRAPHY AND EXHIBITIONS: Ethel K. Schwabacher,

Arshile Gorky, exhibition catalogue (New York: The Macmillan Company for the Whitney Museum of American Art, 1957). Harold Rosenberg, *Arshile Gorky: The Man, The Time, The Idea* (New York: Horizon Press, 1962). William Chapin Seitz, *Arshile Gorky: Paintings, Drawings, Studies* (New York: The Museum of Modern Art, 1962). Julien Levy, *Arshile Gorky* (New York: Harry N. Abrams, 1966). *Arshile Gorky: Drawings to Paintings*, exhibition catalogue (Austin, Tex.: University Art Museum, University of Texas, 1975).

Arshile Gorky was a draftsman gifted with a natural gestural skill. The ink drawings in his *Nighttime, Enigma and Nostalgia* series were produced while the artist was designing a mural. This drawing of 1931–32 relates to the left section of the tripartite, uncompleted murals. The trine aspect of the murals is reiterated in the major vertical panels of this composition. At this moment in history, Gorky's biomorphic abstraction was, according to William Seitz, in advance of Picasso's accomplishments. Gorky was attempting to synthesize abstract and Surrealist thought by placing his freely drawn biomorphic shapes within the formal geometrics of the panels. The rigid black-ink hatching countermands the loose scribbled lines, which are accumulated into a dense, dark surface that presents strongly contrasting moods. His conviction is felt in the skill and control of the drawn line; he has transformed natural and man-made shapes with unquestioned authority, and in his metamorphosis elicits an experience that provokes both the viewer's intellect and emotions.

27. JOHN MARIN
Rutherford, N.J., 1870–Cape Split, Me., 1953

Region of Brooklyn Bridge Fantasy, 1932
Watercolor on paper, 18¾ x 22¼ (47.6 x 56.5). Signed l.r.: Marin 32. Purchase, 49.8.

BIBLIOGRAPHY AND EXHIBITIONS: *John Marin*, tributes by William Carlos Williams, Duncan Phillips, Dorothy Norman (Berkeley and Los Angeles, Calif.: University of California Press, 1956). Charles E. Buckley, *John Marin in Retrospect*, exhibition catalogue (Washington, D.C.: Corcoran Gallery of Art and the Currier Gallery of Art, 1962). Sheldon Reich, *John Marin Drawings*, exhibition catalogue (Salt Lake City, Ut.: University of Utah Press, 1969). Larry Curry, *John Marin, 1870–1953*, exhibition catalogue (Los Angeles, Calif.: Los Angeles County Museum of Art, 1970). *John Marin* (New York: Holt, Rinehart and Winston, 1976). Cummings, *Drawings*.

In the 1930s, Marin produced only watercolors, among which is the 1932 *Region of Brooklyn Bridge Fantasy*. It strikes one as a collection of images, not unlike snapshots assembled into a collage, suggesting that the artist was responding to his myriad impressions of the city. The image implies the spirit of the city as it might be perceived when one is crossing a bridge, moving into the skyscraper reality. Marin always remained constant to the image before him, even though, as here, when the buildings become emblems, he occasionally adjusted elements of the composition according to the formal needs of the picture. In

contrast to the areas laid in by a soft flowing wet brush are the lines, applied by a smaller dry brush, and the textures and colors, established by scratching through the watercolor into the sheet itself. Marin used line to produce planes and edges or rays of light and motion. He described his sketching method as a "sort of short hand writing," and this fractured, stylized attitude often appears in his work. "Color is life," he said, and he used it to formulate his responses to the sounds and power of nature, forces that also motivated Charles Burchfield, but were expressed by Marin in more intellectual ways. Cubist influence could be suggested by the angled incursions so often found at the pictures' edges. Marin's usual design is controlled by these incursions, which are his adaptations of Cubist compositional methods. Like so many Americans, he too enlarged the subtle Cubist facet by transforming the delicate tesserae into large flat planes.

28. CHARLES SHEELER
Philadelphia, Pa., 1883–Dobbs Ferry, N.Y., 1965

Interior, Bucks County Barn, 1932
Conté on paper, 15 x 18¾ (38.1 x 47.6). Signed l.r.: Sheeler/1932. Purchase, 33.78.

BIBLIOGRAPHY AND EXHIBITIONS: Constance Mayfield Rourke, *Charles Sheeler: Artist in the American Tradition* (New York: Harcourt, Brace & Company, 1938). William Carlos Williams, *Charles Sheeler: Paintings, Drawings, Photographs* (New York: The Museum of Modern Art, 1939). *Charles Sheeler*, exhibition catalogue, texts by Martin Friedman, Bartlett Hayes, Charles Millard (Washington, D.C.: Smithsonian Institution Press for the National Collection of Fine Arts, 1968). John P. Driscoll, *Charles Sheeler: The Works on Paper*, exhibition catalogue (University Park, Pa.: Pennsylvania State University, 1974). Martin Friedman, *Charles Sheeler* (New York: Watson-Guptill Publications, 1975). Cummings, *Drawings*.

Precisionism is defined by the work of Charles Sheeler, its most refined and accomplished exponent. The delicate surfaces result from the skillfully controlled application of the pigment, the carefully delineated edges, the sharp contrasts of light and dark, and the strongly geometric compositions. In *Interior, Bucks County Barn*, the individual crayon strokes coalesce into an accumulation of planes and textures. The extraordinary variety of these textures proclaims the artist's control of his materials and the visual discernment with which he observes each surface to be drawn and then assigns to it a specific tone or texture. Sheeler's orchestration of black and white is an outstanding demonstration of the "colors" obtainable from black. Within the interior of the barn, the source of the artificial light is low, producing shadows that cling to the walls and generate an air of timeless mystery. The effect of this soft light, the moment frozen in time, the hard edges and the compulsive control of the crayon encourage one to observe closely how each object is rendered. One then discovers that the buggy has at least one freestanding wheel, that one piece of farm equipment is described as only a bar of light and that fragments of reality hang in space.

29. ANDREW DASBURG
Paris, 1887–Taos, N.M., 1979

Summer Meadows, 1932–33
Watercolor on paper, 13½ x 21⅜ (34.2 x 54.6). Signed l.r.: Dasburg. Lawrence H. Bloedel Bequest, 77.1.14.

BIBLIOGRAPHY AND EXHIBITIONS: Jerry Bywaters, *Andrew Dasburg*, exhibition catalogue (New York: The American Federation of Arts, 1959). Van Deren Coke, *The Drawings of Andrew Dasburg*, exhibition catalogue (Albuquerque, N.M.: University Art Museum, University of New Mexico, 1966). Cummings, *Acquisitions*, p. 27. Van Deren Coke, *Andrew Dasburg* (Albuquerque, N.M.: University of New Mexico, 1979). Cummings, *Drawings*.

Dasburg freely adapted the angles and layered planes of Cubism, opening them wide in response to the deep space of the Southwest, where he lived for so long. In making this work, Dasburg first lightly sketched his view and later applied the watercolor. Unlike Marin, whose images are contained, Dasburg presents a fragment of nature that one feels continues beyond the dimensions of the page. A lively inventiveness is displayed in the textures of the brush-strokes and in the variety of gestures suggested by this assemblage of short, curved, long, narrow, thin, light or heavy lines, all moving across the page, to indicate motion in the clouds or perspective in the mottled tones of the earth. The rhythmic interplay invested in these curves, arcs and angles plays against the straight, orderly lines.

30. GASTON LACHAISE
Paris, 1882–New York City, 1935

Seated Nude, 1932–35
Pencil on paper, 23¾ x 18 (60.4 x 45.7). Signed l.l.: G. Lachaise. Purchase, 38.45.

BIBLIOGRAPHY AND EXHIBITIONS: Lincoln Kirstein, *Gaston Lachaise: Retrospective Exhibition* (New York: The Museum of Modern Art, 1935). Gerald Nordland, *Gaston Lachaise, 1882–1935: Sculpture and Drawings*, exhibition catalogue (Los Angeles, Calif.: Los Angeles County Museum of Art, 1964). Gerald Nordland, *Gaston Lachaise: The Man and His Work* (New York: George Braziller, 1974).

Drawings by sculptors are generally flat, patterned outlines where little attempt is made to suggest three-dimensionality. To perceive the illusion of objects in space, one's mind must be stimulated by suggestions in the drawing. An outline drawing that successfully conveys a sense of three-dimensionality is Lachaise's *Seated Nude*, a pencil work in the artist's mature style. By changing the pressure on his pencil, Lachaise achieved lines of varying widths and tonal modulations that imply form. Our empathy for this sensuously charged figure is excited by the sinuous lines indicating movement. Lachaise aggrandizes the inspiring image of woman into a symbolic earth-mother-goddess who asserts overwhelming fecundity.

31. WILLIAM GROPPER
New York City, 1897–Manhasset, N.Y., 1977

Farmers' Revolt, 1933
Ink on paper, 16 x 19 (40.6 x 48.3). Signed l.l.: Gropper. Purchase, 33.73.

BIBLIOGRAPHY AND EXHIBITIONS: August L. Freundlich, *William Gropper* (Los Angeles, Calif.: W. Ritchie Press, 1968). *William Gropper: Fifty Years of Drawing, 1921–1971*, exhibition catalogue (New York: A.C.A. Galleries, 1971).

Gropper, often an advocate of aggressive social action, symbolically represents farmers revolting against the invasion of the NRA, a government agency set up in part to regulate their business. The bold design in stark black and white depicts farmers armed with pitchforks, rakes and clubs warding off blackbirds which cry *NRA NRA NRA NRA* as they attack the grain fields. The dry brush was used to fill out the men and the birds; flecks and speckles of ink add to the tactile variety. Gropper wrote about learning to be spontaneous: as a provocative newspaper cartoonist, he had to "knock them out," an attitude demonstrated by the journalistic stance that pervades his work.

32. EDWIN DICKINSON
Seneca Falls, N.Y., 1891–Cape Cod, Mass., 1978

Truro, the Pamet River, 1934
Pencil on paper, 9 x 12 (22.8 x 31.2). Signed l.l.: Helen/Edwin Dickinson/Truro 1934. Gift of the Joseph H. Hirshhorn Collection, 63.55.

BIBLIOGRAPHY AND EXHIBITIONS: Lloyd Goodrich, *The Drawings of Edwin Dickinson* (New Haven, Conn.: Yale University Press, 1963). Lloyd Goodrich, *Edwin Dickinson*, exhibition catalogue (New York: Whitney Museum of American Art, 1965). *Edwin Dickinson: Tribute Exhibition*, texts by Edna M. Lindemann, Thomas W. Leavitt, Frances Dickinson (Buffalo, N.Y.: Burchfield Center, New York State University College, 1977).

Dickinson was a student of William Merritt Chase and C. W. Hawthorne, two highly dissimilar teachers in the early years of this century. Chase was an exponent of vivid bravura painting, Hawthorne of closely valued tonal glazing. Dickinson brought their late nineteenth-century teachings into the last quarter of the twentieth century. Our drawing indicates the lasting influence of Hawthorne in its soft grisaille rendering of river and landscape. Graphite is used for the veils of gray, defined by a hard, dark, outlined edge which gives shape to what could otherwise be perceived as an amorphous mass. The definition of a multivalued tonal area by a thin, brittle line is a device Dickinson used frequently.

33. PAUL CADMUS
b. New York City, 1904

To the Lynching! 1935
Pencil and watercolor on paper, 20½ x 15¾ (52.1 x 40). Signed l.c.: paul cadmus. Purchase, 36.32.

BIBLIOGRAPHY AND EXHIBITIONS: Una E. Johnson, *Paul Cadmus: Prints and Drawings* (Brooklyn, N.Y.: The Brooklyn Museum, 1968), pl. 6. Dickran Tashjian, *William Carlos Williams and the American Scene, 1920–1940*, exhibition catalogue (New York: Whitney Museum of American Art in association with University of California Press, 1978), p. 112. Cummings, *Drawings*.

How much terror can a drawing communicate before it becomes unbearable, or pompous? These writhing figures and bloody images of grotesque emotions display man's primitive, animal nature at its most vicious. The carefully organized confusion of the composition increases the expressive force of Cadmus' outrage at the horror of man, as he rises raging against man himself. These dusty creatures are like the distorted souls of the damned in a medieval representation of hell. The movement in the large, twisting shapes of both horse and men is reinforced by similar rhythms echoed in smaller areas within the composition. The line weaves an unrelenting texture that unifies the picture, while abrupt angles in the composition present an effective counterpoint to the sinuous motion. The scratchy lines accumulate into areas of tone whose effect is dramatically increased by the artist's feeling for light. Constant repetition, a consistent line value and a dynamic composition full of thrusts and counterthrusts further increase the effectiveness of Cadmus' statement.

34. ISABEL BISHOP
b. Cincinnati, Oh., 1902

Waiting, 1935
Ink on paper, 7⅛ x 6 (18.4 x 15.3). Signed l.r.: Isabel Bishop. Purchase, 36.31.

BIBLIOGRAPHY AND EXHIBITIONS: Una E. Johnson, *Isabel Bishop: Prints and Drawings, 1925–1964* (Brooklyn, N.Y.: The Brooklyn Museum, 1964). Martin H. Bush and Sheldon Reich, *Isabel Bishop,* exhibition catalogue (Tucson, Ariz.: University of Arizona Museum of Art, 1974), pl. 68. Karl Lunde, *Isabel Bishop* (New York: Harry N. Abrams, 1975), pl. 99.

This is an image of the Depression years in New York City. A woman, tired but vigilant, waits, seated on a bench with a sleeping child. Bishop's frequently expressed concern with "the nobility of life" is stated through her skill in suggesting a personality, a condition of life and a location. The languid, exploratory lines which barely sketch these two figures "are formed like a diafon from light on shade" (Ezra Pound). The forms are defined by the raw skeins of dark lines which also control the thin ink wash. These assorted jottings compose a tranquil composition that awakens our sympathy for the subject.

35. GRANT WOOD
Anamosa, Iowa, 1892–Iowa City, Iowa, 1942

Study for *Breaking the Prairie,* 1935–39
Colored pencil, chalk and pencil on butcher paper; triptych, 22¾ x 80¼ (57.8 x 203.2) overall. Signed left sheet

l.l. GRANT WOOD 1935; center sheet, at right of quotation GRANT WOOD 1939; right sheet l.r. GRANT WOOD 1936. Promised gift of Mr. and Mrs. George Stoddard, P. 2.76.

BIBLIOGRAPHY AND EXHIBITIONS: Darrell Garwood, *Artist in Iowa: A Life of Grant Wood* (New York: W. W. Norton & Company, 1944). James M. Dennis, *Grant Wood: A Study in American Art and Culture* (New York: Viking Press, 1975). Joan Liffring-Zug, *This is Grant Wood Country* (Davenport, Iowa: Davenport Municipal Art Gallery, 1977). Cummings, *Acquisitions,* pp. 62–63. Dickran Tashjian, *William Carlos Williams and the American Scene, 1920–1940,* exhibition catalogue (New York: Whitney Museum of American Art in association with University of California Press, 1978), p. 126.

Wood's homespun American subject matter sometimes obscures his extraordinarily accomplished drawing. Influenced by Flemish and Dutch draftsmen, he meticulously renders his pictures. Here, the refined hatching and cross-hatching in colored pencil, chalk and graphite produce a surface not unlike that of Seurat. In this carefully balanced horizontal composition, focus is continuously directed toward the central panel. The figures in the wings are turned toward the center and implied arcs swing down from the top outer corners to meet at the lower central portion of the panel, beneath the quote. This major mural study of the 1930s public art movement in America is one of Wood's largest colored drawings.

36. REGINALD MARSH
Paris, 1898–Dorset, Vt., 1954

Study for *Twenty Cent Movie,* 1936
Ink and pencil on paper, 9½ x 12¹/₁₆ (23.7 x 30.7). Unsigned. Gift of Mr. and Mrs. Lloyd Goodrich, 73.1.

BIBLIOGRAPHY AND EXHIBITIONS: Lloyd Goodrich, *Reginald Marsh,* exhibition catalogue (New York: Whitney Museum of American Art, 1955). Edward Laning, *East Side, West Side, All Around the Town: A Retrospective Exhibition of Paintings, Watercolors and Drawings by Reginald Marsh* (Tucson, Ariz.: University of Arizona Museum of Art, 1969). Thomas H. Garver, *Reginald Marsh: A Retrospective Exhibition* (Newport Beach, Calif.: Newport Harbor Art Museum, 1972). Lloyd Goodrich, *Reginald Marsh* (New York: Harry N. Abrams, 1972). Edward Laning, *The Sketchbooks of Reginald Marsh* (Greenwich, Conn.: New York Graphic Society, 1973).

Marsh, who liked being entertained, delighted in portraying beach crowds in their tawdry, varicolored costumes, or the cheap amusements he found in the seamy underbelly of New York life. It was a world he depicted enthusiastically. This study for *Twenty Cent Movie* shows the artist's process of gathering information for a painting. In simple, though carefully laid down lines, Marsh records major features of this seedy movie house, with its cashier's box, marquee and tilting signs. His process of selection is evidenced by the pentimenti—ghostly images of rejected figures. The artist is concerned with balance and compo-

sition, and works toward these ends by selecting from what is before him with no consideration for tonal values or plasticity. The elaboration would be developed later, in the painting.

37. KENNETH HAYES MILLER
 Oneida, N.Y., 1876–New York City, 1952

Study for *Box Party*, 1936
Pencil on paper, 6½ x 5¼ (16.5 x 13.2). Signed l.r.: Hayes Miller. Gift of Joseph H. Hirschhorn, 71.240

BIBLIOGRAPHY AND EXHIBITIONS: Lloyd Goodrich, *Kenneth Hayes Miller* (New York: The Arts Publishing Corporation, 1930). Alan Burroughs, *Kenneth Hayes Miller*, American Artists Series (New York: Whitney Museum of American Art, 1931). *Kenneth Hayes Miller* (New York: The Art Students League, 1953).

Miller is best remembered as a teacher; his reputation was developed through nearly forty continuous years of teaching at the Art Students League. While an enlightening and provocative teacher, his personal artistic expression is stilted, hard and crabbed. This drawing is a study for a painting. Our attention is drawn to the central quintet by the composition, which sets the action below the horizontal center of the page, and by a rich rendering of the forms and the relatively individualized figures. The shadowy couple entering through the curtains enlivens an otherwise placid composition, adds verticality to the structure, and gives a feeling of movement to the static design.

38. FEDERICO CASTELLÓN
 Almería, Spain, 1914–New York City, 1971

The Bed, 1937
Graphite on paper, 10¼ x 13 (26 x 33). Signed l.l.: Federico Castellón N.Y. '37. Gift of Mr. and Mrs. Benjamin Weiss, 78.38

BIBLIOGRAPHY AND EXHIBITIONS: Cummings, *Acquisitions*, p. 19. August L. Freundlich, *Federico Castellón: His Graphic Works, 1936–1971* (Syracuse, N.Y.: Syracuse University Press, 1978). Cummings, *Drawings*.

Few autodidacts achieve the skills that allow a unique style to emerge. Though initially influenced by Surrealism, Freud and the art of Dali, Castellón was soon able to evolve a personal imagery. The open space of this desiccated landscape, reminiscent of the artist's native Spain, is the setting for fantastic dreams drawn in a fine pencil point, using an array of refined tonal values. This painterly use of graphite is a skillful demonstration of the pencil's versatility in producing not only a line, but tone, value, light and texture. Castellón's art remains one of the few statements in America which contribute to the advancement of Surrealism.

39. MAN RAY
 Philadelphia, Pa., 1890–Paris, 1976

Etude pour La Fortune, 1938
Ink on paper, 10¼ x 13¼ (26.1 x 33.7). Signed l.r.: Man/Ray/1938. Inscribed l.l.: Etude pour La Fortune. Gift of the Simon Foundation, 74.81.

BIBLIOGRAPHY AND EXHIBITIONS: Man Ray, *Self-Portrait* (Boston: Little, Brown and Company in association with the Atlantic Monthly Press, 1963). *Man Ray*, exhibition catalogue, essays by Jean Leymarie, Alain Jouffroy and Man Ray (Paris: Musée National d'Art Moderne, 1972). Sir Roland Penrose, *Man Ray* (Boston: New York Graphic Society, 1975). Arturo Schwartz, *Man Ray: The Rigour of Imagination* (New York: Rizzoli International Publications, 1977). Cummings, *Acquisitions*, pp. 31, 42. Cummings, *Drawings*.

A curious voyager in the arts, Man Ray was a sometime stylish photographer, a painter, a chess player, a filmmaker and a jester to Marcel Duchamp. He associated with the Dada and Surrealist artists in Paris. This lively drawing is a study for the painting *La Fortune*, of which Man Ray has written:

> I distorted the perspective of that table on purpose. I wanted it to look as big as a lawn. I could have had two people playing tennis on it and I would be watching. . . . The green of the table reminds me of the grass of the lawn. I have always wanted a billiard table out in the country, in my garden. I do not wish to paint anything realistic or even descriptive. There is always an idea behind each of my paintings. It's the idea that interests me, not the description.

A combination of ruled and freely drawn lines differentiates the individual qualities of the objects portrayed: the clouds, castle and table. The drawing is of a type that Man Ray called "dream images"—illustrations of those odd fantasies that occur during sleep.

40. BURGOYNE DILLER
 New York City, 1906–New York City, 1965

Second Theme, 1938
Pencil and crayon on paper, 12½ x 12¾ (31.8 x 32.4). Signed l.r.: B. The List Purchase Fund, 79.5.

BIBLIOGRAPHY AND EXHIBITIONS: *Diller: Paintings, Constructions, Drawings, Watercolors*, exhibition catalogue (New York: Galerie Chalette, 1961). Lawrence Campbell, *Burgoyne Diller, 1906–1965*, exhibition catalogue (Trenton, N.J.: New Jersey State Museum, 1966). Philip Larson, *Burgoyne Diller: Paintings, Sculpture, Drawings*, exhibition catalogue (Minneapolis, Minn.: Walker Art Center, 1971). Cummings, *Drawings*. Kenneth W. Prescott, *Burgoyne Diller, 1938–1962* (New York: Meredith Long, 1979).

Diller was quite probably the first artist in America to follow the Neo-Plastic concepts of Mondrian and *de Stijl*. This drawing, executed during his years as head of the mural division of the Federal Art Project in New York City, presents one of the most avant-garde ideas of the time. Yet Diller's work differs from its European prototypes by virtue of his broad and heavy lines, the suggestion of depth and the bold balance of colors. His use of densely penciled or colored lines makes this more a painterly expression than a drawn one. The individual line is accu-

mulated into a planar surface. Light reflects through these dense planes, introducing a defining luminosity into the composition. Strikingly bold, the sharply drawn edges and the orderliness of this work might suggest calculation, but in fact they heighten the sense of felt balance and tension. The straight edges of the sheet set the limit of the colored surfaces, but the defining measurements are those of the eye and the emotions.

41. CHAIM GROSS
b. Wolowa, Austria, 1904

Untitled (Two Figures), 1938
Graphite on paper, 24¹³⁄₁₆ x 17⅜ (63 x 44.3). Signed l.r.: Chaim Gross/1938. Gift of Mr. and Mrs. Benjamin Weiss, 78.36.

BIBLIOGRAPHY AND EXHIBITIONS: A. L. Chanin and Samuel Atkin, M.D., *Chaim Gross: Fantasy Drawings* (New York: Beechhurst Press, 1956). Janet Flint, *Chaim Gross: Sculpture and Drawings*, exhibition catalogue (Washington, D.C.: Smithsonian Institution Press for the National Collection of Fine Arts, 1974). Frank Getlein, *Chaim Gross* (New York: Harry N. Abrams, 1974). Cummings, *Acquisitions*, p. 31.

Although Gross remarked that "subject matter as such is of little importance," he also said that he was inspired by "the female body in action and play." Moreover, he delights in acrobats "because of the many possibilities of variations in forms and movements." Gross' drawing differs from that of most contemporary sculptors because he employs tonal values rather than rely on a vigorous contour or outline. In the hatching and crosshatching, he examines light playing over these soft forms. The sensation of movement is suggested by the tentative balance of the figures in action, and is augmented by a series of great arcs that swing through the design in various directions.

42. REGINALD MARSH
Paris, 1898–Dorset, Vt., 1954

New Dodgem, 1940
Watercolor on paper, 40¼ x 26¾ (102.3 x 68). Signed l.r.: Reginald/Marsh/1940. Anonymous gift, 53.21.

BIBLIOGRAPHY AND EXHIBITIONS: Lloyd Goodrich, *Reginald Marsh*, exhibition catalogue (New York: Whitney Museum of American Art, 1955). Edward Laning, *East Side, West Side, All Around the Town: A Retrospective Exhibition of Paintings, Watercolors and Drawings by Reginald Marsh* (Tucson, Ariz.: University of Arizona Museum of Art, 1969), p. 56. Thomas H. Garver, *Reginald Marsh: A Retrospective Exhibition* (Newport Beach, Calif.: Newport Harbor Art Museum, 1972). Lloyd Goodrich, *Reginald Marsh* (New York: Harry N. Abrams, 1972). Edward Laning, *The Sketchbooks of Reginald Marsh* (Greenwich, Conn.: New York Graphic Society, 1973). Cummings, *Drawings*.

Marsh's watercolor *New Dodgem* is a view down a midway. A frieze of entertainment seekers occupies the front plane, while a gesticulating barker and the pretentious architecture of an amusement park loom above. Almost a compulsive draftsman, Marsh reiterated his favorite female images in seemingly endless variations. His watercolor shapes are defined by a bold, dark, brushed line—similar to the ones he produced with a pen—which recall the movement of his wrist. *New Dodgem* shows Marsh's facility in making a flat tonal surface or a precise line with the brush. One senses the vigor of his line, though a certain lassitude prevails in the broader strokes. In this penumbral composition, the artist used light to focus the viewer's eye on the elements he wished to dramatize. The bland sky and the regular features of the architecture do not detract from the action below.

43. MORRIS GRAVES
b. Fox Valley, Oreg., 1910

Journey, 1943
Gouache and watercolor on paper, 22¼ x 30⅛ (56.5 x 76.5). Signed l.r.: M. Graves 43. Purchase, 45.14.

BIBLIOGRAPHY AND EXHIBITIONS: Frederick S. Wight, *Contemporary Calligraphers: John Marin, Mark Tobey, Morris Graves*, exhibition catalogue (Houston, Tex.: Contemporary Arts Museum, 1956). *Morris Graves*, texts by Frederick S. Wight, John I. H. Baur, Duncan Phillips (Berkeley and Los Angeles, Calif.: University of California Press, 1956). *Morris Graves: A Retrospective*, exhibition catalogue (Eugene, Oreg.: University of Oregon, 1966). Ida E. Rubin, ed., *The Drawings of Morris Graves*, texts by John Cage, David Daniels (Boston, Mass.: New York Graphic Society for the Drawing Society, 1974), p. 68.

Our reading of the symbolic and mystical art of Graves may not correspond exactly to his own because individual reactions, information and experiences differ, but this invalidates neither the viewer's response nor the artist's intentions. In *Journey,* we see a chalice or cup beached on a rocky shore. The cup is cast upon unknown shores, fractured, but illuminated as the result of its adventures. It is developed out of the same tracery of lines as the rocks, which suggests a relationship between them. What are the dimensions of these objects? What is their relationship to each other and to us? The cheerless, dark tone of the wash establishes the mood of this work, but the figurations, in contrast, are established by a flickering, fractured, luminous white line. This interlace of lines creates an ambience suggesting neither time nor place, as if it were a dream landscape.

44. JOHN WILDE
b. Milwaukee, Wis., 1919

A. *Wedding Portrait*, 1943
Pencil on paper, 27¾ x 17¼ (70.5 x 46.3). Unsigned. Gift of the artist in memory of Helen Wilde, 70.75.

B. *Wedding Portrait*, 1943
Pencil on paper, 27¾ x 17¾ (70.5 x 43.8). Signed u.l.: Wilde. Gift of the artist in memory of Helen Wilde, 70.74.

BIBLIOGRAPHY AND EXHIBITIONS: Margaret Breuning, "Delicate but Definite Drawings," *Art Digest,* 24 (June 1, 1950), p. 18. *Drawings by John Wilde,* exhibition catalogue (New York: Edwin Hewitt Gallery, 1950). Cummings, *Drawings.*

The diptych, with its implications of courtly life, is rarely used today, but here it serves to symbolize the joining of two individuals. The twenty-four-year-old artist skillfully transforms line into tone, focusing our attention on certain areas of the drawing by the exactitude of his draftsmanship. The eye, first attracted to these refined areas, only later moves to the glossed passages. Later still one notices that strewn across the lower picture plane are shards reminiscent of ancient Mediterranean cultures. These fragments become allegories of a longed-for culture. The delicate grays, which unify these neo-Romantic drawings tinctured with Surrealist thought, delineate both the natural marks of necrobiosis and the impersonal patterns of geometry. The artist's powers of observation and his ability to transform evoke a disquieting charm. The text on the male's panel is the artist's autobiographical sketch.

45. GEROME KAMROWSKI
b. Warren, Minn., 1914

Emotional Seasons, 1943
Gouache, collage and paper on wood, 21½ x 30⅛ (55.9 x 76.2). Unsigned. Gift of Charles Simon, 78.69.

BIBLIOGRAPHY AND EXHIBITIONS: Judith Kaye Reed, "Kamrowski, Surrealist," *Art Digest,* 20 (January 15, 1946), p. 17. "Kamrowski's New Surreal Formula," *Art Digest,* 24 (May 15, 1950), p. 20.

Surrealism argued provocative realistic juxtapositions, biomorphism, the transformation of sinuous natural forms by insights culled from the investigations of Freud and Jung. Automatic writing, the technique of simulating a free-flowing graphic expression empowered by the shifting dictates of the unconscious mind, elicited Kamrowski's images. *Emotional Seasons,* one of a series of works suggestive of the desert, plant life, rocks, clouds or the underwater world, is an expression of the artist's personal experience of time and the seasons. Line acts not only to create movement, contain shapes and define edges, but to unify the composition by ordering the assorted mottled surfaces and bursts of color and light.

46. ALFONSO OSSORIO
b. Manila, Philippines, 1916

Red Star, 1944
Watercolor and ink on paper, 13½ x 19¾ (34.3 x 50.2). Signed l.c.: Ⓐ Jan 3rd 44. Inscribed l.r.: Camp Ellis, Illinois. Gift of the artist, 69.153.

BIBLIOGRAPHY AND EXHIBITIONS: Bernard H. Friedman, *Alfonso Ossorio* (New York: Harry N. Abrams, 1965). Francine Du Plessix, "Ossorio the Magnificent," *Art in America,* 55 (March–April 1967), pp. 56–65. Cummings, *Drawings.*

Red Star was drawn during Ossorio's military career, which included a period of service in the medical corps. This drawing, where the artist delves into his psyche with the total freedom demanded by Surrealism, studies the viscerally offensive. Could it be reality transformed, or is it that raging dark dream, the nightmare? The wiry energetic pen lines, with their splotches and hatchings, dramatically counter the soft, flowing qualities of the watercolor, whose bright values increase the impact of the violence in this scene. Scarred scarlet clouds billow from a cauterized earth to scud through a chaotic sky. The dynamic composition enhances the horrific effect of this drama of gore, explosion and dismemberment.

47. LEON KELLY
b. Philadelphia, Pa., 1901

Magic Bird, 1945
Ink on paper, 9¼ x 9¾ (23.5 x 24.7). Signed l.r.: Leon Kelly/1945. Purchase, 46.15.

BIBLIOGRAPHY AND EXHIBITIONS: *Leon Kelly,* exhibition catalogue (New York: Edwin Hewitt Gallery, 1956). Julien Levy, *Leon Kelly: Paintings and Drawings,* exhibition catalogue (Chicago, Ill.: Richard Feigen Gallery, 1970).

Magic Bird presents an enigmatic scene of a man with a wand facing three women—or perhaps three faces of a single individual. Could this drawing represent the Judgment of Paris? As birds are the familiars of Aphrodite, can we ascertain the influence of the chosen goddess? Paris, if it be he, seems on the verge of designating his choice. Who are these godlike figures that bestride the perspective landscape, wrapped in transparent cloth filaments? Kelly employs a short ink line—suggestive of the etched line in its dry, brittle choppiness—juxtaposed to a longer, flowing outline which contains the larger forms. Through simple, direct, graphic means, he establishes a transformation of fantasy images into a reality we can accept.

48. MARK ROTHKO
Dvinsk, Russia, 1903–New York City, 1970

Entombment I, 1946
Gouache on paper, 20¾ x 25¾ (52.7 x 65.4). Signed l.r.: Mark Rothko. Purchase, 47.10.

BIBLIOGRAPHY AND EXHIBITIONS: Peter Selz, *Mark Rothko,* exhibition catalogue (New York: The Museum of Modern Art, 1961). James B. Byrnes, *Mark Rothko: Ten Major Works,* exhibition catalogue (Newport Beach, Calif.: Newport Harbor Art Museum, 1974). Diane Waldman, *Mark Rothko, 1903–1970: A Retrospective,* exhibition catalogue (New York: Harry N. Abrams for the Solomon R. Guggenheim Museum, 1978).

Once a painter of urban scenes with a Social Realist flavor, Rothko, under the influence of Surrealism and abstraction, abandoned figuration in his mature work. The

coloristic possibilities suggested by the art of Milton Avery and the abstraction of Clyfford Still encouraged him to reject the figure-ground relationship and allow the horizontal planes of color in the background of works such as this to rise to prominence. As his figural interest lessened, Rothko came to reject the use of line. His early drawings show little formal interest in the qualities or functions of line other than to roughly define areas. This resulted in a careless, uncontrolled quality, rather like the line drawn by untrained individuals. Line completely disappears in his work after 1947–48, or is suggested only at the periphery of his bulking, massed colors.

49. ARSHILE GORKY
Khorkom, Armenia, 1904–Sherman, Conn., 1948

Study for *Summation*, 1946
Crayon and pencil on paper, 18½ x 24½ (47 x 62.2). Signed l.r.: A. Gorky/46. Gift of Mr. and Mrs. Wolfgang Schwabacher, 50.18.

BIBLIOGRAPHY AND EXHIBITIONS: Ethel K. Schwabacher, *Arshile Gorky*, exhibition catalogue (New York: The Macmillan Company for the Whitney Museum of American Art, 1957). Harold Rosenberg, *Arshile Gorky: The Man, The Time, The Idea* (New York: Horizon Press, 1962). William Chapin Seitz, *Arshile Gorky: Paintings, Drawings, Studies* (New York: The Museum of Modern Art, 1962). Julien Levy, *Arshile Gorky* (New York: Harry N. Abrams, 1966). *Arshile Gorky: Drawings to Paintings*, exhibition catalogue (Austin, Tex.: University Art Museum, University of Texas, 1975). Cummings, *Drawings*.

This is one of the 292 drawings Gorky produced in the summer of 1946. A study for *Summation*, completed near the end of the artist's life, it represents a synthesis of his motives and aspirations which fully demonstrates his mature handwriting. The pencil line, evenly paced and varied in tone, distills the sensual shapes which imply rather than explain. The rhythmic, flowing line imparts a sensation of breathing to these biomorphic images. Soft, inviting shapes are stated in strongly felt lines, augmented by small checks, spots and smudges of color that provide additional visual information. The eye derives pleasure moving through this design, whether we know the specific derivation of each individual shape or not.

50. CHARLES BURCHFIELD
Ashtabula Harbor, Oh., 1893–Buffalo, N.Y., 1967

An April Mood, 1946 and 1955
Watercolor on paper, 40 x 54 (101 x 137.2). Signed l.r.: CEB/1955. Gift of Mr. and Mrs. Lawrence A. Fleischman (and purchase), 55.39.

BIBLIOGRAPHY AND EXHIBITIONS: Leona E. Prasse, *The Drawings of Charles E. Burchfield*, exhibition catalogue (Cleveland, Oh.: The Cleveland Museum of Art, 1953). John I. H. Baur, *Charles Burchfield*, exhibition catalogue (New York: Whitney Museum of American Art, 1956), pl. 53. Edith H. Jones, ed., *The Drawings of Charles Burchfield*, text by Charles Burchfield (New York: Frederick A. Praeger in association with the Drawing Society, 1968). Matthew Baigell, *Charles Burchfield* (New York: Watson-Guptill Publications, 1976). Cummings, *Drawings*. Patterson Sims, *Charles Burchfield: A Concentration of Works from the Permanent Collection of the Whitney Museum of American Art*, exhibition catalogue (New York: Whitney Museum of American Art, 1980), pp. 24–25.

Burchfield drew with either the pencil or the brush. The brush makes thicker, heavier, less airy marks and increases the sensation of weight, so that the artist's brush drawings evoke a different "mood" (one of his favorite words) from that of his pencil drawings. By the 1950s, Burchfield's watercolors were charged with the painterly look characteristic of the decade: loose, brushy, atmospheric manipulation of paint like that of the contemporary Abstract Expressionists. In *An April Mood*, he sought to evoke the religious sentiments aroused by contemplation of the events of Good Friday. Under a sullen, lowering sky, in the sere, stubble-covered fields devastated by a winter storm, leafless trees rise to suggest grotto-like interiors.

51. JOHN GRAHAM
Kiev, Russia, 1881–London, 1961

Mona Anna Uxor de Adolfo Ravenato, 1947
Ink, pencil and chalk on paper, 22¼ x 17⅝ (56.5 x 44.7). Inscribed c.l.: MONAANNAUXOR/DEADOLFORAVENATO Gift of the Friends of the Whitney Museum of American Art, 60.65.

BIBLIOGRAPHY AND EXHIBITIONS: Everett Ellin, *John D. Graham*, exhibition catalogue (New York: André Emmerich Gallery, 1966). Stephan Prokopoff, *John Graham*, exhibition catalogue (Saratoga Springs, N.Y.: Hathorn Gallery, Skidmore College, 1967). Irving Sandler, "John D. Graham: The Painter as Esthetician and Connoisseur," *Artforum*, 7 (October 1968), pp. 50–53. Steven A. Morris, *John D. Graham* (New York: Donald Morris Gallery, 1972).

A noted connoisseur, Graham proselytized for avant-garde art movements until about 1942, when he rejected his past enthusiasms—Marxism, psychology and abstract art—in favor of Uccello, Raphael and Ingres. Evidence of his new loyalties appears first in paintings of Russian soldiers, and later in his portraits of women. The profile here is stated in a careful classical outline that plays against the mass of lines forming the woman's coiffure. Supple lines with terminal hooks or dots—most noticeable in the hair and dress—lend visual excitement to the image. Moreover, it is charged with recondite content, for a lip-like wound opens on the woman's neck. Wounds on women's bodies fascinated Graham, as did the use of Latin or Greek inscriptions. The page is touched with highlights of chalk which provide a subtle counterpoint to the ink line.

52. ANDREW WYETH
 b. Chadds Ford, Pa., 1917

Spool Bed, 1947
Watercolor on paper, 21⅝ x 29⅝ (54.9 x 75.3). Unsigned.
Purchase, 48.10.

BIBLIOGRAPHY AND EXHIBITIONS: Agnes Mongan, *Andrew Wyeth: Dry Brush and Pencil Drawings*, exhibition catalogue (Cambridge, Mass.: Fogg Art Museum, Harvard University, 1963). Mrs. John Brown, *Wyeth's World*, exhibition catalogue (Wichita, Kans.: Wichita Art Museum, 1966). Edgar P. Richardson, *Andrew Wyeth*, exhibition catalogue (Philadelphia, Pa.: Pennsylvania Academy of the Fine Arts, 1966). Wanda M. Corn, *The Art of Andrew Wyeth*, exhibition catalogue, texts by Brian O'Doherty, Richard Meryman, Edgar P. Richardson (Greenwich, Conn.: New York Graphic Society for the Fine Arts Museums of San Francisco, 1973).

In *Spool Bed*, a dark interior by Wyeth, we are shown a moment of casual quiet in a room where bright sunlight creates obscuring shadows. The calm mood is stated by Wyeth's careful line and powerful tonal values. Although the title is taken from the main piece of furniture in the room, this drawing is not concerned with the bed as an object, but as a symbol of human presence and life. The picture comments on the meaning and place of the bed; light and dark, joy and terror are contained in the shadowy interior that also represents the "interior" of the man. The potent, darkling quality denies the splendor of the light outside the window.

53. IVAN LE LORRAINE ALBRIGHT
 b. North Harvey, Ill., 1897

Roaring Fork, Wyoming, 1948
Gouache on paper, 22½ x 30¾ (57.2 x 78). Signed l.r.: Ivan Le Lorraine Albright. Gift of Mr. and Mrs. Lawrence A. Fleischman (and purchase), 62.30.

BIBLIOGRAPHY AND EXHIBITIONS: Frederick A. Sweet, *Ivan Albright*, exhibition catalogue (Chicago, Ill.: The Art Institute of Chicago, 1964), p. 45. Cummings, *Drawings*.

Watercolor drawings often blend linear and painterly qualities to achieve plastic resolutions not obtainable in other media. Ivan Albright used these elements with great facility to demonstrate his unlikely synthesis of late nineteenth-century rendering and multiple views characteristic of Cubist structure. Objects often tend to bulge outward, as if attempting to overcome some restraint. Albright employed a working method that entailed a constant turning and shifting of the sheet; he frequently changed his position in order to view the subject itself from various angles. This process imbues the work with a curious sense of motion. Our sense of space is disoriented when we observe that what we initially might have thought were objects presented in a shallow space are not. In the far right-hand side of the picture a horse grazes, and our sense of spatial relationships is questioned. Albright's jammed compositions, which seem to extend beyond the picture plane, present a complex overall rhythmic pattern not unlike the patterns in Jackson Pollock's work.

54. WILLEM DE KOONING
 b. Rotterdam, Holland, 1904

Landscape, Abstract, c. 1949
Oil on paper mounted on board, 19 x 25½ (48.3 x 64.8). Signed l.r.: de Kooning. Gift of Mr. and Mrs. Alan Temple, 68.96.

BIBLIOGRAPHY AND EXHIBITIONS: Thomas B. Hess, *Willem de Kooning* (New York: George Braziller, 1959). Thomas B. Hess, *Willem de Kooning*, exhibition catalogue (New York: The Museum of Modern Art for the Arts Council of Great Britain, 1968). Thomas B. Hess, *Willem de Kooning Drawings*, A Paul Bianchini Book (Greenwich, Conn.: New York Graphic Society, 1972). Philip Larson and Peter Schjeldahl, *De Kooning: Drawings/Sculptures*, exhibition catalogue (Minneapolis, Minn.: Walker Art Center, 1974). Harold Rosenberg, *Willem de Kooning* (New York: Harry N. Abrams, 1974). Diane Waldman, *Willem de Kooning in East Hampton*, exhibition catalogue (New York: The Solomon R. Guggenheim Museum, 1978). Cummings, *Drawings*.

Blending the memorable forms of woman with the undulating shapes of the landscape, de Kooning effects in his balanced tensions and rhythmic lines forms that are fitted together like a puzzle and set in shallow space. The lines of varying thickness and coloristic weight on the flat, mottled surface are the results of a blotting technique. The surface is devoid of brush marks or other delicate surface refinements. The artist's way of manipulating the space is influenced by collage and late Cubism. These biomorphic shapes indicate the early and profound influence of Gorky. By rejecting his youthful academic skills, de Kooning was able to explore and expound a new aesthetic. He retained the effects of the physical action of painting or drawing, hence emphasizing the materiality of the media and increasing our awareness of the nature of abstraction.

55. RALSTON CRAWFORD
 St. Catharines, Canada, 1906–New York City, 1978

Untitled, c. 1949–51
Ink on paper, 14½ x 11½ (36.9 x 29.2). Signed below largest of three sketches: Ralston Crawford/about 1949–51. Inscribed c.r.: 3 drawings. Inscribed l.l.: Third Avenue "L" and Number 3. Gift of Mr. and Mrs. Frederick M. Roberts in memory of their son, James Reed Roberts, 77.89.

BIBLIOGRAPHY AND EXHIBITIONS: Richard B. Freeman, *Ralston Crawford* (University, Ala.: University of Alabama Press, 1953). Edward H. Dwight and Ralston Crawford, *Ralston Crawford*, exhibition catalogue (Milwaukee, Wis.: Milwaukee Art Center, 1958). L. E. Lubbers, *Ralston Craw-*

ford: *Retrospective Exhibition* (Omaha, Nebr.: Fine Arts Department, Creighton University, 1968). Barbara Rose, *Ralston Crawford, American Modernist*, exhibition catalogue (St. Louis, Mo.: The Helman Gallery, 1971). Cummings, *Acquisitions*, p. 21. Cummings, *Drawings*.

Crawford responded to the regularity of the shapes in architecture, elevated railroads, ships and signs. He frequently used photographs as fugitive notational sketches because he liked their flat black-and-white tonal range. In this drawing of a fragment of New York City's now-destroyed Third Avenue elevated railroad, Crawford used an even, unemphatic line for hatching and crosshatching that accumulates in panels of gray tones. Areas of light are circled, a device which catches our attention because they differ from the rectilinear forms that dominate the composition. Crawford did not make statements of literal description but relied on a retained reference to subject matter—a window, for example—in the same way the Precisionists did. The still life in the lower portion of the sheet, composed of the number three and three-dimensional geometric shapes, is as abstract as Crawford would become.

56. WILLIAM BAZIOTES
Pittsburgh, Pa., 1912–New York City, 1963

Sea Forms, 1951
Pastel on paper on masonite, 38⅛ x 25⅛ (96.9 x 63.8). Signed l.r.: Baziotes. Purchase, 52.19.

BIBLIOGRAPHY AND EXHIBITIONS: Eleanor K. Freed and Ellen Sharp, *The Magical Worlds of Redon, Klee, Baziotes*, exhibition catalogue (Houston, Tex.: Contemporary Arts Museum, 1957). Lawrence Alloway, *William Baziotes: A Memorial Exhibition* (New York: The Solomon R. Guggenheim Museum, 1965). Michael Preble, *William Baziotes: A Retrospective Exhibition* (Newport Beach, Calif.: Newport Harbor Art Museum, 1978).

Though he is often grouped with the Abstract Expressionists, Baziotes remained a singularly mystical artist in his artistic motivations and in the statement made through his art. His images, derived from a subconscious transformation of things seen, evoke a dreamlike state filled with nautical associations. The firm lines in this pastel move like tendrils or tentacles that radiate from the core of some inexplicable, ghostly presence floating through the deep. The black, thin, radiating lines differ dramatically from the luminous surface produced by massed strokes of colored pastel. Baziotes said he stood as a man in quest before the mystery of the canvas, where he found a "more real reality."

57. PHILIP GUSTON
Montreal, Canada, 1913–Woodstock, N.Y., 1980

Ink Drawing, 1952
Ink on paper, 18⅝ x 23⅝ (47.3 x 60). Signed l.c.: Philip Guston 1952. Gift of the Friends of the Whitney Museum of American Art, 61.23.

BIBLIOGRAPHY AND EXHIBITIONS: Dore Ashton, *Philip Guston* (New York: Grove Press, 1960). H. H. Arnason, *Philip Guston*, exhibition catalogue (New York: The Solomon R. Guggenheim Museum, 1962). Harold Rosenberg and Sam Hunter, *Philip Guston: Recent Paintings and Drawings*, exhibition catalogue (New York: The Jewish Museum, 1965). Dore Ashton, *"Yes, But . . .": A Critical Study of Philip Guston* (New York: Viking Press, 1976). *Philip Guston: Drawings, 1947–77* (New York: David McKee Gallery, 1978). Cummings, *Drawings*.

The painterly line, with its autographic nature, is frequently the most pleasurable of lines in drawing because of the variety it offers for personal expression and graphic potential. Such are the lines in Guston's drawings, which move around abstract shapes that appear to have been derived from the Social Realist images in the artist's murals and paintings of the 1930s. By the early 1950s, Guston had rejected identifiable images and transformed them into abstractions composed of soft, fluid lines. Thin, brushed lines were occasionally augmented with lines thickened by repeated parallel accumulations. Such redrawn lines, with their now-engorged interstices, define and increase the coloristic weight of the original marks.

58. YASUO KUNIYOSHI
Okayama, Japan, 1889–New York City, 1953

Juggler, 1952
Ink on cardboard, 22 x 28 (55.9 x 71.1). Signed l.r.: Kuniyoshi. Purchase, 53.37.

BIBLIOGRAPHY AND EXHIBITIONS: William Murrell, *Yasuo Kuniyoshi*, Younger Artists Series (Woodstock, N.Y.: William M. Fisher, 1922). *Yasuo Kuniyoshi* (New York: American Artists Group, 1945). Lloyd Goodrich, *Yasuo Kuniyoshi*, exhibition catalogue (New York: The Macmillan Company for the Whitney Museum of American Art, 1948). Asuo Imaizumi and Lloyd Goodrich, *Kuniyoshi*, exhibition catalogue (Tokyo: The National Museum of Modern Art, 1954). Roy C. Craven and Lloyd Goodrich, *Yasuo Kuniyoshi*, exhibition catalogue (Gainesville, Fla.: University Gallery, University of Florida, 1969). *Yasuo Kuniyoshi, 1889–1953*, exhibition catalogue, texts by Donald B. Goodall, Paul Jenkins, Alexander Brook, Hideo Tomiyama (Austin, Tex.: University Art Museum, University of Texas, 1975). Cummings, *Drawings*.

When viewed with Kuniyoshi's early work (13), this late drawing illustrates the artist's profound evolution in personality and graphic accomplishment. *Juggler*, 1952, drawn in the last years of his life, shows us the mask of a clown, an entertainer; or does the image symbolize the artist's life? Gone are the blithe charms of his earlier work; now, from beneath the dark layering of ink emerges a figure whose forced, frozen smile is not bittersweet but tragic. Kuniyoshi's skill as a draftsman allowed him to express psychological insight without lapsing into maudlin sentimentality. These late works were produced during the years when abstraction of various kinds was taking the day, and artists following a humanistic tradition felt neglected or rejected, and were often reviled for being *retardataire*.

59. THEODORE ROSZAK
 Poznań, Poland, 1907– New York City, 1981

Invocation, 1952
Ink on paper, 39½ x 20⅞ (100.4 x 53). Signed l.r.: T. J. Roszak. Neysa McMein Purchase Award, 77.29.

BIBLIOGRAPHY AND EXHIBITIONS: Theodore Roszak, *In Pursuit of an Image* (Chicago, Ill.: The Art Institute of Chicago, 1955). H. H. Arnason, *Theodore Roszak*, exhibition catalogue (Minneapolis, Minn.: Walker Art Center, 1956). Bernard S. Myers and Daniel Catton Rich, *Roszak: Lithographs and Drawings, 1971–74* (New York: Pierre Matisse Gallery, 1974). Cummings, *Acquisitions*, p. 54. Cummings, *Drawings*.

 Sculptors' ideas are often expressed in simple, linear graphic statements. Sculptors with a background in painting, like David Smith, Claes Oldenburg, Christo and Roszak, generally produce drawings of greater visual interest and complexity. Roszak, a nearly compulsive draftsman, developed a variety of lines with which to express his vivid imagination. In this study for a sculpture, the thin, long, flowing pen-and-ink lines establish the major forms while short, rigid hatchings are used to define the interior shapes and to indicate surface textures. The drawing suggests three-dimensionality rather than the flat patterning that so often characterizes sculptors' drawings. Roszak's pointed, tubular forms allude to organic and inorganic sources that the artist transformed into symbols suggestive of sex and fertility. The drawing conveys another dimension as well: a spiritual sense derived from a contemplative experience of nature. An animistic vitality infuses the lyricism of this baroque image.

60. SAUL STEINBERG
 b. Râmnicul-Sărat, Romania, 1914

Railroad Station, 1952
Ink on paper, 19½ x 24 (49.5 x 61). Signed l.r.: Steinberg/1952. Gift of Mr. and Mrs. Carl L. Selden, 59.44.

BIBLIOGRAPHY AND EXHIBITIONS: Saul Steinberg, *All in Line* (New York: Duell, Sloan & Pearce, 1945). Saul Steinberg, *Passeport* (Paris: Chêne, 1954). Saul Steinberg, *The Labyrinth* (New York: Harper & Row, 1960). Saul Steinberg, *The New World* (New York: Harper & Row, 1965). Michel Butor and Harold Rosenberg, *Le Masque* (Paris: Maeght Editeur, 1966). John Hollander, *Steinberg at the Smithsonian*, exhibition catalogue (Washington, D.C.: Smithsonian Institution Press for the National Collection of Fine Arts, 1973). Saul Steinberg, *The Inspector* (New York: Viking Press, 1973). *Saul Steinberg: Zeichnungen, Aquarelle, Collagen, Gemälde, Reliefs, 1963–1974*, exhibition catalogue, texts by Tilman Osterwald, Wilhelm Salber, Gertrud Textor (Cologne, West Germany: Kölnischer Kunstverein, 1974). Harold Rosenberg, *Saul Steinberg*, exhibition catalogue (New York: Alfred A. Knopf in association with the Whitney Museum of American Art, 1978).

 Saul Steinberg, who was trained as an architect, ruminates here on the great old glass palaces that were European railway stations. Perspective shifts and the image is jostled out of focus to form a montage of architectural elements that recalls several different cities and tells us that this is not a portrait of a single building. The drawing presents an experience, a succession of stations blended in the mind of a traveler to become the general idea of a railroad station. The filigreed, barnlike structures rise amid domes and arches and myriad glass panes. The work is carefully made; the sense of distance is achieved by using tones composed of increasingly dense parallel lines. The rails flow gracefully, almost enveloping the static buildings looming above them. The clear, graphic quality of this work can be illuminated by Steinberg himself: "I am a writer. I draw because the essence of a good piece of writing is precision. Drawing is a precise mode of expression."

61. JACK TWORKOV
 b. Biala, Poland, 1900

Untitled, 1954
Charcoal on paper, 25¾ x 19⅞ (65.4 x 50.5). Signed l.l.: JT/54. Gift of Mr. and Mrs. Arthur Wiesenberger, 66.115.

BIBLIOGRAPHY AND EXHIBITIONS: Edward Bryant, *Jack Tworkov*, exhibition catalogue (New York: Whitney Museum of American Art, 1964). *Jack Tworkov: Recent Paintings and Drawings* (Santa Barbara, Calif.: University of California, 1977). *Jack Tworkov: Paintings, 1950–1978*, exhibition catalogue, essays by Dore Ashton, Marcia Tucker, Andrew Forge, Richard Demarco (Glasgow, Scotland: Third Eye Centre, 1979).

 Tworkov uses the seated figure as a starting point for the act of drawing. It is not studied as a subject of interest in itself, but is reduced to a motif constructed within a network of lines and shifting tones. The kneaded eraser is used to cut through the gray and black tones, bringing up the highlights and illuminating an abstract composition. Fragments of a body are recognizable, but there is little articulation of torso or limbs. By breaking up the form from within, the bold white lines increase the sense of abstraction in this exploded image. The remaining fragments are not meant to be reconstructed in the mind as an examination of the figure. The energetic gesture is paramount, yet is contained in a specific space.

62. RICHARD LINDNER
 Hamburg, Germany, 1901–New York City, 1978

Sunday Afternoon, 1954
Pencil and watercolor on paper, 25 x 19 (63.5 x 48.3). Signed l.r.: Richard Lindner/1954. Gift of the Friends of the Whitney Museum of American Art, 60.3.

BIBLIOGRAPHY AND EXHIBITIONS: Dore Ashton, *Richard Lindner* (New York: Harry N. Abrams, 1970). Nancy Schwartz, *Richard Lindner: Fun City, Original Watercolors*

(New York: Spencer A. Samuels & Company, 1971). Hilton Kramer, *Richard Lindner*, A Paul Bianchini Book (Boston, Mass.: New York Graphic Society, 1975). Richard Lindner and Stephen Prokopoff, *Richard Lindner*, exhibition catalogue (Chicago, Ill.: Museum of Contemporary Art, 1977). Cummings, *Drawings*. Werner Spies and Jean-Louis Prat, *Richard Lindner*, exhibition catalogue (Paris: Fondation Maeght, 1979).

The psychological study of individuals is rare in contemporary art because of the pervasive accomplishments of abstraction. "I believe in the secret behavior of human beings," said Lindner. The substance of that statement is examined in this drawing of a family, in which the two male members observe the viewer with similar stares, stares that match the woman's indifferent gaze. Lindner synthesizes the anonymous space of the portrait photograph, an element of nostalgia and his concern with toys in order to elucidate complex family relationships. By reducing the subjects to dolls—or even puppets—the artist is expressing his control of subject and content. Although the child's face echoes the father's, it is emphasized through contrasting darker tones. Thin, dark, overdrawn lines delineate the figures and construct the composition. Defined shapes and often curious interior spaces are developed with closely hatched lines that mold into soft tones. The repeated roundness of the major forms and the evenness of the tonal surfaces might suggest serenity, but that mood is called into question by the apparent cool formality among the individuals. The style of their clothes places them in another time, helps to establish their personalities and follows another dictum of Lindner's: "Costume gives identity."

63. Leonard Baskin
b. New Brunswick, N.J., 1922

Tormented Man, 1956
Ink on paper, 39½ x 26½ (100.4 x 67.3). Unsigned. Living Arts Foundation Fund, 57.52.

BIBLIOGRAPHY AND EXHIBITIONS: *Leonard Baskin*, exhibition catalogue, texts by Rico Lebrun, Julius S. Held, Winslow Ames, Harold Joachim, Ray Nash (Brunswick, Me.: Bowdoin College Museum of Art, 1962). Robert Doty, *Human Concern/Personal Torment: The Grotesque in American Art*, exhibition catalogue (New York: Whitney Museum of American Art, 1969). Alan Fern, *Leonard Baskin*, exhibition catalogue (Washington, D.C.: Smithsonian Institution Press for the National Collection of Fine Arts, 1970), p. 34. Leonard Baskin, *Baskin: Sculpture, Drawings, and Prints* (New York: George Braziller, 1970). Cummings, *Drawings*.

Leonard Baskin—sculptor, wood-engraver, woodcut maker, printer, writer and publisher—makes drawings that retain traces of the rough textures of woodcuts. The dry brushing, always initially seductive, gives the effect of dappled light; the ink piled on the page partially obscures the image. This unresolved quality had become the hallmark of the artist's style by the mid-1950s. The head of a man,

whose tormented experience of life is blatantly displayed on his face, is crested by a bird—in Baskin's mythology a creature burdened with ponderous knowledge—that suggests a literary impulse on the artist's part. Of drawing, Baskin wrote that "it is to art what chamber playing is to music. It is the finer sensibility that quickens in the perception of drawings." Baskin's drawings differ from those of most other sculptors in that the regimen of his woodcutting experience and later his work as a sculptor trained his graphic eye. The drama suggested by the image is not sustained by a strong sense of form, nor does the viewer establish empathy with the subject.

64. Kay Sage
Albany, N.Y., 1898–Woodbury, Conn., 1963

Constant Variation, 1958
Watercolor and collage on paper, 19⅛ x 26½ (48.3 x 67.4). Signed l.l.: Kay Sage '58. Promised gift of Flora Whitney Miller, P.68.78.

BIBLIOGRAPHY AND EXHIBITIONS: James Thrall Soby, *Kay Sage Retrospective*, exhibition catalogue (New York: Catherine Viviano Gallery, 1960). Regine Tessier Krieger, *Kay Sage, 1898–1963* (Ithaca, N.Y.: Herbert F. Johnson Museum of Art, 1977). Cummings, *Acquisitions*, pp. 54, 56. Cummings, *Drawings*.

Sage has employed decalcomania, a form of monotype in which a fluid substance is spread at random over a smooth, hard surface. A sheet of paper is placed over it, rubbed, then quickly removed, often producing runnels or striations of color in abstract designs. The artist then cut shapes from these proofs, and assembled them before a background of tonal wash; shadows are defined by a judicious addition of watercolor. The sharp, clean edges vary from the soft tonal values of the textural surfaces of the "stones." This menhir or cairn stands in everlasting silence in an anonymous place as a mysterious monument to man's passage. Decalcomania into collage into drawing is Sage's accomplishment.

65. Ben Shahn
Kovno, Lithuania, 1898–New York City, 1969

Conversations, 1958
Watercolor on paper, 39¼ x 27 (99.7 x 68.6). Signed l.r.: Ben Shahn. Gift of the Friends of the Whitney Museum of American Art, 58.21.

BIBLIOGRAPHY AND EXHIBITIONS: Bernarda Bryson, "The Drawings of Ben Shahn," *Image*, Autumn 1949, pp. 39–50. Edward S. Peck, "Ben Shahn: His 'Personal Statement' in Drawings and Prints," *Impression*, September 1957, pp. 6–13. James Thrall Soby, *Ben Shahn Paintings* (New York: George Braziller, 1963), pl. 87. William J. Hesthal, *Ben Shahn: Paintings and Graphics*, exhibition catalogue (Santa Barbara, Calif.: The Santa Barbara Museum of Art, 1967). Kenneth W. Prescott, *Ben Shahn*, exhibition catalogue

(New York: Kennedy Galleries, 1971). John D. Morse, ed., *Ben Shahn* (New York: Praeger Publishers, 1972), pl. 41.

Art manages multiplicity in content, but when it is used to make sociopolitical statements it becomes temporary news. An artist who often employed art to this end was Ben Shahn, a skilled, mannered draftsman who evolved a dry, broken, decorative drawing line by the accumulation of a series of short strokes often stated with the verve that animates the work of popular illustrators. The conventionalized line contrasts with the freely brushed watercolor, which lends weight and solidity to the image. The figures are situated in a flat, posterlike space. In *Conversations*, Shahn's symbolic characters express one personality, and the masks they wear become variations on their actual faces. The drawing suggests that there may be little difference between reality and masquerade, and, if so, what then is truth?

66. CLAES OLDENBURG
b. Stockholm, Sweden, 1929

Bicycle on Ground, 1959
Crayon on paper, 12 x 17⅝ (30.5 x 44.8). Signed l.l.: C.O. Gift of the Lauder Foundation—Drawing Fund, 76.31.

BIBLIOGRAPHY AND EXHIBITIONS: Gene Baro, *Claes Oldenburg: Drawings and Prints*, A Paul Bianchini Book (New York: Chelsea House Publishers, 1969). Barbara Rose, *Claes Oldenburg*, exhibition catalogue (New York: The Museum of Modern Art, 1970). Barbara Haskell, *Claes Oldenburg: Object Into Monument*, exhibition catalogue (Pasadena, Calif.: Pasadena Art Museum, 1971). Ellen H. Johnson, *Claes Oldenburg* (Baltimore, Md.: Penguin Books, 1971). Cossje van Bruggen, *Claes Oldenburg: Dessins, Aquarelles et Estampes*, exhibition catalogue (Paris: Musée National d'Art Moderne, Centre National d'Art et de Culture Georges Pompidou, 1977). Cummings, *Acquisitions*, pp. 46, 54. Cummings, *Drawings*.

A draftsman of outstanding invention, Oldenburg was a painter before he turned to sculpture. In this 1959 crayon drawing, the image is rendered in a variety of loose, sweeping lines that often enclose areas of light, while slower-moving horizontal lines and the rolling hatching suggest motion. Single, jotted marks convey a nervous energy, while tones and textures are stated with bunched lines or in a running hatching. The complex shape of the machine is reduced to its essential elements: circle, triangle, circle. The wheels were repeatedly overdrawn to increase their tonal weight and to define form. The variety in the application of the lines, the sensation of speed, the tones and textures, the bunched or running hatching, the directional shifts and the long, encompassing lines opposed to the single marks are graphic devices well used to sustain our interest. The drawing stimulates a sense of immediacy in our motor response, as if one were participating in its actual making. We respond to the pure formal activity of drawing, rather than being cozened by a glamorous subject.

67. GEORGIA O'KEEFFE
b. Sun Prairie, Wisc., 1887

Drawing IV, 1959
Charcoal on paper, 18½ x 24½ (47 x 62.3). Unsigned. Gift of Chauncey L. Waddell in honor of John I. H. Baur, 74.67.

BIBLIOGRAPHY AND EXHIBITIONS: Daniel Catton Rich, *Georgia O'Keeffe*, exhibition catalogue (Chicago, Ill.: The Art Institute of Chicago, 1943). Daniel Catton Rich, *Georgia O'Keeffe*, exhibition catalogue (Worcester, Mass.: Worcester Art Museum, 1960). Lloyd Goodrich, *Georgia O'Keeffe Drawings* (New York: Atlantis Editions, 1968). Lloyd Goodrich and Doris Bry, *Georgia O'Keeffe*, exhibition catalogue (New York: Whitney Museum of American Art, 1970). Cummings, *Acquisitions*, pp. 41, 46.

O'Keeffe responded to the landscape as seen from an airplane window by drawing small sketches on envelopes or bits of paper. If, on later examination, these pleased her, she would work them up into charcoal drawings like the one seen here. If, in this new state, the image continued to please, it could then be developed into a painting. In this aerial view of a river, the drawn line loses its individuality as it is blended into a cohesive tonal surface. Individual line quality is retained only at the defining edges. The catalectic image of the river, as stark in the landscape as the form is on the page, becomes a fragmenting element in the picture; the soft curves of the white incursions into the dark shapes capture the eye. O'Keeffe has shifted the point of view from that originally seen from above to one seen vertically. Although the image is abstracted, to her it remains "very realistic." As in her paintings, the complex multi-sensual appeal differs with the experience each individual viewer brings to the drawing.

68. FRANZ KLINE
Wilkes-Barre, Pa., 1910–New York City, 1962

Untitled, 1960
Ink on paper, 8½ x 10½ (21.6 x 26.7). Signed l.l.: KLINE. Gift of Mr. and Mrs. Benjamin Weiss, 78.53.

BIBLIOGRAPHY AND EXHIBITIONS: Elaine de Kooning, *Franz Kline: Memorial Exhibition*, exhibition catalogue (Washington, D.C.: Gallery of Modern Art, 1962). Robert Goldwater, *Franz Kline, 1910–1962*, exhibition catalogue (New York: Marlborough-Gerson Gallery, 1967). John Gordon, *Franz Kline, 1910–1962* (New York: Frederick A. Praeger for the Whitney Museum of American Art, 1969). Irving Sandler, *The Triumph of American Painting* (New York: Frederick A. Praeger, 1970). Albert Boime and Fred Mitchell, *Franz Kline: The Early Works as Signals*, exhibition catalogue (Binghamton, N.Y.: University Art Gallery, State University of New York, 1977). Cummings, *Acquisitions*, pp. 32, 38. Cummings, *Drawings*.

Kline produced numerous brush-and-ink drawings for structural and compositional purposes and to develop the personality of his gesture. These studies were often small and were frequently made on telephone directory yellow pages, on which the india ink, when brushed across the

soft, absorbent sheet, retained the spontaneity of the stroke's direction. Kline's drawings have often been compared, inaccurately, to the refined tradition of Oriental calligraphy, but Kline's concern was to express his individuality rather than a historic graphic tradition. The semblance to calligraphy stops with the apparent use of materials and the imaginative manipulation of gestures. Kline said he wished "to create definite positive shapes with the whites as well as with the black." The marks of the creative process remain visible and enhance apprehension of the force and direction of the line, its coloristic weight, the tensions established between the structural units, and the artist's sense of command. Our pleasure is derived in part from the energy expressed in Kline's graphic accomplishment. Drawing is the future of painting.

69. JIMMY ERNST
b. Cologne, Germany, 1920

Face, 1960
Ink on paper, 22 x 29¾ (55.9 x 75.6). Signed l.r.: Jimmy Ernst 60. Purchase, 60.56.

BIBLIOGRAPHY AND EXHIBITIONS: Robert D. Kinsman, *The Art of Jimmy Ernst* (Detroit, Mich.: The Detroit Institute of Arts, 1963).

Ernst confronts the landscape as a wall rising up before him, rather than as an ever-diminishing greensward reaching into the distance. He builds lines and sets the tones with small, obsessive penstrokes that demark shadows and textures. These refined lines contained in shallow space reinforce the barrier effect of the images and induce a pictorial claustrophobia. The continuous pattern of rock, seemingly arbitrary strata, fills the page, while the eye observes the small fragments, but is allowed moments of respite by the larger elements.

70. PHILIP EVERGOOD
New York City, 1901–Bridgewater, Conn., 1973

Miss Barzansky in Summurtime, 1961
Ink on paper, 31 x 23 (78.7 x 58.4). Signed within composition: Philip Evergood. Inscribed u.l.: Title Miss Barzansky in Summurtime. Promised gift of Terry Dintenfass in honor of John I. H. Baur, P.9.74.

BIBLIOGRAPHY AND EXHIBITIONS: John I. H. Baur, *Philip Evergood*, exhibition catalogue (New York: Frederick A. Praeger for the Whitney Museum of American Art, 1960). Lucy R. Lippard, *The Graphic Work of Philip Evergood* (New York: Crown Publishers, 1966). Alfredo Valente, *Philip Evergood: A Painter of Ideas*, exhibition catalogue (New York: Gallery of Modern Art, 1969). John I. H. Baur, *Philip Evergood* (New York: Harry N. Abrams, 1975). Cummings, *Acquisitions*, pp. 25, 29.

A trained academic draftsman, Evergood renounced skillful, controlled rendering in favor of a loose, exploratory expressionism that he felt allowed him greater freedom. Cascades of long, flowing lines describe the fullness of this standing female's filmy summer dress. The somewhat erotic implications of this thick-thighed torso are more the subject of the drawing than is the woman. Yet the tightly drawn hair and the carefully delineated eyes and facial features indicate that Evergood is still concerned with the model's personality and individuality. Evergood considered humanistic content a major attribute. He once described his graphic concerns by stating, "I search for the unexpected in line, in composition, in color."

71. CHARLES BURCHFIELD
Ashtabula Harbor, Oh., 1893–Buffalo, N.Y., 1967

Study of Thistle, 1961
Crayon on bond paper, 13¼ x 18⅞ (33.6 x 48). Signed l.c.: CEB/1961. Purchase, 65.39.

BIBLIOGRAPHY AND EXHIBITIONS: Leona E. Prasse, *The Drawings of Charles E. Burchfield*, exhibition catalogue (Cleveland, Oh.: The Cleveland Museum of Art, 1953). John I. H. Baur, *Charles Burchfield*, exhibition catalogue (New York: Whitney Museum of American Art, 1956). Edith H. Jones, ed., *The Drawings of Charles Burchfield*, text by Charles Burchfield (New York: Frederick A. Praeger in association with the Drawing Society, 1968). Matthew Baigell, *Charles Burchfield* (New York: Watson-Guptill Publications, 1976). Cummings, *Drawings*. Patterson Sims, *Charles Burchfield: A Concentration of Works from the Permanent Collection of the Whitney Museum of American Art*, exhibition catalogue (New York: Whitney Museum of American Art, 1980), p. 27.

This late crayon drawing by Burchfield so clearly delineates the parts of the thistle that it could be used to establish a botanical identification. The artist loved the thistle, which he called "one of the aristocrats of the plant world." Drawn with a varied line sure in its directions, the plant is shown in three stages of flowering. The drawing shows how Burchfield examined the plant, what captured his eye, and how he perceived the individual shapes and joined them into a whole. The spiny leaves and tasseled heads are set forth in a variety of blacks, grays and smudges that retain freshness resulting from a well-developed talent and diversified experience as a draftsman.

72. JOSEF ALBERS
Bottrop, Germany, 1888–New Haven, Conn., 1976

Reverse + Obverse, 1962
Ink on paper, 22½ x 14 (57.2 x 35.5). Signed l.r.: A 62. Gift under the Ford Foundation Purchase Program, 63.13.

BIBLIOGRAPHY AND EXHIBITIONS: George H. Hamilton, *Josef Albers: Paintings, Prints, Projects*, exhibition catalogue (New Haven, Conn.: Yale University Art Gallery, 1956). Gerald Nordland, *Josef Albers: The American Years*, exhibition catalogue (Washington, D.C.: Gallery of Modern Art, 1965). Eugen Gomringer, *Josef Albers*, texts by Clara Diament de Sujo, Will Grohmann, Norbert Lynton,

Michel Seuphor (New York: George Wittenborn, 1967).

Josef Albers, a Bauhaus student and instructor who later taught at Black Mountain College and Yale University, was concerned with the intellectual problems of how works of art are perceived as well as produced. The variety he brought to structures of similar external format, all composed of thin and thick rigid lines, is a monument to his imaginative questioning of reality through the subtle manipulation of one's unstable perceptions. Initially conceived on graph paper, these polygonal planes of shifting directions and changing illusions are stated in depersonalized lines. Albers sought "to bring coherence to the whole complex of design and fabrication, form, color, and perception. He permits an illusion of equilibrium in order to create tension" (F. Boucher). Here, logic is transmuted by optical sensation.

73. ROBERT BARNES
b. Washington, D.C., 1934

W.S., 1962
Pencil on paper, 18¾ x 12½ (47.5 x 31.7). Signed l.r.: 24.ix.62 Robert Barnes. Inscribed l.l.: W.S. Gift of the Allan Frumkin Gallery, 63.1.

BIBLIOGRAPHY AND EXHIBITIONS: "Robert Barnes: Painting and Reading, Reading and Painting," *Allan Frumkin Gallery Newsletter*, Spring 1977, pp. 1–2. Cummings, *Drawings*.

A drawing defines its subject and the artist's philosophy with varying degrees of clarity. Barnes' drawing *W.S.* suggests the portrait of an individual seated on a banquette before some windows through what appear to be high-rise buildings. The later Surrealists, the literary images of Marcel Duchamp, and numerous Romantic writers are among the influences Barnes acknowledged. Here he explores the surreal or fantasy dream-state as an exercise of the imagination. What is seen through the "windows" not only suggests architecture, but enhances the room's dreamlike ambience. The man's facial expression shows that sleep of hubristic dreams through which he occupies the very chamber of which he dreams. This state is transmitted to the viewer by the use of hatchings, checks, dashes, dots and smudges, and by the shift of focus on specific elements, which enlivens the pictorial elements of the drawing. Barnes also relies on the sheet's texture to increase the graphic qualities of his surfaces.

74. ELLSWORTH KELLY
b. Newburgh, N.Y., 1923

Briar, 1963
Pencil on paper, 22⅜ x 28⅜ (57 x 72.3). Signed l.r.: E K 63. Neysa McMein Purchase Award, 65.42.

BIBLIOGRAPHY AND EXHIBITIONS: Diane Waldman, *Ellsworth Kelly: Drawings, Collages, Prints* (Greenwich, Conn.: New York Graphic Society, 1971). John Coplans, *Ellsworth Kelly* (New York: Harry N. Abrams, 1972). E. C.

Goossen, *Ellsworth Kelly* (New York: The Museum of Modern Art, 1973). Cummings, *Drawings*.

Kelly began drawing plants in 1949 in Paris, but it was only after he settled in New York that his characteristic style emerged. In this drawing, he employs a line that establishes edges by silhouetting the leaves and stems while violating neither the image nor the flat surface of the page. The hard line moves along in subtle but definite variation; if the width of the line and the tone or color did not change, *Briar* would be less captivating. The drawn shapes and the negative spaces between them are active. Kelly's purpose in rendering this branch is not reportage, but rather an investigation of the abstract shapes and spatial relationships discovered through the act of drawing. The artist once stated, "My painting is a fragment of the visual world with the third dimension removed."

75. LEE BONTECOU
b. Providence, R.I., 1931

Untitled, 1963
Pencil and soot on muslin, 47¼ (119.4) diameter. Unsigned. Gift of the Friends of the Whitney Museum of American Art, 64.12.

BIBLIOGRAPHY AND EXHIBITIONS: Carter Ratcliff, *Lee Bontecou*, exhibition catalogue (Chicago, Ill.: Museum of Contemporary Art, 1972). Richard S. Field, *Prints and Drawings by Lee Bontecou*, exhibition catalogue (Middletown, Conn.: Davison Art Center, Wesleyan University, 1975).

Soot, a lush, velvety black carboniferous substance, produces a broad range of nuanced "colors" from deep black through gray. Here Bontecou uses it in a painterly manner on fabric. The formative shapes were noted in pencil; the soot was then used to develop the planes, stress the changes of light and determine edges. The imagery— a fantasy on aeronautical forms—suggests jet engine pods, airplane bodies and lights playing on runway surfaces or radiating through the sky. The illuminated, splayed forms convey a feeling of action or motion. A sculptor, Bontecou draws more in the fashion of a painter than in the linear manner most sculptors prefer. These shapes, informed by a degree of scientific interest, proclaim a mysterious quality which is generated in their anthropomorphic or ambiguous cybernetic suggestions.

76. ROY LICHTENSTEIN
b. New York City, 1923

Study for *Fastest Draw*, 1963
Pencil on paper, 2½ x 5¾ (6.4 x 14.6). Signed l.r.: r f l. Inscribed u.l.: Study for "Fastest Draw." Gift of Karen and Arthur Cohen, 75.35.

BIBLIOGRAPHY AND EXHIBITIONS: John Coplans, *Roy Lichtenstein*, exhibition catalogue (Pasadena, Calif.: Pasadena Art Museum, 1967). Diane Waldman, *Roy Lichtenstein: Drawings and Prints*, A Paul Bianchini Book (New York:

Chelsea House Publishers, 1969). John Coplans, *Roy Lichtenstein* (New York: Praeger Publishers, 1972). Cummings, *Acquistions*, p. 40.

In the early 1960s, Lichtenstein selected the images for his paintings from cartoons. He treated the original design much as one might objects in a still life: the elements could be rearranged and reemphasized with fragments eliminated or incorporated from other cartoon frames. In this study for *Fastest Draw*, a painting of 1963, areas of shadow are often outlined and filled in with dark hatching, while other lines are stressed by being overdrawn with dark pencil lines. This process represents a form-making activity not revealed in the original drawing. Edited to reflect the artist's interest in the movie close-up, the dramatic subject matter would later be unemotionally rendered by projecting the sketch onto the canvas with an opaque projector; the image would then be drawn lightly with pencil and painted.

77. WALTER MURCH
Toronto, Canada, 1907–New York City, 1967

Study for *The Birthday*, 1963
Pencil, wash and crayon on paper, 23 x 17½ (58.4 x 44.5). Unsigned. Neysa McMein Purchase Award, 64.6.

BIBLIOGRAPHY AND EXHIBITIONS: "Walter Murch," *Brooklyn Museum Newsletter*, December 1967. David L. Shirey, "Silent World," *Newsweek*, January 8, 1968, p. 59. Eugene Laubach, *Walter Murch, 1907–1967*, exhibition catalogue (New York: Betty Parsons Gallery, 1970). Theodore E. Stebbins, Jr., *American Master Drawings and Watercolors* (New York: Harper & Row in association with the Drawing Society, 1976), p. 392. Cummings, *Drawings*.

Although Murch is concerned with presenting a three-dimensional illusion, he nevertheless questions our apprehension of solidity by suggesting that light emanates from within an object or is an integral part of it. The result is a sense of insubstantiality. The precarious balance of the bowl in the foreground increases the dramatic tension. Line becomes the demarkation between shifts in light, tone and texture. A persuasive solidity is evoked with an unconventional vocabulary of marks. Murch's world is still, soundless and luminous.

78. SEYMOUR LIPTON
b. New York City, 1903

Untitled, 1963
Crayon on paper, 11 x 8½ (28 x 21.6). Signed l.r.: Lipton 63. Gift of the artist, 77.61.

BIBLIOGRAPHY AND EXHIBITIONS: *Register of the Museum of Art, The University of Kansas*, Seymour Lipton issue, 2 (April 1962). Albert Elsen, *Seymour Lipton* (New York: Harry N. Abrams, 1970). Cummings, *Acquisitions*, pp. 33, 40. Cummings, *Drawings*.

An immediate sense of three dimensions is read in Lip-

ton's drawings. The lines, laid down with brio, construct a shape in space, anchored on the page by the horizon line. Monumental and architectural, this construction rises above the low-set horizon to suggest a large-scale work. The quick gestures outline the basic forms, which are then articulated by internal hatching. The consistency of the line gives the drawing its harmonious aspect. The sheet serves as both endless space and the source of highlights. From this drawing the major face of a sculpture will evolve in the maquette, with the other sides worked up to support the premise stated in this view. The final work will expand the development in the maquette.

79. HENRY PEARSON
b. Kinston, N.C., 1914

Ethical Movement, 1965
Ink on paper, 15⅝ x 20¼ (39.7 x 52.1). Signed l.r.: Pearson 1965. Purchase, 65.46.

BIBLIOGRAPHY AND EXHIBITIONS: Lucy R. Lippard, *Henry Pearson*, exhibition catalogue (Duluth, Minn.: Tweed Gallery, Department of Art, University of Minnesota, 1965). Lucy R. Lippard, *Henry Pearson*, exhibition catalogue (Raleigh, N.C.: North Carolina Museum of Art, 1969). Cummings, *Drawings*.

A carefully drawn line moves slowly across the page, varying only according to changes in the paper's texture and movements of the artist's hand. As the two arcs move toward each other, the line establishes a harmonious surface and introduces optical properties that produce a rippling, shifting surface. This surface fabric could be destroyed if the line varied greatly from its set width and spacing. At an unpredetermined location on the page, these opposing forces collide to form a straight line.

80. FAIRFIELD PORTER
Winnetka, Ill., 1907–Southampton, N.Y., 1975

Study, n.d.
Ink on paper, 13½ x 10¼ (34.3 x 26.1). Signed l.r.: Fairfield Porter. Gift of Alex Katz, 77.58.

BIBLIOGRAPHY AND EXHIBITIONS: James M. Carpenter, *Fairfield Porter, Paintings; Eliot Porter, Photographs*, exhibition catalogue (Waterville, Me.: Colby College Art Museum, 1969). Peter Schjeldahl, *Fairfield Porter*, exhibition catalogue (New York: Hirschl & Adler Galleries, 1972). *Fairfield Porter: Retrospective Exhibition*, (Huntington, N.Y.: Heckscher Museum, 1975). Cummings, *Acquisitions*, p. 48.

By sketching the view through the windows of a screened porch, Porter suggests an interior-exterior experience. A thin, elegant outline surrounds areas of color, bursts of light and the forms of trees and foliage. Each panel, with its color annotations, is a charming composition of its own. This sketch is the first grasp of the subject, allowing the artist to state what he feels is important.

81. KARL WIRSUM
b. Chicago, Ill., 1939

Study for *Doggerel II*, 1966
Crayon with ball-point pen on paper, 13⅞ x 11 (35.7 x 28). Signed l.r.: Karl Wirsum. Gift of Marjorie Dell, 68.63.

BIBLIOGRAPHY AND EXHIBITIONS: Donald James Anderson, "The Believe It or Not World of Karl Wirsum," *Chicago Magazine*, September–October 1971, pp. 7–8+.

The Hairy Who, a group of young Chicago artists who banded together in the mid-1960s, proclaimed an aesthetic that continued some of the traditions of the Monster school of the previous decade. Their attitudes differed greatly from the Pop Art manifestations of the East and West Coasts. Wirsum, a member of the group, derives much of his imagery from pulp magazines, cartoons and other mass media and draws his splashy, explosive, zigzag patterns with a hard, relentless line. The persistent outline describes the basic forms; the color is added later. There is a generous wit at work here, but a bizarre, addled effect pervades this synthetic man-dog icon. Its general graphic aspiration stands outside the major dialogues in twentieth-century drawing. The image codifies the artist's response to myth-making or to the aggrandizement of everyday aspirations.

82. SAUL STEINBERG
b. Râmnicul-Sărat, Romania, 1914

Government Regulations on Autobiography, 1966
Ink, pastel and watercolor on paper, 28 x 22 (71.2 x 55.8). Signed l.r.: Steinberg/1966. Gift of the artist, 68.77.

BIBLIOGRAPHY AND EXHIBITIONS: Saul Steinberg, *All in Line* (New York: Duell, Sloan & Pearce, 1945). Saul Steinberg, *Passeport* (Paris: Chêne, 1954). Saul Steinberg, *The Labyrinth* (New York: Harper & Row, 1960). Saul Steinberg, *The New World* (New York: Harper & Row, 1965). Michel Butor and Harold Rosenberg, *Le Masque* (Paris: Maeght Editeur, 1966). John Hollander, *Steinberg at the Smithsonian*, exhibition catalogue (Washington, D.C.: Smithsonian Institution Press for the National Collection of Fine Arts, 1973). Saul Steinberg, *The Inspector* (New York: Viking Press, 1973). *Saul Steinberg: Zeichnungen, Aquarelle, Collagen, Gemälde, Reliefs, 1963–1974*, exhibition catalogue, texts by Tilman Osterwald, Wilhelm Salber, Gertrud Textor (Cologne, West Germany: Kölnischer Kunstverein, 1974). Harold Rosenberg, *Saul Steinberg*, exhibition catalogue (New York: Alfred A. Knopf in association with the Whitney Museum of American Art, 1978).

Unlike the earlier drawing by Steinberg, of an architectural fantasy (60), this work resembles a sketchbook page with various ideas scattered over it. In this catalogue of classic Steinberg images, we recognize the maze, the spiral, the false signatures, the artist and the faithful dog, the automobile, the rainbows, the letters A and B (their use suggestive of rules, limitations, problems) and documents. At the left, amid the calligraphy, a tree and rainbow are enclosed with a text, much as Ruskin might have annotated a landscape drawing. The letters at the right imply that there are many ways of arriving at B from A, and suggest a literary dimension: the artist tells tales, or indicates that the viewer should construe tales from these clues. The variety of character in the line increases the visual interest in his work. It combines rules and smudges, brittle, hesitant, lyrical or expressionistic lines and the rubber stamp—a once-made and oft-repeated drawing. Is this a rebus or a fanciful handling of important issues? An air of importance is guaranteed by the flourished signatures, the seals and the official stamps; even the artist's signature is notarized for compounded assurances.

83. ROBERT INDIANA
b. New Castle, Ind., 1928

The Great American Dream: New York, 1966
Crayon and frottage on paper, 39½ x 26 (100.3 x 66). Signed l.r.: R. Indiana 8/9 III. 1966. Inscribed l.l.: The Great American Dream: New York (The Glory-Star Version). Gift of Norman Dubrow, 77.98.

BIBLIOGRAPHY AND EXHIBITIONS: John W. McCoubrey and Robert Indiana, *Love*, exhibition catalogue (Philadelphia, Pa.: Institute of Contemporary Art of the University of Pennsylvania, 1968). *Robert Indiana*, exhibition catalogue, texts by Donald B. Goodall, Robert L. B. Tobin, William Katz, Robert Indiana (Austin, Tex.: University Art Museum, University of Texas, 1977). Cummings, *Acquisitions*, pp. 33, 37. Cummings, *Drawings*.

Frottage is the procedure in which a sheet of paper is laid over a textured surface, then rubbed with a pencil, crayon or other firm mark to induce a texture which bears the image. Indiana uses this process over a metal stencil by applying pencil in short, even strokes that yield a surface of tightly bunched hatching. The artist's one-directional stroke and controlled gesture result in a mottled screen of lights and darks that simultaneously reveal and obscure the image. Occasionally a negative line intrudes, introducing light as edge; this is seen where the pencil drops over an opening in the stencil, breaking the line's continuity. Indiana says that his initial intention in the "Great American Dream" series was to convey irony, but the series continued to become a celebration of American life through the use of emblems.

84. MEL BOCHNER
b. Pittsburgh, Pa., 1941

Isomorph (Plan for a Photopiece), 1966–67
Ink on graph paper; two sheets, each 13 x 19 (33 x 48.3). Signed l.r., first sheet: Isomorph (1966–67)/Plan for a Photo Piece/(sheet 1 of 2)/Mel Bochner; l.r., second sheet: Isomorph (1966–67)/Plan for a Photo Piece/(sheet 2 of 2)/Mel Bochner. Gift of Norman Dubrow, 77.101.

BIBLIOGRAPHY AND EXHIBITIONS: *Mel Bochner, Barry Le*

Va, Dorothea Rickburne, Richard Tuttle, exhibition catalogue, texts by Carroll Dunham, Barry Le Va, Naomi Spector, Dorothy Alexander (Cincinnati, Oh.: The Contemporary Arts Center, 1975). Brenda Richardson, *Mel Bochner: Number and Shape,* exhibition catalogue (Baltimore, Md.: The Baltimore Museum of Art, 1976). Cummings, *Acquisitions,* p. 15. Cummings, *Drawings.*

When the individual drawing marks and gestures are reduced to an impersonal or mechanical method, we must look for reasons other than draftsmanship to arouse our interest in a drawing. Bochner, like Albers and others, uses graph paper to state proportions and shapes in fine lines and flatly painted surfaces, to aid the easy identification of shapes. "Isomorph" is a scientific term which describes the same or closely related forms—as seen, for example, in crystals and other natural constructions. Drawing allows Bochner to establish a visual narrative between the elements stated in the upper sheet and their reworking in the lower sheet. In the reconstruction, he destroys the three-dimensional illusion of the cube with its grid structure, transforming it into a predominantly flat geometric shape. The drawing does not change in its qualities; the image changes. Because the graphic qualities in this drawing parallel the skilled anonymity seen in architectural drafting, the idea, not the draftsman's skills, assumes the paramount role. It is the interplay between the images on the two sheets, not the graphic rhetoric, that communicates the artist's meaning.

85. IBRAM LASSAW
 b. Alexandria, Egypt, 1913

Untitled, 1967
Ink on paper, 13⅜ x 16 (34 x 40.6). Signed l.r.: Ibram Lassaw 1967. Neysa McMein Purchase Award, 77.30.

BIBLIOGRAPHY AND EXHIBITIONS: *Ibram Lassaw,* exhibition catalogue (Durham, N.C.: Department of Art, Duke University, 1963). Ibram Lassaw, "Perspectives and Reflections of a Sculptor," *Leonardo,* 1 (1968), pp. 351–61. Cummings, *Acquisitions,* pp. 29, 38. Cummings, *Drawings.*

In this boldly stated drawing—a generalized study of sculptural ideas—the looping lines retreat from the major form in the foreground. As the forms recede, a perspective is introduced, as is a spatial effect similar to the one presented by Lassaw's sculpture. To maintain consistency, the artist reduced the weight of the line as the shape it describes was reduced. When the form suddenly split, turning at right angles to itself, a new layer of visual complexity was introduced. The describing parallel lines simulate the sensation of organic growth, as in nature. The shapes looping through space become tighter as they entwine in the distance, propelling our eyes ever deeper until we are entrapped by the obsession of the maze.

86. ROBERT RAUSCHENBERG
 b. Port Arthur, Tex., 1925

Untitled, 1968
Magazine transfer, pencil and gouache on paper, 22¼ x 29⅞ (56.5 x 75.9). Signed u.r.: Rauschenberg 68. Purchased with the aid of funds from the National Endowment for the Arts, 72.134.

BIBLIOGRAPHY AND EXHIBITIONS: Andrew Forge, *Robert Rauschenberg* (New York: Harry N. Abrams, 1969). Lawrence Alloway, *Robert Rauschenberg* (Washington, D.C.: Smithsonian Institution Press for the National Collection of Fine Arts, 1977). Cummings, *Drawings.*

Rauschenberg matured in a generation whose critical rhetoric briefly decried drawing, yet he produced many fine works on paper. Transfer drawings are made by a process of dampening a four-color or black-and-white illustration from a newspaper or magazine with solvent, then applying the paper to another surface and rubbing. This technique differs from frottage, but produces a similar surface of marks or bunched hatching and a ghost of the transferred image. The drawing gesture is boldly apparent as is the photographic origin of the fragmented image. An abstract drawing with figurative implications results. The patches of hatching become tesserae in a design that incorporates the structural principles of the Bauhaus, which Rauschenberg learned at Black Mountain College. The images of the now-transformed photographs suggest wider meanings than they did in their original state. The pure graphic expression evident in the drawing gestures and the literary provocations of the photographic image suggest that Rauschenberg is an artist in transition between high abstraction and the figural concerns of Pop Art and later forms of realism.

87. ROBERT SMITHSON
 Passaic, N.J., 1938–Teaovas Lake, Tex., 1973

Mud Flow, 1969
Crayon and felt pen on paper, 17½ x 23¾ (44.5 x 60.4). Signed l.r.: R. Smithson. Inscribed l.l.: MUD FLOW 1969. Gift of Norman Dubrow, 77.99.

BIBLIOGRAPHY AND EXHIBITIONS: Susan Ginsburg, *Robert Smithson: Drawings,* exhibition catalogue (New York: The New York Cultural Center, 1974). Hayden Herrera, "A Way of Thinking Out Loud: The Drawings of Robert Smithson," *Art in America,* 62 (September–October 1974), pp. 98–99. John Beardsley, *Probing the Earth: Contemporary Land Projects,* exhibition catalogue (Washington, D.C.: Smithsonian Institution Press for the Hirshhorn Museum and Sculpture Garden, 1977). Cummings, *Acquisitions,* pp. 46, 56. Cummings, *Drawings.*

Smithson was one of the first artists to consider the possibilities of using the earth as an art material. In this exuberant drawing made of hooked lines, dots, checks, hatching and color, he conveys, through a variety of graphic marks, his novel idea: man's hand intruding on the surface of the earth to produce a work of art. Soil transferred from one location to another establishes a sense of dislocation through contrasting colors and textures. The transformation of the hillside by the mud flow constitutes an admixture of the realms of painting and sculpture.

88. MICHAEL HEIZER
 b. Berkeley, Calif., 1944

Untitled, 1969
Photograph, pencil and watercolor on paper, 39 x 30 (99 x 76.2). Unsigned. Promised gift of Norman Dubrow, P.74.78.

BIBLIOGRAPHY AND EXHIBITIONS: "The Art of Michael Heizer," caption notes by Michael Heizer, *Artforum*, 8 (December 1969), pp. 32–39. Cummings, *Drawings. Michael Heizer*, exhibition catalogue, texts by Michael Heizer, Zdenek Felix, Ellen Joosten (Essen, West Germany: Museum Folkwang; Otterlo, Holland: Rijksmuseum Kröller-Müller, 1979).

In the late 1960s, many artists followed Robert Smithson in considering the earth a raw art material. In often inaccessible country sites, they cut, sliced, dug or "drew" on a variety of the earth's surfaces, assuming these incursions would result in works of art. Heizer's drawing combines a photograph of Arizona's noted meteor crater with a proposal for a revised shape. The artist's image mirrors and re-forms the crater's shape with a painterly, brushy wash, following the tonal values of the photograph. Light formed the image for Heizer as it did for the photographer. This is drawing used as a rough, annotated working presentation of an artist's idea.

89. ED RUSCHA
 b. Omaha, Nebr., 1937

Motor, 1970
Gunpowder on paper, 23 x 29 (58.5 x 73.7). Signed l.l.: E. Ruscha 70. Gift of the Lauder Foundation—Drawing Fund, 77.78.

BIBLIOGRAPHY AND EXHIBITIONS: Linda L. Cathcart, *Edward Ruscha*, exhibition catalogue (Buffalo, N.Y.: Albright-Knox Art Gallery, 1976). Edward Ruscha, *Guacamole Airlines and Other Drawings* (New York: Harry N. Abrams, 1976). Cummings, *Acquisitions*, pp. 51, 54. Henry Geldzahler and Andrew Bogle, *Graphic Works by Edward Ruscha*, exhibition catalogue (Auckland, New Zealand: Auckland City Art Gallery, 1978). Cummings, *Drawings*.

From folk art, Cubism and Constructivism, through Abstract Expressionism and Pop Art, letters have played an important role in the art of our century. Ruscha, who has remarked that he can contend with the reality of his subjects only in their original scale, utilizes words because "words are the only things that do not have a recognizable size, so I can operate in that world of 'no size.'" The model for a ribbon drawing is constructed of cut paper, shaped and held in place with straight pins. The planes and surfaces are defined by the subtle, painterly use of tone. Shadows are stated by darkening the tonal values. Line becomes the point of transition between the lights and darks. By darkening the center of the O's, Ruscha has not only indicated a shift in the spatial depth to below the picture plane, but has added a touch of humor; the flattened interior ovals

now resemble the kohl-tinted eyelids of the vamps of yesteryear. These objects in a field of ambiguous scale may suggest a still life or that ubiquitous American sentinel, the billboard. Do these shapes grace a tabletop still life or bestride the landscape?

90. ROBERT BEAUCHAMP
 b. Denver, Colo., 1923

Untitled, 1971
Graphite on paper, 36 x 79¾ (91.4 x 202.5). Signed l.r.: Beauchamp. The List Purchase Fund, 72.23.

BIBLIOGRAPHY AND EXHIBITIONS: E. F. Sanguinetti and Scott Burton, *Robert Beauchamp*, exhibition catalogue (Salt Lake City, Ut.: Utah Museum of Fine Arts, University of Utah, 1967). Cummings, *Drawings*.

Beauchamp greets us with a carnival of roistering creatures, cynical, guffawing animals and libidinous, insatiable, earthy women. The larger images that cross the page in bold bands are reminiscent of the animated gestures and design concepts of the Abstract Expressionists. The diagonals create spaces filled with smaller figures. Because of Beauchamp's ability to endow each image with a personality, one accepts the world presented here. The line, which varies in width, texture, coloristic weight, motion and direction, increases the graphic texture, not only within individual images but throughout the whole composition.

91. JOE BRAINARD
 b. Salem, Ark., 1942

Love, 1972
Pastel on paper, 13¾ x 10¾ (34.9 x 27.3). Signed l.r.: BRAINARD-72. Gift of Marilyn Cole Fischbach and A. Aladar Marberger, 77.92.

BIBLIOGRAPHY AND EXHIBITIONS: John Ashbery, *Joe Brainard*, exhibition catalogue (New York: The Alan Gallery, 1965). Cummings, *Drawings*.

Of the contemporary poets who draw, Brainard is one of the most delightful and incisive. His quick eye ascertains the spirit of the object, and he presents it in a felicitous and recognizable mode, while simultaneously cataloguing styles. Here he demonstrates his ability to grasp the stylistic semblances of painters (those of de Kooning and others), of photographs and of anonymous advertising graphics. Eighty images carefully organized in a grid or checkerboard tell a tale of the 1960s very similar in structure and image to Brainard's poem "I Remember." An important American mode of expression, the catalogue or inventory states information as a confirmation of the experience; it is a visual history that validates our existence. The style of Brainard's drawings—of toys, signs, graffiti and so on—is subservient to the content: the presentation of well-known images. This drawing is a joyful account to be prized by those who shared similar moments in their youth or by those who wished that they had.

92. RICHARD SERRA
 b. San Francisco, Calif., 1939

Untitled, 1972
Lithographic crayon on paper, 37¾ x 49¾ (95.9 x 126.4).
Signed l.r.: Serra 72. Gift of Susan Morse Hilles, 74.10.

BIBLIOGRAPHY AND EXHIBITIONS: E. de Wilde and Lizzie
Borden, *Richard Serra: Tekeningen/Drawings, 1971–1977*,
exhibition catalogue (Amsterdam: Stedelijk Museum, 1977),
cat. 6. Cummings, *Acquisitions*, pp. 47, 55. *Richard Serra*,
exhibition catalogue, texts by Clara Weyergraf, Max Im-
dahl, Lizzie Borden, B. H. D. Buchloh (Tübingen, West
Germany: Kunsthalle Tübingen; Baden-Baden, West Ger-
many: Staatliche Kunsthalle Baden-Baden, 1978), p. 111.
Cummings, *Drawings*.

Among the boldest drawings produced by an American
sculptor are those by Serra. Clear, precise shapes are drawn
on large sheets with lithographic crayon in a repeated ges-
ture until the line is lost in the compacted surface. Serra
draws in one direction, turning the sheet in the process of
refining his imagery. In this work, the obtuse triangle,
which appears to be suspended by its hypotenuse, projects
an ominous threat, much as the artist's sculpture does. A
crushing weight held in precarious balance conveys a sense
of impending monumental destruction. Drawing is more
than image making; it is a ritual investigation of primary
shapes and the effects these elicit. Serra has stated that
"drawing is a way of seeing into your own nature. There
is no way to make a drawing—there is only drawing. The
more I draw the better I see and the more I understand."

93. DONALD JUDD
 b. Excelsior Springs, Mo., 1928

Stainless Steel, Blue Recessed, 1973
Pencil on paper, 30 x 22 (76.2 x 55.8). Signed l.r.: Judd
73. Inscribed l.l.: STAINLESS STEEL/ULTRAMARINE BLUE RE-
CESSED. Gift of Mrs. Agnes Saalfield, 78.21.

BIBLIOGRAPHY AND EXHIBITIONS: *Don Judd*, exhibition cat-
alogue, texts by William C. Agee, Dan Flavin, Don Judd
(New York: Whitney Museum of American Art, 1968).
John Coplans, *Don Judd*, exhibition catalogue (Pasadena,
Calif.: Pasadena Art Museum, 1971). Roberta Smith and
Brydon Smith, *Donald Judd*, exhibition catalogue (Ottawa,
Canada: National Gallery of Canada, 1975). Dieter Koep-
plin, *Donald Judd: Zeichnungen/Drawings, 1956–1976*
(Basel, Switzerland: Kunstmuseum Basel; New York: New
York University Press, 1976). Cummings, *Acquisitions*, pp.
28, 37. Cummings, *Drawings*.

The repeated pattern is often used in Minimal sculpture
to increase the impact of simple shapes. A single element
is reticent; but seven images become a presence that moves
off the wall into the space of the room. In this work, Judd
presents the stack viewed at eye level with ascending and
descending elements. Because the background is suggested
but not indicated, the drawing offers the illusion of objects
suspended in endless, unidentified space. The mechani-
cally drawn lines present a defined working plan or in-

stallation guide. Although the size is indicated, any scale
is imaginable, as long as the proportions remain consistent.

94. SOL LEWITT
 b. Hartford, Conn., 1928

*All Crossing Combinations of Arcs, Straight Lines, Not-
Straight Lines, and Broken Lines*, 1973
Ink on paper, 19⅛ x 19⅛ (48.6 x 48.6). Signed u.c.: All
crossing combinations of arcs, straight lines, not-straight
lines, and broken lines/Sol LeWitt Jan. 24, 1973. Promised
gift of Norman Dubrow, P.76.78.

BIBLIOGRAPHY AND EXHIBITIONS: Barbara Reise, "Sol
LeWitt Drawings, 1968–1969," *Studio International*, 178
(December 1969), pp. 222–25. Sol LeWitt, *Geometric Fig-
ures within Geometric Figures* (Boulder, Colo.: Department
of Fine Arts, University of Colorado, 1976). Phyllis Plous,
Contemporary Drawing/New York, exhibition catalogue
(Santa Barbara, Calif.: University Art Galleries, University
of California, 1978). *Sol LeWitt*, exhibition catalogue, texts
by Lucy R. Lippard, Bernice Rose, Robert Rosenblum
(New York: The Museum of Modern Art, 1978). Cum-
mings, *Drawings*.

An implied theoretical position of Minimal Art is to
suppress the display of the hand's gesture and to elevate
mechanical or impersonal mark-making systems. LeWitt's
use of the grid is an organizational device that both sep-
arates and contains in quiet space its ritualistically pro-
duced, repetitive patterns. The text that describes this
graphic system results in a drawing that for all its abstract-
ness, illustrates the words. Squares which do not produce
crossing lines are left empty in the final design. We read
the drawing either by moving through the rows of boxes
or as a large, variegated pattern. Minimal words are less
forceful than those that result from felt experiences. In
this, a type of mechanical or architectural drawing, the idea
is paramount, and all that is required is to clearly present
information in a legible manner.

95. ALEX KATZ
 b. New York City, 1927

2:30 II, 1973
Pencil on paper, 24½ x 33½ (62.2 x 84.5). Signed l.r.:
Alex Katz/73. Neysa McMein Purchase Award, 73.73.

BIBLIOGRAPHY AND EXHIBITIONS: Irving Sandler and Wil-
liam Berkson, eds., *Alex Katz*, texts by William Berkson,
Lucy R. Lippard, Robert Rosenblum, David Antin, Ron Pad-
gett (New York: Frederick A. Praeger, 1971). *Alex Katz:
Recent Paintings*, exhibition catalogue (New York: Marl-
borough Gallery, 1978). Cummings, *Acquisitions*, pp. 37,
48. Roberta Smith, *Alex Katz in the Seventies*, exhibition
catalogue (Waltham, Mass.: Rose Art Museum, Brandeis
University, 1978). Irving Sandler, *Alex Katz* (New York:
Harry N. Abrams, 1979), pl. 163.

Katz, a figurative painter, developed his style during the
ascendancy of Abstract Expressionism. In this drawing,

working from a simple outline, he introduces areas made up of parallel lines that state textures, shadows and transitions between the composition's major planes. The impressionistic texture resulting from these bunched lines is further refined by the artist's stressing of interior transitions in a firm but delicate dark line. His presentation of the subject is casual, suggesting either a snapshot or a movie close-up. In greatly simplifying his subject's features, he nearly exalts her image to the status of a symbol.

96. ALEXANDER CALDER
Philadelphia, Pa., 1898–New York City, 1976

Four Black Dots, 1974
Gouache on paper, 29½ x 43 (74.3 x 109.3). Signed l.r.: 74/Calder. Gift of the Howard and Jean Lipman Foundation, Inc., 74.94.

BIBLIOGRAPHY AND EXHIBITIONS: Alexander Calder, *An Autobiography with Pictures* (New York: Pantheon Books, 1966). Wahneta T. Robinson, *Calder Gouaches*, exhibition catalogue (Long Beach, Calif.: Long Beach Museum of Art, 1970). Cummings, *Acquisitions*, p. 21. Maurice Bruzeau, *Calder* (New York: Harry N. Abrams, 1979).

In much of his work, Calder relied on the basic, Neo-Plastic palette of red, black, white, blue and yellow. Like many other major twentieth-century sculptors, he first worked as a painter. His graphic experience is evident in the plasticity of these bold shapes that bear implications of motion. The strong sense of movement is accomplished by a composition that explores a catalogue of rhythmic patterns. The sensation is enhanced by the contrast between the painted lines and the arcs of white between them, which establishes a general airiness. This drawing is charged with Calder's wit and joyful charm. Its radiating lines remind one of the Africa-inspired hammered-wire patterns of his jewelry.

97. RICHARD TUTTLE
b. Rahway, N.J., 1941

Sirakus, 1974
Ink on paper, 14 x 11 (35.6 x 28). Unsigned. The List Purchase Fund, 74.21.

BIBLIOGRAPHY AND EXHIBITIONS: *Mel Bochner, Barry Le Va, Dorothea Rockburne, Richard Tuttle*, exhibition catalogue texts by Carroll Dunham, Barry Le Va, Naomi Spector, Dorothy Alexander (Cincinnati, Oh.: Contemporary Arts Center, 1975). Elke M. Solomon, *Recent Drawings: William Allan, James Bishop, Vija Celmins, Brice Marden, Jim Nutt, Alan Saret, Pat Steir, Richard Tuttle*, exhibition catalogue (New York: The American Federation of Arts, 1975). Marcia Tucker, *Richard Tuttle*, exhibition catalogue (New York: Whitney Museum of American Art, 1975), p. 69. Maria Netter and Richard Tuttle, *Richard Tuttle*, exhibition catalogue (Basel, Switzerland: Kunsthalle Basel, 1977). Cummings, *Acquisitions*, p. 59. Michael H. Smith, *Richard Tuttle: From 210 Collage-Drawings*, exhibition cat-

alogue (Pasadena, Calif.: Baxter Art Gallery, California Institute of Technology, 1980).

Tuttle's drawings are often slight images nearly verging into the invisible. In this drawing, eight elongated, open-ended oval shapes decline from the left in even, measured stages. Like the drawings of so many sculptors, Tuttle's works on paper tend to be flat patterns even when watercolor incorporates tonal variations. They remain studies for objects to be made in other materials to be situated in a greater space. Tuttle repeats shapes or marks in a ritual fashion to elicit complex images. The meaning of the information he gives us is not explained by the title. Perhaps the explanation is to be found in Tuttle's own words: "Art is discipline and discipline is drawing. Drawing will change before art will."

98. LUCAS SAMARAS
b. Kastoria, Greece, 1936

Extra Large Drawing #2, 1975
Ink on paper, 30¼ x 22 (76.8 x 55.9). Unsigned. Gift of the Crawford Foundation, 77.69.

BIBLIOGRAPHY AND EXHIBITIONS: Lawrence Alloway, *Samaras: Selected Works, 1960–1966* (New York: The Pace Gallery, 1966). Lucas Samaras and Robert Doty, *Lucas Samaras*, exhibition catalogue (New York: Whitney Museum of American Art, 1972). Kim Levin, *Lucas Samaras* (New York: Harry N. Abrams, 1975). Cummings, *Drawings*.

For the past three centuries, letters and words taken from signs have insinuated their way into American art through artists as different as Social Realists and abstractionists. Samaras uses a hypodermic needle to extrude his ink lines, which differ in quality from lines made by pens, brushes or pencils. The artist confronts the work with its implications of command, admonition, suggestion, musing or realization—and, for Samaras, to whom art is discovery—provocation. These convoluted lines re-form letters that demand study. Tinctured by our experience of Western letter shapes, we respond to this demand for attention. Confined in a quadrant of blotches, dense with obliteration and illuminated by an interior light, the baroque forms grasp the page with their fingers of ink. Although the letters stand separately, they are combined in the mind's eye into the word DRAW.

99. PHILIP PEARLSTEIN
b. Pittsburgh, Pa., 1924

Male and Female Models on Greek Revival Sofa, 1976
Watercolor on paper, 29½ x 41 (75 x 104.1). Signed l.r.: Pearlstein 1976. Gift of the Louis and Bessie Adler Foundation, Inc., 77.6.

BIBLIOGRAPHY AND EXHIBITIONS: Linda Nochlin, *Philip Pearlstein*, exhibition catalogue (Athens, Ga.: Georgia Museum of Art, University of Georgia, 1970). Alexander Dückers and Philip Pearlstein, *Philip Pearlstein, Zeichnun-*

gen und Aquarelle: Die Druckgraphik, exhibition catalogue (Berlin: Staatliche Museen, Preussischer Kulturbesitz, 1972). *Philip Pearlstein: Watercolors and Drawings*, exhibition catalogue (New York: Allan Frumkin Gallery, 1977). Cummings, *Acquisitions*, pp. 42, 47. Cummings, *Drawings*.

Any rendering of the nude reveals not only the attitudes of the artist but documents those of his time toward the subject. In this drawing, Pearlstein's figures occupy an intimate space charged with an air of indifference symptomatic of American life in the mid-1970s. The artist's theory—the torso as abstract shape and the limbs as directional counterpoints—denies the erotic nature of his subject matter. The conflict this establishes is augmented by the dramatic use of the close-up. What initially appears to be a naturalistic rendering, one that would usually stimulate curiosity and inquiry, is actually a carefully stylized composition, drawn with a hard outline and inpainted in soft tonal shifts of color that modulate the eccentric lighting and form planes. The rug pattern adds color and defines and encloses the compositional space. This is a rigorous investigation of the figure as shape, form or object rather than as flesh or personality. Although our natural response to the figure is curiosity, we react here to the artist's ideas.

100. ELLSWORTH KELLY
 b. Newburgh, N.Y., 1923

Black Triangle with White, 1977
Collage and ink on paper, 31½ x 34½ (80 x 87.6). Signed l.r.: Kelly 77. Gift of Philip Morris Incorporated, 78.100.

BIBLIOGRAPHY AND EXHIBITIONS: Diane Waldman, *Ellsworth Kelly: Drawings, Collages, Prints* (Greenwich, Conn.: New York Graphic Society, 1971). John Coplans, *Ellsworth Kelly* (New York: Harry N. Abrams, 1972). E. C. Goossen, *Ellsworth Kelly* (New York: The Museum of Modern Art, 1973). Cummings, *Drawings*.

What appears to be limpid simplicity often indicates an exceptionally refined accomplishment. Kelly, whose work evolved into a form of high abstraction, gathers his creative impulses by observing the mutable patterns caused by sunlight on natural forms and man-made constructions. The paintings and sculpture that result from the artist's transformation of these phenomena become icons of difficult and subtle beauty. They maintain their impact because they are the results of felt perceptions. Kelly's feeling for natural and man-made shapes enriches our visual experience by generating new associations through his extraordinary control of balance, tension and color. The ruled line, a common drawing element, is made to delineate shapes that proclaim pictorial depth, weight, tension, interaction of planes, or stable forms contained by aggressive ones, all vitalized by a sense of anticipated movement.

101. BARRY LE VA
 b. Long Beach, Calif., 1941

Installation Study for Any Rectangular Space: Accumulated

Vision: Boundaries Designated (Configurations Indicated), 1977
Ink and pencil on construction and tracing paper, 42 x 62½ (106.6 x 158.8). Signed u.r.: B Le Va. The List Purchase Fund, 77.71.

BIBLIOGRAPHY AND EXHIBITIONS: *Mel Bochner, Barry Le Va, Dorothea Rockburne, Richard Tuttle*, exhibition catalogue, texts by Carroll Dunham, Barry Le Va, Naomi Spector, Dorothy Alexander (Cincinnati, Oh.: Contemporary Arts Center, 1975). Robert Pincus-Witten, "Barry Le Va: The Invisibility of Content," *Arts Magazine*, 50 (October 1975), pp. 60–67. Cummings, *Acquisitions*, p. 39. Phyllis Plous, *Contemporary Drawing/New York*, exhibition catalogue (Santa Barbara, Calif.: University Art Galleries, University of California, 1978). Cummings, *Drawings*.

Le Va, a sculptor, moves small three-dimensional fragments about in shallow space, usually placing them on the floor in calculated compositions. Drawing is a process of visualizing complex compositional relationships: it is a way of displaying the unseen coordinates and the lines that unify the often apparently random placement of elements. The images formed are interrelated through discriminating geometric relationships. Le Va's sculpture, although executed in thickish materials, is informed more by a painterly sensibility than a sculptural one. In this drawing, the patterns retain their relationships between variables and constants, while the actual dimensions may vary according to the room in which the work is placed. Drawing is thus a plan, a map, a graphic design. Various layers of paper and the changing tonal weight of the lines, which move between layers of paper, introduce shifts in light and tonal value.

102. WILLIAM T. WILEY
 b. Bedford, Ind., 1937

Nothing Conforms, 1978
Watercolor on paper, 29½ x 22½ (76.5 x 57.2). Inscribed across bottom: NOTHING COMFORMS TO X SPECK STATIONS .. FANCY REAM ARC'S AND A LIL FALTER PEACE WHILE WAITING FOR THE MODEL../SHADOWSLICKASEALSLITHERTHROUGH. Neysa McMein Purchase Award (and purchase), 79.25.

BIBLIOGRAPHY AND EXHIBITIONS: Brenda Richardson, *William T. Wiley*, exhibition catalogue (Berkeley, Calif.: University Art Museum, University of California, 1971). Graham W. J. Beal and John Perreault, *Wiley Territory*, exhibition catalogue (Minneapolis, Minn.: Walker Art Center, 1979).

Wiley's art presents a Northern California pantechnicon of images and visual tricks, all conjured through the artist's wonderful bag of graphic devices. In *Nothing Conforms*, he transforms, informs and misinforms. This work, a vision of his studio interior, contains traditional Wiley icons, visual puns, comic-book lore, signs and symbols of West Coast drug and funk cultures, and suggests the out-of-doors consciousness trumpeted by poets like Gary Snyder. Inclined to nostalgia, Wiley presents a kind of rebus in this still-life interior in which the symbol of infinity hangs from the

branch of a tree, while its shadow is incorporated into the canvas on the back wall. The drawn line defines indented edges, profiles, animals, icicles, small objects and birds, while the carefully laid-down watercolor reveals layers of images. Threading a path between fiction and reality, Wiley incorporates what he calls "tender" objects of delight into a design that intrepidly approaches high art. The visual puns, like trick drawings, seem to unfold their magic before the viewer's eye. The shifting color and luminosity of the watercolor contrast with the forming function of line; the sheet is enriched with interior light and surface vibrance.

103. CHUCK CLOSE
b. Monroe, Wash., 1940

Phil/Fingerprint II, 1978
Stamp-pad ink and pencil on paper, 29¾ x 22¼ (75.5 x 56.5). Signed l.r.: C. Close 1978. Inscribed l.r.: Phil/Fingerprint II. Anonymous gift, 78.55.

BIBLIOGRAPHY AND EXHIBITIONS: William Dyckes, "The Photo as Subject: The Paintings and Drawings of Chuck Close," *Arts Magazine*, 48 (February 1974), pp. 28–33. Christopher Finch, *Chuck Close: Dot Drawings, 1973 to 1975*, exhibition catalogue (Austin, Tex.: Laguna Gloria Art Museum, 1975). Cummings, *Acquisitions*, pp. 24, 43. Phyllis Plous, *Contemporary Drawing/New York*, exhibition catalogue (Santa Barbara, Calif.: Art Galleries, University of California, 1978).

Working from a photograph patterned with a grid, Close uses a single, repeated mark to create each drawing or painting. The mark is employed to ritually construct an image following an intellectual formula. *Phil/Fingerprint II* is a drawing with light values, tones and textures all accomplished by the artist's finger, inked on a stamp pad, to make marks that reestablish the tonal variations of the photograph. At a distance, the eye blends the rounded tesserae into surface patterns that indicate little of the sitter's personality. The drawing is an effective imposition of the artist's stylistic technique upon a subject.

104. H. C. WESTERMANN
b. Los Angeles, Calif., 1922

The Sweetest Flower, 1978
Watercolor on paper, 22⅛ x 31 (56.3 x 78.7). Signed l.r.: H. C. Westermann '78. Inscribed l.l.: "Death lies on her, like an/untimely frost—/Upon the sweetest flower of/the field."/Shakespeare. Gift of the Lauder Foundation—Drawing Fund, 78.102.

BIBLIOGRAPHY AND EXHIBITIONS: Max Kozloff, *H. C. Westermann*, exhibition catalogue (Los Angeles, Calif.: Los Angeles County Museum of Art, 1968). Barbara Haskell, *H. C. Westermann*, exhibition catalogue (New York: Whitney Museum of American Art, 1978). Cummings, *Drawings*.

Some late twentieth-century American art employs an iconography derived from comic books, movies, folk images, street life and, occasionally, literature. The draftsmen who draw on these sources often imbue their work with bitter, ironic humor. Westermann frequently becomes a player in his own art; here he depicts himself as a version of the suave, debonair film star Clark Gable. The mystery, evil and bittersweet humor of Westermann's dreamworld is admired by many artists, for example Wiley (102). Using a dry, scratchy line or a running, fluid one, Westermann modifies the image by a painterly use of watercolor. He makes diverse textures to differentiate the sky, the sea, the pier and the characters in his drama. The message in Westermann's art is more profound than the cartoonlike qualities of his subjects suggest.